PAGANS

Also by James J. O'Donnell

The Ruin of the Roman Empire: A New History

Augustine: A New Biography

Avatars of the Word: From Papyrus to Cyberspace

Scholarly Journals at the Crossroads:
A Subversive Proposal for Electronic Publishing

PAGANS

THE END OF
TRADITIONAL RELIGION
AND
THE RISE OF CHRISTIANITY

JAMES J. O'DONNELL

ecco

An Imprint of HarperCollins*Publishers*

HarperCollins books may be purchased for educational, business, or sales promotional use. For information please e-mail the Special Markets Department at SPsales@harpercollins.com.

FIRST EDITION

Designed by Suet Yee Chong
Mosaic image by ilyianne/Shutterstock, Inc.

Library of Congress Cataloging-in-Publication Data has been applied for.

ISBN 978-0-06-184535-2

15 16 17 18 19 OV/RRD 10 9 8 7 6 5 4 3 2 1

Ann
always

CONTENTS

PAGANS

PROLOGUE

WHEN POLYNICES QUARRELED WITH HIS BROTHER, ETEOCLES, over control of ancient Thebes, he raised an army led by seven mighty captains. Capaneus among them was notorious for his arrogance. On his shield was the image of a warrior with no weapon but a torch, instrument of an ancient city's most dreaded threat—fire. He appears in Aeschylus's *Seven Against Thebes,* but his best scene comes in the Latin Thebes epic of Statius. There, as battle rages, Capaneus, mighty and arrogant, scales a high tower of the city wall, aroar with boasting. All the defenders launch their catapults and javelins against him, to no avail. Taunting his enemies, he begins to rip walls apart with his bare hands.

Watching from high on Olympus, the gods are in full dither, taking sides in the war and clamoring for Jupiter's attention and favor. Bacchus, Apollo, Juno: they all fret and fume as storm clouds gather over the divine palace itself. Then Capaneus bellows his challenge:[1]

Are there no gods to defend this quaking Thebes? Where are the coward gods who were born here? You, Jupiter, do your

best against me with all your flames! Or are you only brave when you're scaring timid girls?

Now even Jupiter snorts with angry laughter, and suddenly clouds rush together, the sun vanishes, and storms brew in silence without a gust of wind. A moment's poise of terror, the warrior on his height, heaven holding its breath: then the storm begins for real, lightning crashing on all sides, and Capaneus gets one last line:

Here are the fires I need for Thebes! From these lightning bolts, I will refresh my torch!

Then a thunderbolt strikes him, flung from above with all the power of the king of the gods. Capaneus looks like a ball of flame on his high perch as the armies draw back in fear, not knowing where he might fall. Helmet and hair catch flame, his armor becomes a fiery furnace, but he stands firm there still, gasping his life away. At last, beyond endurance, he fails and falls in a mighty roar and crash—to the great relief of the bystanders, who could feel a second, mightier thunderbolt gathering strength in case it was needed.

So DO *YOU* BELIEVE in gods?

No, I didn't ask, "Do you believe in God?" That's a very different question. I mean, do you believe in the gods Capaneus challenged, Jupiter and Juno and that crowd? What about Serapis and the Thracian rider god and Epona the Gaulish god who looked after the horses once they got back to the stables—do you believe in *them*? Do you believe that once upon a time there were such beings who went about the world with superhuman powers of various kinds, interfering in the ordinary run of events?

No, I don't either.[2]

How was it, then, that once upon a time, people all across western Asia, the Mediterranean basin, and Europe took for granted that such gods existed, were found everywhere, and involved themselves in running the world—and then one day didn't think that way any longer? As late as 300 CE, no one could have imagined a world without those traditional gods, lords since time immemorial. A century and a half later, few could remember what the world with those gods had been like.

Their passing, as we will see, was disconcertingly easy and undramatic. The Christians who prevailed made the noise—so much that moderns were long persuaded that there had been a mighty struggle, pagans versus Christians, somewhere on the scale of Ali versus Frazier or the Thirty Years War. It just wasn't so.

Yes, the variety of religious stories, beliefs, and practices in that old world was simply too vast to comprehend, so their disappearance is all the more remarkable. Altars in homes, shrines on street corners, and public ceremonies in the open air made ancient Rome more akin to Kathmandu during festival season than anything we could imagine in modern Europe. No one could inventory that world in one book and I will not try. The modern scholars who bring together the evidence for what Greeks and Romans and Egyptians and Jews and Phoenicians and Scythians and Carthaginians and Thracians and Gauls did about their gods deserve vast respect for taking on an endless and thankless task.[3] The story of what happened when those gods passed is easier to grasp and colorful enough. It's also important for us today—and easy to get wrong.

Sure, everybody knows—though always be careful of what *everybody* knows—that there were once pagans and Christians, people of the old and people of the new, engaged in that mighty struggle that only one side could win. The new prevailed. Conflict like that makes for great stories and the pagan–Christian dustup tale has been written repeatedly.[4] But the passing of the gods who

never existed needs a different kind of story. It's not a question of who vanquished whom, but of just what changed when and where.

Remember, the story of Christianity's rise takes a long time, from Jesus's lifetime to the emperor Constantine's conversion, three centuries. The traditional way to think about it is to imagine fervent Christians adding to their number, each generation larger than the last, carrying a pristine Christian message to the world. On that model, when the last Roman citizen was baptized, everyone had become what the earliest Christians had been.

The world doesn't work that way. Whatever core ideas Christianity sought to transmit, every baptism brought someone unshaped by Christianity into the fold, mixing their ideas and expectations with what they found. The pristine essence of Christianity acquired a lot of old-fashioned baggage along the way. When Christians talked about their pure and unique gift of illumination for a dark world, who really needed to be persuaded?

The storytelling is itself important. For us, religion comes with history, and history matters. No classical Greek or Roman writer ever thought to address the history of religion, because religion was woven seamlessly into everyday life, the kind of life that has no history to speak of. Our modern historians can make history for everything, to be sure,[5] but when they reconstruct a story for Greco-Roman religion, they tell a story the ancients didn't themselves know. And when they do so, they are in cahoots with the story-making Christians of the fourth century.

So the first half of this book is about that ancient world of religion that had no history. The second part will show what happened when religion acquired a history in the fourth century CE.

The apparent victory of the Christians then was one upheaval among many. The fundamental notion of divine power itself had grown so large in the hands of various philosophers and cults that it

overpowered the small, quarrelsome gods of old. Earlier practices, like blood sacrifice and augury, had faded so much from favor that they almost didn't need abolishing. Fresh ideas are always exciting, and we'll see how Judaism reinvented itself for a new world, while Christianity discovered its ability to take advantage of unearned good luck and make itself powerful in a way that crossed boundaries between empires and nations, between genders, and between classes.

To go back to the world of the gods and their worshippers, we must learn to do without a coherent story. Indeed, we must forget much of what we take for granted about "religion"—like its intimate connection to questions of ethical conduct. And we will see that what people thought about gods was much less important than what they did about them.

All religion was local. Even when you found the same gods in different places, meaningful connection between worshippers in one place and those in another was rare. When we visit Delphi in these pages, we'll come as close as we can to a single location drawing together believers from many places, but even that was more Times Square than Vatican. For the most part, what happened in Antioch stayed in Antioch; what trickled down to villages and towns stayed there, of no interest to anybody elsewhere.

My first chapters will offer more travelogue than story, with selected sites and sights and rites and rituals, to give an idea of what went on that would go away. This tour will concentrate on the Roman Empire, starting with the age of Augustus. We'll keep a special eye on practices of blood sacrifice as the most vivid way of watching for what changed—and what didn't.

Then we'll settle down for a *real* story, when we begin, quite late, to hear of "pagans" and their ways. The very notion of paganism was invented late, to persuade people that something else, a very different

something else, existed and deserved to succeed. That's when the historical narrative we inherit was first constructed, to give that something else a credible backstory. Nobody we might call a pagan would have thought it made any sense at all. To do justice to all sides, we'll have to tell it differently.

And the gods? Few noticed their passing, few wept. Collateral damage, we might say.

I

RELIGION
WITHOUT
HISTORY

Chapter 1

THE TOUR GUIDE'S VERSION

THE BEST WAY TO EXPLORE ROMAN RELIGION IS TO GO TO ROME for a few days and spend some time in the homes of the ancient gods. We could take a camera. We'd likely have a tour guide to annoy us in a hundred petty ways, but at least we'd hear stories about what we saw. The good news is that we'd hear a story about paganism that sounded very familiar and wouldn't tax our attention too much. The bad news is that it wouldn't have much truth to it.

If there's no time for a trip to Rome, let me see if I can get the guide's story down here. Take this as a sincere effort to set a starting point, based not so much on the best current scholarship—which has gone well beyond what I say here—but on what filters down as the well-educated and well-read general reader's accumulated understanding of this slice of the past. History as the historians practice it is in constant motion, but history as the general reader remembers it is held down by inertia. Like Tolkien's hobbits, we like to hear stories we already know, after all. That's what tour guides are for.

Once upon a time, the world was young, people were naive and simple, and cares were few. Men and women believed intuitively that there were higher powers who controlled the fates and destinies of a world full of arbitrary chances. Weather and war, health and wealth, love and hate were all powerful forces that lay beyond human, but not divine, control. From ancient days long before imagining or memory, stories and rituals had emerged that offered hope of understanding and even some control over what the mysterious superhuman beings might do.

These rites and beliefs arose spontaneously and locally in some cases, but also spread along routes of trade and migration. From one place to another, strikingly similar practices suggest that people in motion were bearers of new ideas and popular practices that gradually spread widely. Sky gods, sometimes with similar names, are found manywhere, in widely separated settings. All this progress was natural and unforced, for no one cared to compel anyone else to believe or practice anything. The gods allowed mankind great freedom.

With time, civilization and the accumulation of wealth made it possible to extend and glorify practices and the associated buildings and artworks in lavish ways. A city that became wealthy and powerful soon built elaborate edifices, erected mighty sculptures, and instituted rituals that all consumed, quite conspicuously, enormous wealth. These buildings and rituals let communities demonstrate their loyalty to their gods and impress their neighbors and rivals. A god who helped people become rich and powerful could expect to be well treated; one who harmed them could expect to be treated almost as well, by way of bribery.

No idyllic time can last. Wealthy and powerful cities developed not only their religious capacities but their war-making

ones. Victors in war boasted of their divine patrons, and the people they vanquished found themselves, half involuntarily, half voluntarily, accepting in fear some of the stories and practices of their new overlords. Short of warfare itself, envy, admiration, and credulity all led people to invite gods to relocate or extend their reach.

At about this point on our tour, we might be entering Hadrian's Pantheon, the most glorious building still surviving from the Roman world. The dome soars serene over a space whose tranquillity cannot be disturbed even by the throngs and the clutter of modern religious sculptures and furnishings that have made their way in. (There were likely comparably overdone images and furnishings cluttering the place in antiquity.)

Hadrian died in 138 CE, when the wealth, power, and extensiveness of Rome were all at their greatest. His Pantheon was a temple for all the gods—and that *all* was a marker of the generosity and the terrifying power of Rome. To be Roman was a privilege, of sorts, though often a painful privilege to acquire. A few miles from Rome in his great villa at Tivoli, Hadrian captured another kind of comprehensiveness in building for himself a theme park of the Roman world, re-creating shrines and scenes and temples and rites from across the known world. How could anyone complain? All the gods smiled on the ruler of all mankind, and all his subjects benefited.

The guide goes on:

With all this, communities diversified. Small groups in a large city might have now their own cults and creeds. For the most part, no one else much cared. As long as what was done out of tradition and pride still earned respect, an upstart group could be harmless; but sometimes, just sometimes, the

newcomer seemed to bring a threat against the establishment, which could lead to hostile reaction.

The great turn came when the stiff-necked cult of the god from Jerusalem began to make itself known. Did it bring ruination or transcendence? Curious people these Judeans, preposterously insisting not only that their god was a mighty god, but that he was supremely important and powerful. These people thought well of themselves, but in their overweening pride, they overestimated their ability to project their identity onto a world full of greater powers than theirs. They found little sympathy.

The Christians were every bit as stiff-necked as the Jews, but sought converts more provocatively. They not only claimed they were right, but insisted that everyone else should join their way of being right. They cocked a snoot at the old gods, the old ways, and even the emperors. So arrogant and assertive were they that they brought down on their own heads the wrath of governors and emperors in waves of persecution, culminating in the great persecutions of the 250s and 300s CE, when the full force of imperial law insisted that every citizen of the emperor show his or her loyalty by performing sacrifice to the traditional gods. Their heroic resistance to persecution was exemplary.

And the Jews and Christians were not the only troublemakers. A whole host of other eastern religions sprang up under Roman rule with cults and myths that ranged from the curious to the outrageous. Even the generous inclusiveness of a Hadrian could not encompass all that the world had to offer. For long decades and centuries, there was serious competition among mystery cults of the East, with secret rituals and a powerful appeal to individual practitioners to change their lives at the god's command. They spoke to the faith of people who wanted a personal connection with the divine and an assurance of real

"salvation," something more than the general expectation of material prosperity and a painless afterlife that traditional religion had offered.

But there was something intrinsically new and unique about Christianity.

There are Christian and non-Christian ways to tell this story from this point. To the devout, the success of Christianity was divinely engineered. Eusebius in his *Ecclesiastical History* from the fourth century CE created this version, making sure to match up ten waves of persecution with the ten plagues the Hebrew slaves had experienced in Egypt. The undevout are left to scramble for material explanations sufficiently robust to allow for a remarkable triumph, and wind up accepting Christian exceptionalism. Our guide is a little wishy-washy, not wanting to offend:

The power of the new religion was too great to suppress with mere military might. It had the force of truth, the truth that the old gods were nothing but myths and adumbrations of spiritual reality, the truth that a fundamental unity of all earthly being was coming to expression in increasing recognition of the power of monotheism. Christianity was well poised, with its army of faithful, to take advantage of this dawning realization and to use its many strengths to make itself the religious movement of the future.

Whether it was miracle or tactical ingenuity that led the emperor Constantine to the Christian fold, there he came and there he stayed. Once he became emperor in his own name and right, he quickly moved to make his true religion the unique religion of the Roman Empire, reining in the pagan gods and their cults and beginning to shut them down. He helped Christians advance in government and imperial service while turn-

ing his back on pagans. On his deathbed in 337 CE, he accepted baptism and left an empire greatly changed from the one he had received. His son and heir, the emperor Constantius, continued his policies for another two decades. Father and son together had worked closely with the bishops of the church, who banded together to establish and promote a clear orthodoxy of doctrine, notably at the Council of Nicea in 325, that would express and preserve the unity of Christian thought and practice against all challenges from heretics, Jews, and pagans.

When Constantius died in 361, childless, he was replaced by the sole surviving member of the imperial family, his young cousin Julian. In student days at Athens, Julian had explored and espoused the cults of the ancient gods, to whom he was devotedly but secretly loyal. In his early years of imperial service, he concealed his religious leanings behind a mask of philosophy and discretion, but when Constantius died, Julian threw off the mask and declared himself openly in support of the old gods, rallying the true believers in the old ways. He revoked privileges the Christians had acquired and, cunningly, allowed all those Christians who had been exiled as heretics to return to their homes—there, assuredly, to make trouble among their coreligionists. His pursuit of ancient authenticity went so far as to sponsor reconstruction of the ancient temple of the Jews at Jerusalem. He raised a banner of hope for many loyal followers of the old gods.

Julian died in 363, falling in battle on the Persian frontier, most likely to the mischance of war, though there were strong rumors of Christian perfidy. With his death, though he had given hope to pagan theologians and statesmen, resistance faltered. Over the next generation, a great struggle was fought between pagans and Christians, notably at Rome, where dignified pagan aristocrats from the oldest and best families made a

proud stand for the ancient ways. In a repeated series of confrontations, Christian zealots swarming about the imperial throne succeeded in getting the altar of the goddess Victory removed from the Senate house in Rome and leading pagan lights of the Senate fought steadily to have it replaced.

At a time when often two or three emperors reigned jointly to supervise different regions of the empire, one or the other of them would be actively supporting Christian zealots. By 391, the emperor Theodosius felt strong enough to publish a formal ban on all forms of traditional pagan religion.

Pagan resistance roused itself now to the point where it could hope for the throne itself. In 392, the dignified intellectual Eugenius came forward as a claimant to the imperial title, supported by leading pagan aristocrats and intellectuals seeking restoration of the old ways. His claim was resisted by Theodosius, who had the backing of the church. The issue was resolved in battle, at the river Frigidus in northern Italy, and ended with the death of Eugenius and the victory of Theodosius. Jupiter and Hercules themselves were seen to fight on the side of the defeated army. From that day forward, paganism was dead.

And Christianity triumphed. The patronage of emperors made it possible for the sublime and simple message of love and salvation to be heard, and converts flocked to the churches. The rise of the practice of infant baptism among Christians meant that within two generations, the entire population of the Roman world was smoothly and homogeneously Christian, in a unity preserved without material interruption until the time of the Reformation.

That's a great yarn, but full of facts and nonfacts and put together all wrong. Note especially the satisfying narrative arc it describes: 'umble beginnings, misunderstanding and oppression, a sudden fairy-

tale rescue by a benevolent prince, then a wicked subversive insurgent from inside the royal family—but he gets what he deserves—and finally a wise, patient, and far-seeing monarch who sets things to right once and for all. A story that neat deserves our suspicion.

When our tour is over, we should go someplace and sit for a bit with a cappuccino or gelato and think about how to make sense of what we've seen and heard. Afterward we can walk along to the oldest place in the city, the "cattle forum" at the bend of the Tiber where the low pass between the Capitoline and Palatine hills comes out— and where the ancient "great sewer" (*Cloaca Maxima*) emptied as well. There we find little temples dedicated to Portunus and Hercules the Victor. The curious round Hercules shrine going back to the second century BCE is about the oldest well-preserved building of its period in the city.

This is where Rome began, a place where religious practices and religious buildings have been layered on each other patiently for many centuries. It makes a good place to stand, in reality or imagination, to begin to think seriously about what those practices and buildings mean. To do that, we'll supplement our contemporary tour with a bit of time travel and put ourselves just outside the little Hercules temple on a spring evening in 17 BCE.

Chapter 2

THE GAMES OF THE CENTURY

NIGHT FALLS ON THE CITY. THIS IS NO ORDINARY NIGHT.
The calendar marks tonight as the Kalends of June in the 737th year from the founding of Rome. (We would say, May 31, 17 BCE.) The month of the longest days and shortest nights is beginning, and tonight the moon is near full. It will be a night without true darkness, and each of the next two will be like this. The exact full moon will fall two mornings hence.

The city has been mainly at peace for more than a decade and its ruler is now a man in his full years of power, in his mid-forties, "grave" but not (quite yet) "old" on a Roman reckoning that saw you from infancy to boyhood to adolescence to youth to gravity to old age. To say his name is to take a position on the politics of his age, but there isn't much choice. Call him Caesar Augustus—it's best not to annoy the lord of the world. If I called him his birth name, Gaius Octavius Thurinus, few would even have an idea of whom I was speaking, and if I settled for a modernized version of his interim names, such as "Octavian," I would be emphasizing his rise to power, where "Augustus" points to what he made of himself.

The poet Ovid got the political statement of his chosen name just right: "He has a name in common with highest Jupiter, for the ancients call divine things 'august,' 'august' are called temples consecrated ritely by the hands of priests."[1] A cloud of piety hovers over Caesar Augustus's head, while blood drips from his hands. He was shrewd and lucky at critical moments in his life, with a shrewdness now laudable, now detestable. His greatest success was not entirely his own doing: he lived to a ripe old age.

He entered public life at age eighteen, thrust forward by the assassination of his uncle Julius Caesar and his selection as adopted heir. He fought to keep life and limb together and to build his power. By his early thirties, he had bet on his inheritance and on the city of Rome itself and he had outlasted, defeated, and done his enemies to death. Mark Antony was the last of them, defeated in the sea battle at Actium in 31 BCE. Antony had bet on his own star and on a different city—cosmopolitan, wealthy, venerable Alexandria. Rome's capital would eventually, with Constantine, move east to Constantinople; with Antony it might have moved earlier to Egypt. With Augustus triumphant, the not-really-eternal Rome had a respite of a few centuries. From Actium to his deathbed in 14 CE, Augustus saw his world through another forty-four years, fifty-seven in all from his uncle's murder.

In the year we call 17 BCE, fear had not been forgotten. The last serious plot against Augustus had been only five years earlier, and he had been seriously ill not long after. He was now Augustus the ruler—as opposed to the general—in the way that posterity would remember him. He no longer exercised formal consular authority year to year, but depended on the veto power of the office of tribune to supplement his prestige and manifold influence over Roman life. In the year before this night, he famously promoted formal legislation on marriage, penalizing the unwed and the adulterous and supporting childbearers.

He was also taking care that public representations of him moved firmly away from the heroic (often nude) sculpture that promoted his ambitions when he was young and fighting for his life and a throne. Now he preferred to be seen wearing the toga of civil life and, as often as possible, to be depicted performing sacrifice or in other postures of piety and deference to the gods.[2] He held various religious offices through these years, though not yet, by bad luck, the highest religious office, that of *pontifex maximus*. The "pontiffs" were the public sacrificers, and the *pontifex maximus* was the most senior of them, embodying a role that originally went back to the time of the kings of pre-Republican Rome. That title was still held by Lepidus, the other surviving generalissimo of the bad years, discreetly in retirement on the coast fifty miles south of Rome. He never came to the city, but the diversity of religious rites, offices, and opportunities gave Augustus ample room to be seen in public as the one leading Rome at worship. Lepidus would die in 12 BCE, leaving the title for Augustus and his successors.

In securing his later boast that he had found Rome a city of brick and left it a city of marble, Augustus constructed temples to great gods. He honored his benefactor, whom people were persuaded to believe had become a god, the "divine Julius" (*divus Iulius*), but also erected fresh temples to Apollo on the Palatine hill (we will spend time there), to Venus Genetrix ("Venus Our Mother") in the forum Julius Caesar had built, to Mars Ultor ("Mars the Avenger") in the forum Augustus built himself, and to Jupiter Tonans ("Jupiter Who Thunders") on the Capitoline. Then there was renovation and rededication of the temple of "Quirinus" (an alternative name for Romulus) on the Quirinal. Further down the social ladder, Augustus reformed city administration and emphasized neighborhood units for control and management. Each neighborhood had its own shrinelet to the *lares,* the "tutelary deities" we say, of the locality. Think of them as bodyguards, or divine soldiers, or perhaps the divine cops on the

beat, while the famous gods in the big temples were the great warriors and commanders.

The city at the heart of Augustus's realm, the old city, the real city, was still small and crowded. The bend in the Tiber and the small island here offered early residents and visitors easy crossing of the river at almost all seasons. Just below the city, the river opens out and its shores become waterlogged and so land traffic was effectively prevented along the coast in that direction; while farther up the river, the terrain became more rugged and uneven, offering different discouragement. The site is not unlike that of Washington, D.C., and London in that regard, where modern Georgetown and Westminster found their sites for similar reasons.

The site was liable to flooding in the rainy months of winter. The seven "hills" of the city stay dry and offered needed refuge, because even though the center of the city, the Forum, is a dozen or so meters above river level, it repeatedly flooded in historic times until modern engineering intervened. (A seventeenth-century engraving shows boats and boatmen plashing about inside the domed space of the Pantheon, whose floor is about ten meters above the river.) The heart of the city known since earliest times, then, stayed between and atop those hills bunched around the Forum—the Capitoline, Palatine, Caelian, Quirinal, Viminal, and Esquiline. (Counting up to seven hills required including the Aventine a few hundred yards past the Palatine along the next bend of the Tiber and technically outside the official city limits.)

The commercial business of the place began just where the gap between the Capitoline and the Palatine opens out to the river shore, here where we imagine we are standing by our little temples. From the Capitoline and the Forum, a circle no more than a mile in radius encompasses all the ancient city, which broke those bounds only very slowly and carefully. Flood-fearing prudence was one reason, but religious prescription another, for there was a sacred boundary of the

city called the *pomerium*, marked not by walls but by modest boundary stones. Strict rules governed that border; so a general had to give up his bodyguard to cross it on entering the city, the place of peace, while certain religious figures were not allowed to cross it and leave the city during their term of office. What the gods preserved most vehemently was that small core of the city.

The wealthy still maintained their primary homes very close to the center (Cicero's house was on the Palatine, a five minutes' walk from the Senate), supplementing them with villas in the country or south along the Latin and Campanian shore down to the bay of Naples. The poor found themselves aswarm up the often fetid valleys between the low-rising Quirinal, Viminal, and Esquiline on the side of town away from the river. (They were fetid not least because even with great efforts at managing the flow of water and sewage, a crowded ancient city manufactured odors far more efficiently than it could dispose of them, especially in warm, humid weather.)

But then outside the *pomerium* was the Campus Martius, the field of Mars. It lay, most of a square mile, flat and boggy on the edges, outside the city lines, north of the Capitoline, inside the bend of the Tiber in the direction of what is now Vatican City across the river. In the modern city, the Via del Corso runs north from the Capitoline along the east side of the Campus, and all the area from there west to the river, along the Corso Vittorio Emmanuele and including places like the Piazza Navona, was strictly outside the city and only beginning to be developed in Augustus's time. It was Mars's field because the army—forbidden from entering the city—would originally camp and train there, but it was also the place of assemblies and elections, the only one that now could handle the crowds of the city's formal ceremonies.

Over the century before Augustus, wealthy Romans began to build into this area. The Theater of Pompey was the most elaborate construction there, combining spectacle, temple, and urban buzz. If

a formal, permanent theater building felt a little daring and risqué to staid Romans, then making the theater building in the form of a temple sanitized it and gave Pompey a chance to display wealth and power on a scale grander than anything possible inside the city walls. (Pompey died in Egypt in 49 BCE, during the civil wars, but had his posthumous revenge when Julius Caesar was assassinated at the feet of his statue in the temple/theater complex when the Senate met there on the Ides of March in 44.)

This night's rituals would begin on a far edge of the field of Mars, where development had not yet edged too close to the river. To get there we would walk up along the riverbank, stopping just short of the bend in the river where the tomb of Hadrian (the "Castel Sant'Angelo") now looms across the stream. Modern tour guides don't bother with this spot.

Before we can see what happened, we have to know a legend.

It seems there was a man named Valesius, a founder of the influential Valerian family and a great man among the Sabines, Rome's neighbors up-country to the northeast. Things went badly for him. Lightning struck the trees that shaded his house and his children fell ill. He consulted the experts—quacks and medicine men, we might say, if we were unsympathetic—and they told him that the gods were angry. Reasonable fellow that he was, Valesius took to sacrificing to the gods to propitiate them. (How does sacrifice make the gods less angry? We'll talk about that later.) Desperate for his children's health and seeing no improvement, he was on the point of offering the very ancient goddess Vesta his own and his wife's lives, but then he heard a voice among the fire-ruined trees. Take your children to Tarentum, it said, and heat some Tiber water at the altars of Pluto and Proserpina, the gods of the underworld. Give the water to your children to drink and they will be well.

This made no sense. Tarentum, modern Taranto, was far away to the south on the coast of Italy, with no Tiber water anywhere in

the vicinity. And the gods of the underworld? The thought of involving them would alarm anyone. The voice repeated itself and so, good man of legend dealing with gods that he was, Valesius put his children in a small boat on the river, taking along a well-nursed bit of fire with him in order to do the gods' will. He came along the river to a quiet place for the night and took refuge with—who else?—a shepherd, who told him that the name of this nowhere place was, of all things, Tarentum. (Divine commands often have these tricky bits of wordplay in them.) So of course he did as he was told, heated up a little Tiber water, the children drank, and they were well.

Now another vision came to them, in their recuperative sleep, a huge godlike man telling them to offer black victims to Pluto and Proserpina of the underworld and to spend three nights singing and dancing in their honor. They're to do this all in the Campus Martius. Valesius by now knows well what kind of story he's in, so he sets to work to build an altar for the gods. When he and some men dig down on the chosen site, they find an altar inscribed to Pluto and Proserpina already there. At this point, there's no choice: sacrifices, singing, dancing—and thus the pleasure of the gods.

That story hovered in the background for everything that happened over these first days of June.

The place we've reached was old Tarentum. In 1890, a huge stone tablet was unearthed just there at the northwestern end of the Campus Martius, bearing a detailed inscription telling us what happened and where on just these nights. It was dug roughly between the modern church of St. John of the Florentines and the bridge that carries the Corso Vittorio Emmanuele across the river to join up with the Via della Consolazione and its grand approach to the Vatican. That bridge had just been designed but not yet built, as part of the creation of modern traffic and river management in this area. (The actual ground level today right here is five to ten meters higher than it was in antiquity, and river walls now make sure that

the Tiber behaves itself.) Not only was there the inscription, but we have a good idea from later texts that there were two small temples to Pluto (also called Dis) and Proserpina at this site. This makes sense from the legend, but it is also plausible for the purposes of Augustus's own ceremonies.

This spot would have been pretty soggy through the winter months, right out on the edge of the city (the Vatican was a suburb of no interest at the time). When the winter rains ended, men could be put to work clearing and drying open land for a spring festival. If the place were called Tarentum and the legend and past events had attached themselves to it—as seems to be the case—all the better. If there were a couple of caves in the riverbank, out here at the back of beyond, stories about the underworld and bad things happening would gravitate here. With no bridge, no buildings, no normal access, this would have been a spooky place on a dark night. Business that wanted to hide from attention came here, but stray wayfarers might come to a bad end, even just disappear into the river with a splash, turning up dead and bloated miles away.

Valesius's legend had already been employed in the service of religious ritual here. At least once before, in 149 or 146 BCE, at the culmination of the third Punic war against Carthage, the "games of the century" had been held more or less on this site, and there's a reasonable chance something similar had happened in 249 as well. The underlying idea was clear in the name of the event: *ludi saeculares*.[3]

Saeculum was a word that did business more or less where we use the word *century*. It pointed to an "age," a lifetime of maximum extent, and had roots in planting and in the name of the god Saturn, Jupiter's overthrown father. Though average lifetimes were short, some people did already live to astonishing ages in antiquity, and so without our decimal precision the length of an age was thought to be something like a century. The "games" of the age/century were thus meant to take place only just as often as they could without any liv-

ing human being able to attend them twice, even in infancy and great age.[4] They were intended to be a "once in a lifetime" experience.

Games? No one has made a better translation in English for *ludi,* a word that ranges in meaning from a children's pastime to stage plays to religious pageants to chariot races. German *Feier,* "celebration," does a bit better job with some of the meaning. The word *ludi* is applied to the whole constellation of activities, from sacrifices to horse races to hymn-singing in front of a temple.

We have a good idea what would have happened in the games of 249 and 149. Called then the *ludi Tarentini,* after the place, they were rites for the dark of a moonless night. The main sacrifices offered a black bull to Dis/Pluto and a black cow to Proserpina, then ritual banquets to which the gods were invited. In what was called the *lectisternium,* figures of male gods were arrayed on banquet couches as wealthy men might be—and wealthy men would be invited as well. Then came the ritual meal, sharing the product of sacrifice. Next came the *sellisternium,* for goddesses and women only, now with more dignified chairs replacing the couches used by menfolk. After the sacrifices, three nights of shows and games would follow. Everything about the ritual was of the night, of the gods of the darkness, and doubtless carried out by flickering torchlight.

More than once in the years before Augustus, people had thought it was time to mount the games of the century again. Julius Caesar was busy fighting a civil war in 49 BCE, and in that war and the renewed conflict after his assassination, no one volunteered to placate the gods of the underworld. The powers of death were appeased by other religious means if at all, or at least by the eventual success of Augustus in eradicating and terrifying his opposition. It made every good sense that the supreme citizen should revive now this venerable rite—for reviving venerable rites was much his way.

Or was it? One of the keenest modern observers, Eduard Fraenkel, captured Augustus's way as the monarch's instinct to abolish the

old order of the Roman Republic by making a great show of his intention to rejuvenate it.[5] (That trick has been imitated by many since.) In many and fundamental ways, the mission Augustus set for himself was to invent a new order while making out to all and sundry that he was not only not changing anything at all but was really only restoring, strengthening, and refreshing what had been there and been of value all along.

When the thought of mounting the games of the century again came to Augustus and his circle, they saw the value of hosting the old celebration in a remarkably new way. Their views are carved in stone, on that inscription discovered at the site. There we read of the preliminary deliberations, which arose when the college of *quindecemviri sacris faciundis* ("the fifteen in charge of performing rites") met to consult the Sibylline books. That assurance already should make us nervous.

The Sibylline books were very ancient, going back to the time of the kings five centuries and more earlier, books of Greek hexameter verse to be consulted when the gods were unhappy. Their purpose was not to help predict the future directly, but to determine what it would take to placate the gods—and thus produce a better future. For a very long time, these books were kept locked away beneath the temple of Jupiter on the Capitoline, never seen publicly but scrutinized confidentially. They were under the control of the *quindecemviri,* senior statesmen, originally meant to be beyond public affairs and with no other public responsibility. In a matter of this importance, the *quindecemviri* would review the books, report to the Senate, and recommend the ceremonies they judged appropriate.

Before we hear the unprecedented rituals they recommended in this case, we need to notice something a little odd about the venerable and ancient Sibylline books of the year 17. They were brand-new.

In 83 BCE, when the generals Marius and Sulla were at war for control of Senate and state, the temple of Jupiter on the Capi-

toline burned down. Everything within it, including the Sibylline books, was destroyed. Sixty meters by sixty meters in floor plan, the temple had towered over the city, with Jupiter flanked by Juno and Minerva, Jupiter looming in a great cult statue inside and in another as charioteer atop the building. Its destruction was a spectacle without parallel and, as it happened, a most accurate predictor of the grim half century that would follow for Rome. Fifteen years it took to rebuild, though it and its successors would burn several more times in antiquity.

The Sibylline books were lost in that fire, but not gone forever. By 76 BCE, the Senate had sent out a delegation to tour religious sites of the Greek world collecting replacements. A fresh collection of Greek oracular texts, sifted and sorted by the *quindecemviri*, were put in place in the new temple. What seems like rank humbuggery went over astonishingly well, with no Roman source troubled by this process. The texts were oracularly obscure at best, and their interpretation involved a variety of mechanical processes, such as taking acrostics of the first letter of each line of a section of verse and then drawing out various permutations and combinations of those letters. Any books of a suitably divine quality were probably acceptable. (We'll see the scribe Ezra, after the Babylonian captivity, perform a similar service of reinvention for the books of the Torah.)

Augustus was warm to the Sibyllines and their use. When he took his great house atop the Palatine hill, he erected alongside it a temple in honor of Apollo—a kinder, gentler Apollo than the plague bringer of the *Iliad,* a figure of beauty and wisdom and strength (who reminded Augustus of himself). Then he discreetly brought the Sibylline books down from Jupiter's temple and entrusted them to Apollo, where he could himself keep an eye on them. Henceforth the *quindecemviri* of the next centuries (the last were still doing their business four hundred years later) would always consult the Sibyllines under imperial supervision. Only a very rude person would

pause to wonder whether the books were *perfectly* immune to further supplementation, correction, and humbuggery.

Since Etruscan lore on matters of divination was highly regarded, the grave and learned scholar Ateius Capito, of an old Etruscan family, author of books on the pontiffs and augurs, was brought in to help interpret the texts. With perhaps a few hints and nods from Augustus, a program was set and the preparations begun. It was no accident at all that the ceremonies would fall on the bright nights of May 31 and June 1 and 2, and in that choice was the fundamental change in the old rituals that Augustus insisted on. Though they would begin at the ancient site and pay respects to the worship of underworld gods, *these* games of the century would be games of light, on bright nights and long bright days, linking night sacrifice to day, and with gods chosen very carefully for the purpose.

First, that boggy place was remade for the occasion. The old, small temples for Pluto/Dis and Proserpina would not suit for sacrifice to other gods, so new purpose-made wooden altars were erected. The most powerful and important people in Rome would attend, so space and dry footing befitting great dignity would be carved out and assured. Throngs might be near, but the ceremonies themselves would be conducted with propriety, in a circle of well-washed and well-oiled faces. The masters of ceremonies were careful to stipulate that these rites and games would be unusually inclusive in two important ways. Importantly in light of Augustus's marriage legislation, the order was given that unmarried citizens would be allowed to attend (with some hope of future fertility), but even more remarkably these games would be open to full participation by women—at least women of the right social standing. Night sacrifices that women would attend called for particular care and attention, not just at the site, but for the coming and going on the mile or so that separated this corner of town from the more appropriately urban and dignified regions closer to the Forum.

Along the line of the Tiber as it made its way back southeastward from the Tarentum site toward the heart of the city, a racecourse and stages and stands had been built. That entertainment zone was large even by our standards, something like 350 meters long and 150 meters wide. All this had taken weeks at least and reshaped for the moment the whole landscape of the river and the Campus. Not many would attend the sacrifices and religious ceremonies and be able to stand or crouch close enough to see the great and the good at prayer, but many more would be able to throng the streets, follow the processions, and cheer the plays and contests. Among the preparations, then, for the last days of May, the *quindecemviri* themselves, great men all, sat on the steps of the temples of Jupiter Capitoline and Apollo Palatine, greeting all comers and handing out the makings of festival. Torches with pitch and bitumen for coating and fuel were given out. Those torches would reappear lighting the way back and forth between the center of the city and the sites of sacrifice and spectacle. At the temple of Diana on the Aventine, wheat, barley, and beans were handed out to those who would bring these foodstuffs back as offerings to the gods, especially Diana herself, in the course of the rituals.

Certainly people who made their residence in the city and its environs knew that a great event was going on; harder to tell how many people from the surrounding rural districts and the next towns to Rome knew or cared or came to see the show. Dignitaries from the city and surrounding towns who could make sure they were seen would be more likely to attend. The ordinary life of the city likely did not come to a halt, most particularly for women and young children of the ordinary town classes, to say nothing of slaves, but there was undeniably a considerable stir. Many people had a notional care for how the gods dealt with the state, but all were far more interested in their own private dealings with the gods, which took place much closer to home—or at a cemetery. A modern Jew, Christian, or Muslim who goes to a gigantic holiday liturgy is attending for his own

benefit, not merely as a spectator. Not so the ancient Roman on these occasions.

The sun sets at Rome that season around half past seven. Bustle and preparation would have begun as the sun neared setting, but the real night hours would have run from a bit after 8 P.M. to just before 4 A.M. With two days to go until full moon, the near-complete globe loomed in the east already before sunset. From the Tarentum site, that meant that the moon rose over the Capitol and other hills of the city center, and as the night progressed, it would stand higher and brighter in that direction, then move above and beyond to cross the river and set some time around dawn.

As twilight dimmed, the greater dignitaries came lighted by torches. As night set in, the presiding officers emerged into full view: Augustus himself and, scarcely second to him, his indispensable son-in-law and friend, Marcus Vipsanius Agrippa. Born like Augustus in the year Cicero destroyed Catiline, Agrippa was the future Augustus's friend from adolescence, a leading officer in the war years, and a pillar of Augustus's reign. He was lucky in his fathers-in-law: first he married the daughter of Cicero's great and wealthy friend Atticus and later, in 21 BCE, Augustus's only child, Julia. At the moment of the *ludi saeculares,* Julia had borne him one son and would bear a second just two weeks after the celebrations began. These boys would be the great hopes of succession for Augustus and Agrippa, as their father was at the height of his public and private influence at this moment, leaving in a few weeks on a military command in the East for his friend and master. (Agrippa died in 11 BCE and both of his boys died young, one of illness, one of war wounds, in 2 and 4 CE, leaving Augustus at that point with no real succession choice but his lumpy stepson, Tiberius.)

Sacrifice began. Augustus and Agrippa themselves were the presiding "priests" for this event, but they were surrounded by a scrum of colleagues and assistants, including the rest of the *quindecemviri*

sacris faciundis. At a moment like this, when getting every detail of the prescribed ritual exactly right was important, there were always functionaries at the great men's elbows to guide and correct and supplement what they did.

The invisible partners were *very* fussy. There was a particular way to perform the ritual and make the gifts and if it were not followed exactly, all bets were off. If flaws in performance were detected during the ceremonies, then a halt had to be called, messes cleaned up, and everything had to start over. If things went badly for the community afterward, there was a decent chance that someone would observe that the sacrifices *must have* gone wrong somehow (perhaps even remembering after the fact this or that error of procedure), and so the only way to safety was to undertake the whole business over again from scratch.

Words first, of course. Tonight the sacrifices began in the darkest place, appealing to the Moerae, the fates, the goddesses who determined how long life would last and when it would end. Called now by Greek names and worshipped in the Greek way, they were thought to be cold and unfeeling, but all the more worth attention from mortals for that reason. If they *could* be placated, some of the ordinary risks to life and limb could fade from concern a little. The name given in the official inscription is a Greek name, not Latin, and many would think of them under the names of three sister fates spoken of by the Greeks, Clotho, Lachesis, and Atropos. Hesiod, hundreds of years earlier, had said that even Zeus prudently showed them honor.

It must have been Ateius Capito, reading the Sibylline books, who found, with whatever encouragement from Augustus, the right sequence of goddesses and gods for the *ludi* to address. Here the choice evokes the fears of life and death, but in a far less blunt and desperate way than when Valesius came to the same site to propitiate directly the gods who already ruled over the world of death, Dis/ Pluto and Proserpina. Perhaps we should trust Capito's religious

learning and his insight into the meaning of the sacred books or perhaps we should surmise Augustus had already given an indication of how he wanted to see this ritual unfold and how the turn from dark to light would be managed, beginning with propitiation of goddesses merely dubious rather than overtly hostile in their intent.

So it begins. Tethered and penned a few yards away from the torchlit altars were the nine female lambs and nine female goats who were to be sacrificed that evening. Each was brought forth singly, each dispatched with care and patience. Their deaths likely filled the eight or so night hours of darkness. As each was led forward, the celebrant (Augustus and Agrippa probably alternated) began by inviting the gods to attend, pouring a little incense and wine into a fire kindled at the beginning of the evening. Odors play a large part in these ceremonies, giving those at the front of the crowd a concrete sense of what was happening. As the first lamb came forward, the celebrant sprinkled a few grains from a dish along its back and sprinkled again a little water on its forehead. For this kind of public Roman ceremony, it was likely a mixture of salt and wheat grain that had been prepared in advance on specific days by the vestal virgins at their "house of Vesta" just off the Forum. (While there were always two vestals on duty at the house attending the fire, the other two or four would have been free to attend an event like this and likely did. They would have their own high holy days in the second week of June.) Then the celebrant nicked a few hairs from the victim's head and burned them in the fire. This was how things went, the organizers would have said, in the "Greek rite." That is, in what was called "Greek rite" at Rome, to give it a flavor of exotic mysticism perhaps and to distinguish from what was presented as the more native ceremony—to which the presiders would switch the next day in broad daylight. For now, Augustus and Agrippa were unveiled and crowned with laurel in that Greekish way.

Now for the killing.[6] With sheep and goats, the method of choice

was slitting the throat. (For cattle a clubbing first, right between the eyes, or a well-placed axe to the skull made the victim less dangerous to bystanders.) The animal was guided to the moment in a way meant to show acquiescence by the bowing of the head. This was, after all, how the gods wanted it. A victim who resisted was thought to be a bad omen. Blood was carefully drained away, but there's no getting over the fact that this was now messy, smelly, and unpleasant business—palliated by dignity, fine clothing, formal language, and incense for the smell. The victim was laid out on its back and cut open by attendants who knew what they were doing and dressed for mess. (When the *paterfamilias* of a rustic household presided over family sacrifice, he did more of the dirty work himself.) An appropriate soothsayer, called a *haruspex,* was brought forward alongside the celebrant to inspect the condition of the victim's entrails. When all was normal, that was a sign that the gods accepted this sacrifice. Abnormal, misshapen, or even missing organs meant divine disfavor; the offering was regarded as null and void and had to be done over. On many occasions, the haruspex was asked to examine certain organs (notably the liver) with particular care and to make prophecy for the future from them.

The internal organs were then cut out to be burned up completely on the altar. The meat was formally touched and lifted, at least symbolically, by Augustus or Agrippa, to signify that it was being reclaimed for human use, then grilled separately for sharing with the attending public. For a ritual like this, each animal would be taken through to butchery and the parts disposed for cooking, but the final sacrificial offering would be saved up until all the animals had been slaughtered.

One done, seventeen to go. Think a quarter to a half hour to take down each of them; think of the blood and the meat and the smells and the grills needed. We see now that this space had to be fairly considerable. I've seen goats for an open-air banquet on grid-

irons over open fire on the high plains of Algeria and remember the smoke, the smell, the gusts of heat, and then the greasy mess of plunging in to rip off chunks for eating. We modern tourists were less ritual-fastidious than the Romans, but the experience left a vivid impression.

As the night wore on and the eighteen were brought to their end, there came a moment for this formal prayer, taken from the ceremonial inscription that recorded the event.

[Augustus is speaking:] O Moerae! As it is set out for you in the books, so it is done. From this may every good fortune come to the Roman people, the Romulans (*Quirites*). Let sacrifice be done with nine ewes and nine she-goats. Just as you have strengthened the empire and majesty of the Romulans in peace and war, so by this sacrifice may the Latin peoples always be obedient. May the Roman people have eternal health, victory, and safety, the Romulans; protect them and their legions; be favorable to the Romulans, to the *quindecemviri*, to me, to my house and my household, and accept then this sacrifice of nine ewes and nine she-goats, all spotless and perfect for the sacrifice.

The eating will have gone likely through the night. In an event of this kind, the meat of eighteen animals could only have been shared out among a limited number of the dignitaries present. When there were more (or larger) animals and smaller crowds, the *natural* function of such events was to move from ritual and excitement through slaughter and cookery to feasting and frivolity. In this kind of state ritual, it would be the few elite who would perform that sequence on public view, to assure everyone that this sacrifice was real and authentic and rightly completed.

Dawn eventually washed the sky, and surely the principals disappeared into some shelter for clean clothes and a breather, because

now came the first procession from the end of the city to its heart, from the Tarentum to the Capitol. The procession passed along by the temporary structures built for racing and shows, staying close to the river and keeping Pompey's theater to the left. Then it entered the city's formal center near its most ancient heart. We would guess that the celebrants and their attendants would pass the Capitoline and then pass along under the brow of the Palatine Hill, glancing up at Augustus's temples decked for the day as the sun's light began to peek over the ridge. They would circle left then between Palatine and Caelian, and left again along the *via sacra,* the "sacred way" that led down into the Forum. As they made that turn, they passed the place where Nero would eventually build his vast "golden house," the *Domus Aurea,* and his successors would build the Flavian amphitheater we call the Colosseum. In passing this way, they would have followed with a few differences the route that ancient generals took to make their formal approach to the city for a triumph. One of Augustus's sly tricks was to do things that made him appear in people's eyes to be even more dignified than he was, and to call no attention to them.

The Capitoline's ancient configuration is best seen today from the Forum, to which the procession moved. The last stretch of ascent took the procession up some thirty meters or so above the level of the Forum, to the recently rebuilt great temple of Jupiter on the Capitoline, the site where the cackling geese had, according to the story, awakened defenders and prevented a night attack by the Gauls in 390 BCE. In the forecourt of the great temple came the next sacrifices. Today, the first day of June, there would be two great bulls sacrificed to "Jupiter, the Best, the Greatest" (*Iupiter Optimus Maximus*), one each by Augustus and by Agrippa. The fundamental ritual of words, a sprinkling (perhaps now with wine if we have shifted from the "Greek" rite to the Roman), then the more dramatically brutal business of killing a bull: stunning, jugulating, draining, opening, examining, butchering, barbecuing, dining. It was probably here on

the first day that the ritual banquet of the gods themselves was performed, with couches (now inside the temple, seen only by a relative few?), upon each of which an appropriate cult image of a senior god sat; plates presented and taken away; and a larger meal for the human participants. Bulls—huge, immaculately white bulls, appropriate for gods of the sky and light—were a tougher business to get through this way than sheep and goats, but this ritual would only have taken some of the morning. With these duties accomplished, I imagine Augustus and Agrippa slipping away to the Palatine for a few hours' rest, while the crowds would now swarm to the riverbank again for a day of shows, racing, and what we would recognize as festival. No one would be surprised if there were a crowd there already, gathering since before dawn to get the good places and not entirely enthralled with the sacrificial rituals that, after all, most people could not get near. A long afternoon holiday, with many events and much hilarity would follow.

The second night, Augustus and Agrippa would appear again at the Tarentum altars, but now for a much more sedate set of ceremonies. Instead of beasts and blood, the sacrificial objects were specially made cakes, twenty-seven of them, nine each of three unique creations. A recipe for one kind we can find in old Cato's book of agriculture from a hundred fifty years before: "Crush two pounds of cheese in a mixing bowl; when that is thoroughly mashed, add a pound of wheat flour or, if you want cake to be lighter, just half a pound of wheat flour and mix thoroughly with the cheese. Add one egg and mix together well. Make it into a loaf, place it on leaves and bake slowly on a warm hearth under a crock." Asiago ciabatta, you might think.[7]

The goddesses of this night were the Ilythiae, again Greek named, the goddesses of childbirth. In Latin they would be called Carmentes, a little committee of divine attendants who would stir around the childbed to see an infant into the world nursed and nur-

tured appropriately. The experience of childbirth was terrifying and dangerous for any woman in antiquity, so keeping those godlets well disposed was worth a sacrifice or two. Would Augustus's heavily pregnant daughter, Julia, have been carried out to the end of town in a sedan chair to observe and, gods willing, be blessed by this propitiation? Her stepmother, Livia, may have been there as well, watching with mixed emotions.

What whooping and hollering and conviviality carried itself on into the night, around the fairgrounds or back in the neighborhoods of the city, we do not know. Romans were wary enough of the night to call its dead time after midnight "unseasonable" (*intempesta*), but surely these nights were special. Dignitaries and senators were likely enough engaged in temperate private celebrations and early enough to bed.

The next morning belonged to Juno. As her frenemy, brother, and husband, Jupiter, had received two bulls in sacrifice the day before, so would she receive two cows on the second full day, again on the Capitoline at the same site as before, where she had her own cell in Jupiter's great temple and where the forecourt was still set for pageantry. Again Augustus and Agrippa took turns. Women will have been more prominently on display and had roles to play in the ceremony, but the killing and butchering were still men's work. These proceedings ended with a *supplicatio,* a particular ceremony of prayer and hymns for divine favor, here performed by and on behalf of the married women of the city, for whom Juno was the special patron and protector. The women's version of the divine banquet, the *sellisternia,* was set out now back at the fairgrounds, a first great event for that day of games and shows. This one was hosted by 110 matrons who had been selected by the *quindecemviri* for this special honor.[8]

Without the texture of small events—the individual performers, the colorful costumes, the flavor of the food for sale—this all seems routine. You really had to be there, caught up in the

spirit of festival, frolic mixing with formality, crowds, smells, and excitement—excitement arising from the *expectation* of excitement.

On the third night came the goddess Terra Mater ("Earth Mother"). Nothing wrong with that choice, but once again the goddesses of the night this week were figures of lower status. The *Magna Mater,* Greek Cybele, the "Great Mother," had been imported from Asia Minor with great ceremony during the second Punic war two hundred years before, the object of scandalous rituals and the affections of castrated followers. That's *not* who was invoked for these purposes. Under the name Terra Mater, devotees would have sought the favors of a goddess much tamer, much less a celebrity, but by her name a generous nurturer of lands and crops. The fears set for calming by three nights of sacrifice—fate, childbirth, fertility—were deep ones, the placation important, but the charge, the buzz, the excitement, the link to mythology and a sense of really volatile power was—likely deliberately—defused behind these calmer rituals. She, Terra Mater, received now only a pregnant sow as her sacrificial victim, back at the original site.

The last day was special.

The focus shifted from Tarentum and the Capitol initially to a place that would not have come to mind as recently as twenty years earlier. The Palatine Hill frames the south side of the Roman Forum as the Capitoline does the west. Where the Capitol had been the place of temples and the Forum the place of business, traditional Palatine life had been residential. The other hills, to north and east, were for the larger population, even if interspersed with a few mansions on choice sites. The Palatine was Augustus's choice and he seized upon this second eminence of the city (not really higher than the other hills, but closest to the river and thus making for a dramatic presence) and made it his own, filling its heights with a mix of new and old construction for his own compound. We get our English word *palace* from what he did there, and the site would remain the home

of emperors when at Rome for as long as there were emperors to reside or at least visit there; that is, for another five hundred years or more. The Circus Maximus lies at the foot of the Palatine on the river side and as the craze for horse races grew and the facilities of the Circus were elaborated, so it became convenient for the emperor to have his own "box"—really more like a modern plutocrat's "sky box"—poised at the edge of the hill, with a view from which to see and be seen.

Pious Augustus bolstered his authority by bringing with him to the Palatine his favorite god, Apollo. Apollo, Greek by origin but entirely Roman in acculturation, the only one of the great gods known by the same name in both languages, had many roles. He brought death and life with plague and medicine, he enlightened and delighted with poetry and the arts, he was a god of truth and voice of many oracles—notably the greatest one at Delphi—and he rode the great gleaming chariot of the sun in the sky. Like all such divine beings, he was terrifying, but Augustus could tame him and share his glory.

Augustus picked a site for him that Apollo himself had marked—by sending a thunderbolt that struck just there. In thanksgiving for victories and especially for the ultimate victory at Actium, Augustus built Apollo his own temple on the crest of the Palatine and dedicated it in 28 BCE. The chariot of the sun could be seen atop it, and inside was a radiant cult statue of the god. Probably half the size of the temple of Jupiter on the Capitoline, it faced the southern sky through which the sun's chariot passed, and consciously did not compete for visibility with the homes of the more senior gods. The temple itself, a public place and property, was at the same time part of the house of the first citizen, Augustus, and Apollo was in some special way the household god of the family. It's unlikely Augustus could have *said* something so astonishingly presumptuous as that, but if *others* drew that conclusion, he might not resist it. Here the

Sibylline books would reside, and so it was not a work of unusual spiritual perspicacity if Ateius Capito suggested that the culminating day of the games of the century should start here.

For the day, Apollo would be joined by his sister Diana—Artemis, as she was known in Greek. Diana was the goddess of the wild powers of the world, of animals and the moon, the space beyond civilization. Unapproachable virgin, she looked after women in childbirth. At Rome she had her own temple on the Aventine hill outside the pomerium, so she was able to retain her status as outsider, of but not in the city. Her true home was a shrine at Aricia on the Alban Lake about fifteen miles southeast of the city, early home to Aeneas. Every divinity partook of the eerie, but Diana was always specially elusive and remote and for as long as people cared about her, she always escaped domestication.

Now she came to join her brother on the Palatine, where they jointly received sacrifice at his temple: again, the twenty-seven cakes, surrounded in the sunlight of morning with all the pageantry of the day. The modern equivalent that comes to mind is the radiant day of song and community that concludes Wagner's *Die Meistersinger,* which is best performed on a stage lit almost too brightly for the eye to bear. Where the second day had followed sacrifice with formal supplication, this day had something even more special in reserve—a hymn for the day by the reigning poet of Rome, Quintus Horatius Flaccus, Horace, as we call him. Since Vergil had died two years earlier and the younger Ovid was still a figure of promise, Horace was the master poet of the hour. We have the unambiguous record of that public inscription that he provided the official hymn of this last day of the festival, a "song of the century," or *Carmen saeculare*. It was to be sung by a chorus of twenty-seven boys and twenty-seven girls, all unblemished, none pubescent, all with both parents still alive (a sign of divine favor).

The poem survives. Simple enough, certainly, to ask fifty-four chosen young people to memorize seventy-six lines of poetry and even learn to chant them back with grace and feeling. Touching enough to imagine their 108 living parents standing by with pride on one side while Augustus and Agrippa and the others of the *quinde-cemviri* preside. The performance was out of doors in a space with no good acoustics. Today's traffic noise and aircraft overhead, at least, would not intrude, but what must be seen is the performance, not the comprehension. Many people would have been in attendance, but few could reasonably have heard what high, thin voices said or sang into whatever spring breezes wafted and over whatever mild restlessness of a crowd or distant buzz of movement was heard from beyond the circle of participants. The metrical and syntactical demands of the Sapphic stanza, moreover, create a flow of words that is not always instantly easy to grasp at first hearing.

Celebrating celebration, the *Carmen saeculare* was a poem to be recited at the games of the century *about* the games of the century.

O Phoebus and Diana who rule the woods,
Shining glory of the sky, always venerable and venerated,
Grant our prayer in this sacred time,
When Sibylline verses bid us,
Chosen maidens and chaste boys,
To tell a song to the gods who are pleased by the seven hills.[9]
Gentle Sun, who show us the day in a shining car
And hide it, then are born again new and the same,
May you gaze on nothing grander than the city of Rome.
Kindly, Ilithyia, watch over mothers
Bearing children at full term,
Whether you'd rather be called Lucina
or Genitalis.

The poem goes on to recapitulate the setting, of games mounted every hundred years, three days and nights of song and celebration. The fates are named here "Parcae" in the Latin way, Terra Mater is "Tellus."

The poem goes on to recapitulate the setting of games, the city's role as successor of Troy and Aeneas's heroism and now as lord of a world reaching to the Indies in a time of peace and plenty and (especially) virtue. Apollo is the healer here, preserving all for the future, Diana a friendly patroness for what children *or* fifteen men may ask of her.

> I bring home good and certain hope
> That Jupiter and all the gods will hear,
> For our chorus has learned from Apollo and Diana
> To say their praises.

Surely the children's song was well received—and then repeated. For the procession of dignitaries and choristers moved at the very end of the ceremonies back to the grandest of its sites, atop the Capitoline, and the children sang their song again.

The song comes closest of anything to showing us the gods, but still we cannot see them. Prayer and song addressed them as beings present and listening, but how it felt to feel that presence—that we cannot feel. Outside of myth, the gods are always that kind of elusive.

With the second singing of the *Carmen*, the rituals ended. The sacrificing was done, but the partying continued. From the fifth to the eleventh of the month, Greek and Latin plays continued on display, and then on the twelfth a day of chariot racing and hunting shows featuring doomed animals and doubtless very bad acting by those portraying the hunters, all still as specified by the *quindecemviri*.

Games of the century occurred again later no fewer than five times. One school of thought evidently regarded the postponement

of the games from the 40s to the year 17 to have been an irregularity, so the emperor Claudius mounted the games in 47 CE on the original schedule, while the emperor Domitian welcomed the opportunity to sponsor them on a schedule in line with Augustus's date in the year 88. Following Claudius, similar games were staged in 148 and 248, by now consolidating "games of the century" with celebration of what were the 900th and 1000th anniversaries of the traditional date of the founding of the city of Rome in 753 BCE. But with no sense of inconsistency, the emperor Septimius Severus also arranged *ludi saeculares* for the year 204. The first lapses occurred under emperors who were themselves Christian, Constantine neglecting the Domitian-Severus sequence in about 313 and his son Constantius omitting the anniversarial date in 348. Around the year 500, in the unmistakably, heavily imperial city of Constantinople, a state official named Zosimus, of high but not the highest rank, wrote a "New History" of Rome's empire from Augustus forward and made much of the *ludi saeculares,* even offering us a Greek text of the Sibyl's oracle.[10] Augustus's reinvention of the past became the solemn past.

It's still common to say that Augustus worked hard to revive a Roman religious culture that had fallen on hard times, but nothing suggests there had been any outsized lapse in religious belief, practice, or assiduousness in the decades before Augustus. When the temple of Jupiter had been destroyed by fire, the concern to rebuild it and manage appropriate rituals was quite direct and effective. The single most notable gap in recorded religious behavior was a long lapse in the office of *flamen dialis* ("Jupiter's priest," roughly) vacant since 87, filled by Augustus in 11 BCE. Jupiter's highest priest, this official lived with traditional restrictions of a sort to make the office almost as inconvenient as that of the vestals. He could never spend a night outside the ancient *pomerium* of the city, nor be away from his own house for more than two nights. He could not touch iron, ride or even touch a horse, or look at a dead body. His clothing was prescribed and oddly

archaic, his diet restricted. It is hardly surprising that such an office would be increasingly unwelcome to those of lofty enough family to hold it, and there had evidently grown up a set of "workarounds" to allow the sacrificial duties to Jupiter to be carried out during an extended vacancy. We do *not* need to regard that vacancy, in other words, as a sign of irreligion or neglect. If the likeliest date for the filling of the office by Augustus is 11 BCE (there's a variant tradition about the date in Tacitus), then it's a reminder that for the last thirty years of the lapse, the office was probably under the authority of the absent and marginalized *pontifex maximus,* the triumvir Lepidus. *His* absence and inactivity, even more so, had nothing to do with disrespect for religion and everything to do with ordinary surly politics. It seems likeliest that when he died and Augustus could assume the *pontifex maximus* role, then finding a *flamen dialis* was easier. (Augustus institutionalized some concessions for him to make the office less annoying.) Pushing religion was good politics for Augustus, but there's nothing to say it needed pushing.

Chapter 3

AN ELOQUENT MAN
WHO LOVED HIS COUNTRY

T HE GAMES OF THE CENTURY MADE FOR GREAT SPECTACLE, BUT did everyone really believe that the gods got high on barbecue smoke? That the thin high voices of chanting children reached divine ears? Surely there were skeptics and sages who knew better. For example, what would Cicero have said?

Augustus could not deny responsibility for Cicero's murder. In the proscriptions that followed Caesar's assassination, he went along with putting Cicero's name on the death list, perhaps imagining the orator would escape Rome and Italy in time to evade execution. The killers caught up with him, though, on the seashore south of Rome in 43 and Augustus could have seen his head and hands hung up to ridicule in the Roman Forum shortly after.

Years later, though, Augustus, secure in his power, came upon one of his grandsons hurriedly trying to cover up the book of Cicero he was reading to avoid the first citizen's displeasure. The *princeps* was reassuring: "He was an eloquent man, and he loved his country."[1]

Cicero isn't the perfect witness to the beliefs and practices of Roman aristocrats, but he's often the best one we have. If he had been alive, Augustus would surely have welcomed him wholeheartedly for the games of the century as the embodiment of Roman wisdom and statesmanship. Ever the newcomer to high society, the well-respected man who always needed to make sure he fit right in, doing the best things so conservatively, Cicero spoke on the gods in several voices. He was believer and skeptic, both at once.

Plutarch tells another story that need not be false or exaggerated.[2] When Cicero was deciding whether or not to execute the imprisoned coconspirators of Catiline in 63 BCE—a delicate and weighty decision—he went to a neighbor's house, for his own was taken over that night by his wife, other distinguished matrons, and the leading vestal virgins, all celebrating the Good Goddess, *bona dea,* whose rites only women could attend. While he was away, the women saw a sign. The fire had died down on the altar of sacrifice, but suddenly a great bright blaze flared up from it. They were all terrified, but the vestals told Cicero's wife to hurry to her husband and tell him to act boldly, for the goddess was offering him a wonderful light on his road to safety and glory.

Cicero had the conspirators put to death, but his political career was irreparably damaged when the aristocrats who had found him usefully naive dropped him cold when complaints about peremptory political murder grew too sticky. Cicero was exiled, and his house was confiscated, torn down, and the land "rezoned" as a temple to prevent rebuilding there. When he returned from exile the next year, his two long speeches "On his house" and "On the responses of the haruspices" catch him seizing religion as an instrument of policy and arguing successfully to have the land deconsecrated and returned to him for building a new house. Not long after, he became an augur, which meant he accepted the occasional duty of performing a role in ritual.

Cicero the scholar and writer *and* augur, moreover, wrote well and persuasively on other pages of the ways of doing religion in and at Rome. The second book of his treatise *The Laws* shows us his most sober and respectful views of religion in the city and offers a fair place to quote him.[3]

> So first, let the citizens be persuaded that the gods are the lords and governors of all things and that all that occurs is done with their approval and divine power. They well deserve the respect of men and they see and understand what each mortal man is like, what he does, what wrongs he commits, and with what spirit he performs his religious duties. They assuredly take into account the difference between those who perform their duties and those who do not.

This is religion for *citizens,* for the real Romans, the full participants in the work and responsibility of the Roman state. Others will have other gods and good luck to them.

These gods act by virtue of their innate character—the thing about a god that is godly, called *numen* in Latin.

> Minds full of these things will not be strangers to what is useful and what is true. What is truer than this? That no one should be so foolish and arrogant as to think that he has mind and reason within him, but that the sky and the world do not. . . . The man who is not moved by the order he sees in the stars above and in the alternation of nights and days, in the moderation of the seasons and in all the things that are spun into being for our delight—well, who can really count him to be a man at all?

The *obligation* of gratitude is a starting point, in a divine economy which is very like the Roman human economy, where beneficiaries

and dependents stand in perpetual obligation of gratitude to lords and masters. To a modern small-D democrat, this sounds imposing. To Cicero's readers, it sounded natural.

Now we get to the "law" and he begins with old maxims.

Let men approach the gods in chastity, let them bring a spirit of loyalty, let them do without riches. If a man does otherwise, a god himself will punish him.

No one should have gods of his own, not new ones, not imported ones, unless they have been publicly invited in and accepted. Private worship should only be for those approved by the fathers.

Respect temples.

Take care of country groves and the shrines of the household gods.

Observe the rites of family and fathers.

The gods who are regarded as heavenly—worship those, and those who have earned heaven by their deeds: Hercules, Liber, Aesculapius, Castor, Pollux, Quirinus; and worship those virtues by which men achieve ascent to heaven: Intelligence, Courage, Piety, Faithfulness.

Let no one attend rites in honor of the vices.

Let there be no quarrels on festal days, and let servants observe them when their work is done, for so they were placed on the annual calendar.

. . . Let there be priests for the gods, pontiffs for all, and a priest for each.

Let the vestal virgins in the city look after the fire on the public hearth forever.

Let there be no night-time sacrifices by women except those done properly on behalf of the people.

Let there be no initiations except for the customary one for Ceres in the Greek way.

... At the public games, whatever there is of races and fights and singing and music, keep the popular celebration under control and connected to the honor shown the gods.

Cicero wrote *The Laws* when he was in political eclipse, but still fancied himself a player in Roman affairs, in the late 50s BCE. A few years later, under the rule and thumb of Julius Caesar, he found his voice as a philosopher and wrote a series of works that have never received the respect they deserve.

Two books he wrote in those late seasons speak to the matter of the gods in a different voice from *The Laws*. First was *The Nature of the Gods*, in which Cicero presents himself as a young man decades earlier listening to debate among a Stoic, an Epicurean, and an Academic, seeking to establish philosophically just what to make of gods. The work presents Epicurean and then Stoic views at some length, with critique from the Academic perspective. That last school was the descendant of the followers of Socrates and Plato. The high flights of Platonic imagination and the dazzling virtuosity of his dialogues had ripened gradually into an institutionalization of skepticism. The hard position of the Academics was that there was nothing that could be known with certainty but only probabilities to be established.

The great issue in *The Nature of the Gods* has little to do with the gods themselves and more to do with their relations with humankind. As often when we speak about the divine, it's really all about us. Do they care about us or don't they? The Stoics thought the gods knew and cared what we do, the Epicureans believed in gods but firmly believed as well that they were so high and lofty and remote, so wrapped in concerns of their own, that they had no time for meddling in human affairs or paying attention to human prayers.

Cicero ends the dialogue among them, finally, with his own still-tantalizing reaction. "When they'd said all this, we left it that the Epicurean Velleius thought the Academic Cotta had the truer argument, but I thought the Stoic Balbus's argument came closer to something resembling the truth." At first glance, that might mean that the Stoic had worsted the skeptic and the skeptic in turn worsted the Epicurean. "Something resembling the truth" was jargon from the Academic school that Cicero placed in the mouth of the younger version of himself appearing in the dialogue. The thing most like the truth was the best thing available to uncertain mortal minds in the Academic view: you could act on it as if it were true. What Cicero managed neatly to say was that even the Academic had no lock on the truth, but that it was still worth making a good case for a philosophical basis, however hesitant, for continuing in the ways of Roman piety.

Taken together, *The Laws* and *The Nature of the Gods* recommend respect for the conventional, seasoned with skepticism. The speakers in *The Nature of the Gods* had been men of standing in Roman life and religion, the Stoic Balbus a *pontifex*, the young Cicero a future augur. Even the skeptic Cotta would serve a few years after the date of the dialogue as consul, a role in which he necessarily performed many of the traditional offices of Roman religion. These men were imbued with the substance and flavor of life with the gods.

Then came Cicero's *On Divination* (more or less, "On Fortune-telling"), written in 44 after Caesar's death, to take on the question of how the gods can help humankind know the future. The dialogue has Cicero conversing with his brother Quintus, making it easier than in other works to see the author's own position in the words he gives himself to speak.

The dialogue lets us into a Roman world where coincidence is unknown. Meaning and connection *must* be present in large events and small. Leave aside the arguments of *The Nature of the Gods* now, for this underlying belief in the meaningfulness of what seems ran-

dom and arbitrary is fundamental, common, and in one way unquestionable. The history of Rome is a history of stories in which men, faced with perplexity and anomaly, have found in them a divine message. When a message turns out to be incorrect, it is simply forgotten and belief goes on as strong as ever.

Cicero's stories here very rarely bring him into the living world of his own time, and the most notable contemporary case he has should give us caution. Twice in his last days, Julius Caesar performed sacrifice and found the animal on inspection defective. Once the animal implausibly had no heart, then the next day the victim's liver had no "head." In retrospect, Cicero turns these into signs of Caesar's coming assassination.

Divination then is more history than present fact, and its successes are recorded in all the books of old. At every age and stage, accounts of the validity of divination must be accompanied or fringed with stories of doubt. This skepticism turns on the deepest fact about the gods—that no one has ever really seen them. They remain invisible and, in vital ways, unrevealed. Every belief about them faces skepticism.

Quintus Cicero fills the first book of dialogue arguing that the old rituals of divination can help know the future. (Even Socrates supports credulity. He had his familiar spirit, his *daimonion*, who cautioned him against error, did he not?) The second book is dominated by Cicero himself and he speaks with blunt criticism. In this voice, Cicero knows well that many predictions of gut-reading haruspices simply did not turn out as foretold. He catches one king shamefacedly explaining that it's all right that the birds told him to join what proved to be the losing side in the war between Caesar and Pompey because after all, Pompey's side was the side of liberty and principle, despite the disaster of defeat.

There's also humor here, as when he invokes the great Cato, insufferable paragon of all that was Roman, as saying that he didn't

understand why one haruspex didn't laugh out loud when he laid eyes on another one. Can we not mock Marcus Marcellus, five times consul in the second Punic war, who traveled in a closed litter so he would not see unpropitious signs after he had decided on a course of action? He insisted on having any cattle he saw taken out from under their yokes, because it was unpropitious if two yoked cows relieved themselves at the same time. Or again, did all the Romans who died at the great battle against Hannibal at Cannae in that war have the same horoscope?

If we read only *On Divination*, in other words, we come to the conclusion that Cicero, our Cicero, surely didn't believe in the clap-trap he was forced to practice. Various modern strategies of inter-pretation intervene here. Straussians hold that ancient skeptics had to suppress their true views for public purposes and had to go along with common superstition as protection against the hostile obscurantism that had taken Socrates's life. Or did Cicero's views have to change over time as his hopes for Rome grew colder and colder? Did he work his way from credulity (*The Laws*) to skepticism (*The Nature of the Gods*) to outright disbelief (*On Divination*)? None of these interpreta-tions is persuasive.

Other ancient readers were not deceived. Four hundred years later, the sternly traditional Roman historian Ammianus knew just what Cicero had stood for. "Wherefore Cicero has this fine saying, among others: 'The gods,' says he, 'show signs of coming events. With regard to these if one err, it is not the nature of the gods that is at fault, but man's interpretation.'" Ammianus had his quotation wrong, but not his Cicero.[4]

What we should see most of all in Cicero is an astonishment he speaks to briefly in one of his works on Academic skepticism.[5] He had read a monumental work by his contemporary Marcus Terentius Varro. Varro was a marvel of the nations in several regards, for his long life (born in 116 BCE, he lived eighty-nine years, to die in the

year Octavian took the title Augustus) and for his polymath gifts and prolific output of learned works in every domain of literature, culture, and history. He fought for Pompey in the civil war and was pardoned twice by Caesar. Then he earned his own "proscription" from the junta that killed Cicero, but survived to be patronized in great old age by Augustus. His *Human and Divine Antiquities* in perhaps forty-one books was effectively the first great compilation of Roman religious culture and lore that a curious senator could read.

Cicero makes clear that the work was a revelation to him. It brought to the fore a world of half-forgotten gods, cults, and rituals. Without exhaustive travel and investigation, no one could easily or naturally get to know the diversity of practices and ideas that flourished just in the old Latin towns of central Italy. Seeing Roman practices in a landscape had the effect for Cicero of reinventing "Roman religion"—that is, the religion of the city and its gods and its aristocrats.

We should perhaps better argue that Varro did not reinvent but invent. That is, Romans with their gods, until Varro showed them the diversity of their world, did not yet know they possessed a distinct and distinguishable and uniquely important set of gods and practices. They had never been able to think about the subject before. *The Nature of the Gods* is very much about that newfound religion, carefully singled out from the swamp of beliefs in which it quite naturally dwelled. This same old-seeming but newly invented "Roman religion" would be the object of Augustus's attention as well. Embracing it was as easy for them as it was to nurture their skepticism.

Cicero was every bit the traditionalist and every bit the modern in matters of religion and got to have it both ways. His skepticism, which some have thought an invention, was the most traditional thing about him. His positive attachment to the old ways of Rome was the novelty.

Chapter 4

WHAT IS A GOD?

L ET US DO OUR ANCIENTS, THEN, THE FAVOR OF TAKING THEM
seriously about their gods. They talked about them insistently
and often, they had special places and did special things just
for them. If we can stop worrying long enough about whether the
gods existed or whether people really believed they existed, if we can
just try to look at them, what do we see? What is a god? Think of
this chapter as a modern treatise in Cicero's spirit concerning "The
Nature of the Gods." There is, emphatically, no simple, coherent, or
straightforward answer to the question *What is a god?* This may be
the most important thing I say in this book.

To track the gods, let's pretend we are extraterrestrials. We land
here and use our magic language translator and start trying to make
sense of what we see. What do we find? The same word (allow-
ing for the easy and univocal translations of Gott, Dieu, God, Dio,
Bog, even Allah, just for some of the major languages spoken on
the European continent) is being used in an extraordinary variety
of ways to describe an extraordinary variety of beings, places, and
events. As extraterrestrials, I submit, we would be more interested in

the diversity of fact than in the habit of reduction and simplification.

I suggest that beings called "gods" can be inventoried and tagged if we ask them approximately seven questions.[1] To be sure, not many gods will likely be able to answer all of them, much less answer them in congruent ways. Nor will the gods be entirely summed up by these questions. It's a start.

Question number one: Where is this god found? Does he or she have natural sites that are home turf? Are there artificial sites—call them temples and bear in mind that's a specifically Roman word—where human beings go to encounter them? If gods are mobile, even miraculously mobile, they still show a strong tendency to linger in certain specific places. Can we be pedantic enough to plot on a map where those sites are and see, in a collection of those maps, patterns?

One caution. Ancient stories, like the one about the Great Mother, regularly showed gods moving in space from east to west. Modern scholars equally love to speak of "eastern religions" and once made an overarching theory of religious change out of the idea, including Christianity among the migrants. The exotic "orient" created religious enthusiasms that migrated west, some modest, some growing larger as they went, subverting "western" rationality.[2] The last fifty years have seen this theory crack and crumble, but it does not disappear. The societies of the eastern Mediterranean and beyond were mainly just larger, more complex, more diverse, more prosperous, and more sophisticated than the western ones, so many cultural novelties would arise there. Nothing essentially "oriental" or "eastern" about that.

Question number two: When does this god appear? In nature, there are gods who are conventionally thought of to appear in seasons and circumstances unique to their qualities. A goddess of childbirth never appears in a celibate household, but visits the young married every couple of years. Gods of crops and storms know their times of the year. The artificial answer to this question is enshrined in a calen-

dar of festivals, often but not always offering a compelling explana-
tion for why a particular god's festival falls at such and such a season,
but some seem to our eye completely arbitrary.

Third question: Who paid attention to the god? This question
applies both to the wider community of worshippers, loyalists, enthu-
siasts, and the like, but more specifically to the cast of functionaries
and—well, I'm resisting the word *clergy* here. If there was a temple,
there were temple people: guards and cleaners, surely, functionaries
who looked after ritual obligations of one kind or another, but also
hangers-on, vendors, and obsessives living with the god for longer
or shorter periods. Those people might well include those who dif-
fered with each other considerably when it came to describing the
god, explaining his functions, or prescribing his rituals.

Fourth: What did this god do? Here again, a natural and an arti-
ficial answer. Was this a god warding off scarlet fever or ensuring
victory in battle? Did she look after kittens or hunt boar? What hap-
pened, therefore, around her places and in her times? And when you
pulled out the handbooks called *indigitamenta* and looked up what *you*
were supposed to do for a god, what were you told? It may very often
be hard for us to see why a particular ritual went with a particular
god, but it was very clear that there was real limit on worshippers'
discretion. You did what you were supposed to do, no questions. All
this was knowable.

Fifth: What did this god look like? This was in many cases the
easiest question for ancients to answer and easiest for us as well,
because artistic representation of the divine being was a common
form of showing respect—and especially useful, inasmuch as wor-
shippers were unlikely to get a good look at the god himself. Here
again, there might be a fair amount of variety from place to place and
time to time, but it is relatively easy for archaeologists and art histo-
rians to look at a newly discovered piece and tell you with confidence
just who it's supposed to be—most of the time. (There were some

"aniconic" gods who could not be imaged, but there was never appreciable hostility to images as such.)

Sixth: What was the god's story? The story is closely related in many cases to the appearance, as when Heracles/Hercules was regularly depicted with a lion skin that alluded to the first of his twelve labors, slaying the seemingly invincible lion of Nemea in the Peloponnese. Major gods, popular gods, had very canonical stories that did not vary drastically—so the lists of street-wise Hercules's twelve labors as he fought the rising odds were about as consistent as the lists of Disney's seven dwarfs. Truly major gods *also* got supplemental stories less universally told, embroideries, "the further adventures" kind of narrative, tales that gave the god a more vivid life in the mind of a community that was happy to pay him or her attention. Then there were gods who barely had any story at all—or whose official story was heard on ritual days once a year and not much otherwise. And there were gods who were, as far as we know, storyless. I don't mean that nobody ever told—that is, made up—a story about them, but at our distance there turn out for many "lesser" gods to be no documented tales and perhaps only a modest amount of evidence for how they appeared.

Last, yet perhaps most important: What was the god's name? Gods almost without exception had names. The individual identity and the personality that go with a name are fundamental functions in making a "god" resemble a human being and be able to have something to do with human beings. The connection is dramatic and obvious. To see that, think of the domain of science fiction. When the creatures from another galaxy have names, you are in one space; but when they are nameless, they terrify, and they are likely to be out of human scale otherwise. Rilke's angels are terrifying—and nameless, while Paul seized on the spookiness of the "unknown god" in Athens to make it his own.[3] For all that gods are different from human beings, their names and personalities keep them connected and imaginable.

How do you know what a god's name is? Assuming he or she doesn't tell you directly, you learn from others around you. The god worshipped here is Ba'al or Zeus or Jupiter, they say. Aha, you say, and you may have several reactions. This might be interesting—never heard of this one before, what's he like? That's one possibility. Ah, yes, Zeus, Zeus the mighty, very familiar, thanks. Then there's negotiation. Sorry, I'm not from around here, Ba'al you say? Tell me about him. After a bit, your realization dawns and you say, why that sounds exactly like Zeus back in my world.

I exaggerate the naïveté to make the point. People who passed back and forth in the space of the ancient Greek and Roman worlds were for a very long time entirely ready to discern a familiar god behind an unfamiliar name. When they saw a recognizable basket of features, traits, and pastimes, they were inclined to identify the new with the familiar. That happened in real historic time in ways we can see—Julius Caesar in Gaul matches up the local gods to the ones he knows, likely with some encouragement from those who had gone that way before him but at the same with a real sense of discovery and shaping.[4] It also happened before and beyond our reach, as in the fundamental equations of Greek and Roman gods, Zeus and Jupiter, Hera and Juno, Athena and Minerva, Ares and Mars. That great syncretization of the communities of the gods was fundamental to the cohabitation of Greek and Latin speakers in the Mediterranean world and to the cultural mobility that the Roman Empire offered. Romans deferred to Greek cultural superiority, but then expected that other gods from other places could be assimilated to gods already known. This had the effect, with little of anything religious about it, of making it easier for peoples to assimilate to one another, move around, and imagine they lived in a common space.

There were exceptions and boundaries in the divine world as in the human. A few major figures traveled widely without name changes, such as Apollo and Heracles merely respelled as Hercules.

Others remained purely local and puzzled outsiders. The most interesting cases are the identifications that took on a life of their own. For example, take the name "Jupiter Dolichenus."

If you compared the group of people at the temple of Jupiter Dolichenus on the Aventine in Rome with those in his hometown not far from modern Gaziantep in Turkey, a little west of the Euphrates, you might find some fairly striking differences in all sorts of things— ritual, furniture, images, stories.[5]

Doliche was a town between—between the Mediterranean and Mesopotamia, between the highlands of Asia Minor, the Euphrates/ Tigris basin to the southeast, Antioch and Tyre to the southwest, and the caravan world south to Aleppo and Damascus. The god worshipped there is one that careful moderns would call Ba'al, well aware that the name is tricky even there. The word can be a generic kind of word for many deities, close in meaning to "lord" and "master." Within the Semitic world where such gods were found, the word had its widest application. Step away from the worship of those gods, and the word shrinks down a bit to apply to the great lord god of any place or region, most notably Hadad, the sky and master god found at Ugarit (near modern Lattakia in Syria).

As Phoenicians, particularly, got about the Mediterranean and founded colonies, those communities would speak of their protecting deity as "the Ba'al of Carthage," for example. It was a short step—not directly attested to in history—from that kind of assimilation to recognizing that the powers of a lord and master sky god in the Syrian uplands were a lot like those of a lord and master sky god sitting on Olympus or the Capitoline.

That's what happened to "the Ba'al" cherished at Doliche. His home fell under Roman control in the days of Pompey, but the new name first starts showing up over a hundred fifty years later, when "Jupiter Dolichenus" acquires temples in Africa, Rome, the Balkans, and Germany. That range of locations in that period suggests

that the enthusiasm spread through the army and its generals. This need not mean any particularly military tone or enthusiasm, only that assignments with the army offered the most effective way for people with money and political standing to move from one part of the world to another. The first step in the history of Jupiter Doliche-nus could well have been a single high-ranking officer, impressed with what he had seen in Syria, perhaps grateful for a victory or a cure or a promotion, eager to show off his own wealth and connect-edness to the gods, investing in a temple somewhere else. The name "Jupiter Dolichenus," after all, only makes sense when you are far from Doliche.

The Jupiter of Doliche did not have a long afterlife, but what he had was active and impressive. Though he was getting abroad well into the early and middle second century CE, it was particularly the reign of Septimius Severus (died c. 211) that saw him patronized from on high. An inscription in modern Hungary on the Roman side of the Danube tells us that all the priests of this god there gathered and erected an altar in his honor, perhaps when that emperor was visiting the region in 202. A powerful emperor's god was, by definition, a powerful god. There might be some ordinary sycophancy in toady-ing up to the emperor's god, but it was also cold-blooded self-interest of a different kind. If this god is so powerful and can show such favor to this man that he becomes the all-ruling emperor, I might be well advised to show that god a little positive attention myself. A god who couldn't make you rich or victorious or healthy wasn't worth paying attention to; but a god who could bestow those gifts abundantly on someone else was well worth a good look. At minimum, you wanted to avoid his anger.

Then the Jupiter of Doliche more or less vanishes in the later third century though there is no direct evidence to explain why. The imperial family who patronized him faded with the death of Alexander Severus, who was assassinated in a mutiny at Mainz on

the German frontier in 235 CE. This happened just as the revitalized Persian Empire was pressing hard on Rome from the east. The next fifty years were bad ones for Rome in many ways, and much expenditure on old and prominent religion seems to have failed. A god specially patronized by an imperial family that had fallen would not have been in favor. When, moreover, the god's own hometown of Doliche was captured and pillaged by the great Persian emperor Shapur twenty years later, the god's very power and persuasiveness will have been called into question. Few would build temples for him after that, and many would be lured away by other, more promising, gods.

Now look back over my last paragraphs and see how I spoke of these creatures. Then read these words from Jane Harrison, one of the founders of the modern study of ancient religion over a century ago:

> It is only by a somewhat severe mental effort that we realize the fact that *there were no gods at all,* that what we have to investigate are not so many actual facts and existences but only conceptions of the human mind, shifting and changing colour with every human mind that conceived them.[6]

I shouldn't need reminding of that, but look how badly I do. I have been speaking of the god of Doliche as though he existed, as though there really were a being, with a definable name and traits and proclivities, who in some sense moved around the Mediterranean world, was found in a variety of places, and was consistently himself in all those places. Nothing is so common in the way we all speak of these things and nothing is so misleading.

The true thing to say is that it was *people* who imagined and did all this. Some "gods" were carried by hand, so to speak, from one town or province to the next, when the name and the story and the

rites and the images were consciously brought to a new place. Others seemed to move because the name used in one place was integrated with existing practices somewhere else. But no god was in fact any more than a fistful of answers to my basket of questions, and we need not expect to find any regular consistency or clarity in them. Cult objects, stories, pictures, names—all are meaningless and empty without human imagination and credulity to bring them to life.

We are taken in by the names especially. It's just easier to talk about the cult of Jupiter Dolichenus in many places than it is to observe the spread of specific kinds of practices, styles of religious art, and architectural features of religious buildings, and how they were distributed and changed over time—even when we know that is what we should be doing. Talking about these gods as if they really existed is *easy*. And if it's easy for us, think how easy it was for the ancients.

How misleading can this be? Let me take a paragraph from the work of the single most eminent contemporary scholar of Greek religion, Walter Burkert, long professor at the University of Zurich, author of many fundamental works to which every student of the ancient world owes much.[7]

Offerings are among the most common practices of religious practice; we may define them as actions whereby goods are transferred from mortals to transcendent recipients. The value of the goods involved bespeaks the seriousness of the transaction and importance of the addressees; there is high hope that it shall not be undertaken in vain. Whoever sacrifices signals to the addressee that the offerer wishes to make contact and expects an answer to be given or a request to be met. Typical addressees include gods, demons, and the dead; their specific characteristics, as elaborated in local tradition, help to shape the performance of the ritual.

Can we count what's problematic about that paragraph?

1. The "transcendent recipients" never existed.
2. Nothing was transferred. Things were left in a public place; or taken to a public place and destroyed; or taken to a public place, destroyed (that is, brutally and bloodily killed), cooked, and eaten.
3. There was no "transaction" to be taken seriously.
4. There were no addressees to think important.
5. The action was *always*, unquestionably and unarguably, undertaken in vain, with regard to its stated purposes. No addressee was pleased by what worshippers did or offered in consequence any assistance of any kind.
6. No contact was made, no answer was given, no request was met.

Burkert knows all these things, but the manner of speaking is insidious and hard to avoid. Some of the ways we deceive ourselves go back to the way early Christians dealt with the phenomena of their world, for they held a perspective that their modern heirs might find unsettling.

Early Christians believed in the traditional gods. That is, they thought the gods really existed, had real power, and did real favors for their worshippers. They came to believe as well that their own god was in essential and intrinsic ways not just superior to "the gods" but absolutely superior in kind and category. "The gods" were not what they made themselves out to be. In the developed form of this view, which lasts quite strongly among Christians for as long as there was serious rivalry from other forms of religion and even beyond, "the gods" were spirits an order of magnitude below the nature and domain of the great god of the Christians. Augustine would make it clear that the gods of old were nothing more and nothing less than the

fallen angels of the Old Testament, and he and his coreligionists used a good old word for them: *demons*.

Even the Christians' own texts supported this view. The seventh chapter of Exodus introduces the contest between Moses and Aaron on the one hand and the magicians and sorcerers of Pharaoh on the other. It's no surprise that Moses and Aaron triumph. Each time Moses passes a miracle, the magicians pass one of their own; but Moses's version triumphs. He turns Aaron's rod into a snake; so the magicians turn rods into snakes; but Moses's snake devours the others; and the contest continues through multiple rounds. Jewish, Christian, and Muslim readers of that passage had to admit that Pharaoh's men really did have magical power at their disposal. Where did that come from? The early Christian answer was the straightforward one—they were in touch with these false and paltry gods and they got their limited and paltry powers from them.

Who invented *real* monotheism? That is, the idea not only that the god of Abraham was supreme but that he was alone? One persuasive recent scholar thinks this may have been the fourth-century writer Firmicus Maternus, whose surviving books include an astrological manual and a fiercely antipagan tract whose enthusiasm may derive as much from his desire to please the reigning emperor as from any theological passion of his own. The issue is so contentious that one of that scholar's reviewers insisted on dating the innovation to the seventeenth century![8]

If the world is not so full of gods for us now, we still have the habit of speaking as though it were. Those names entice, seduce, and mislead us into shaping the way we talk about the world of practices and ideas in accord with those fundamental illusions. I toyed with trying to write this book while rigorously abstaining from any sentences of the form "Jupiter was worshipped" or "the Great Mother demanded" or "the Thracian rider god gradually spread" and have obviously given up—mostly in frustration with

myself. The ancient ways of thinking and speaking about religion remain powerful even among those of us who think we share nothing in common with those backward pagans.

SAYING WHAT I HAVE said about ancient ideas of the gods could be misleading unless I also say what the (nonexistent) gods were not. Ideas of the divine were so strongly upgraded in later times, particularly in Christianity and Islam, that most of us have notions of divinity quite alien to ancient practitioners.

Their gods weren't perfect. They were large and powerful and smart, but they weren't perfect. They were immortal, but they were not eternal—that is, they lived inside time and went on living, but there was no overall conception of boundless time or a world beyond time in which they resided. We'll see how Platonists and Christians and others later found themselves gradually raising their expectations of divinity to heights unknown in classical times. Zeus, father of gods and men, king of Olympus—he was small potatoes compared to the highest and most elaborated form that the gods imagined in later centuries would take.

The gods weren't very nice. True, they more or less knew the same rules and conventions of morality and ethics that human beings did. Knowing, however, that they had certain immunities from penalty, they seemed less inclined to do the right thing.

Accordingly, they mostly didn't care whether or not human beings did the right thing. Ethical precepts, living the good life, avoiding sin: that was your business, not the gods'. They cared a lot, sometimes, about whether you performed your devotions toward them or complied with their whims, but that means they cared more (in principle) about getting the smoke from just the right incinerated cow wafting to their Olympian nostrils than they did whether the sacrificing officer had slept with someone he wasn't supposed to

sleep with—unless his sleeping with anybody at all the night before might contaminate the pure quality of the smoke. Ethical and conventional principles of behavior were for negotiation between and among people and the gods stayed out of it. The reverse could be true, as Agamemnon might have complained in Aeschylus's play, where it seems the gods think him fit to die for the crime of sacrificing his daughter Iphigeneia, even though he did so at divine command.[9] When Augustine resorted to the novel idea of original sin to explain how it could be just that his god brought tiny babies into the world doomed to die before they could flourish and suffer eternal punishment besides, he was still in the ancient moral universe.

The gods hadn't created the world, either. Oh, some of them had been vaguely involved, according to certain stories, but they were mainly the mightiest part of the world itself, not beings that somehow stood outside it all. When Olympus came to feel too earthen, then the planets were thought to be the homes of the gods, and the domains of space beyond were thought to be the highest and most perfect places in the world—but emphatically *in* the world. If and when people worried about whether the world we know would end or whether there were other worlds, the gods had little say in the matter and were considered irrelevant.

They *could* help you, if you were nice to them. The form of "impetrative" prayer was not, therefore, "Dear god, I have been good, please help me pass my chemistry test," but "Dear god, look at what I've done for you, so how about you do something for me once in a while? Would it spoil some vast eternal plan if you did?" In full bargaining mode, this meant promissory notes and contracts: "Dear god, if you do this for me, I'll sacrifice a really splendid heifer to you." That's the sort of thing you wrote down, perhaps scratched on a piece of pottery, and left at the god's shrine. If he kept his part of the bargain, you knew to keep yours. That kind of pledge had the advantage that it was not due and payable unless the god came through.

But yes, the gods did live in stories, and they lived there quite well because they were so very like human beings. We have a hard time seeing this properly because we know the later history of the god of Abraham—who was later divided up and fought over by Jews, Christians, and Muslims. The figure we meet in the Old Testament posed a problem for many Christians and critics of Christianity. He was too readily angered and too arbitrary and he countenanced far too much polygamy and worse among his favored ones. He too began his history as a character in stories, but then in Christian times he gradually became immortal, omniscient, and omnipotent. Science fiction writers long ago discovered that the rules of stories all collapse when we imagine a character who doesn't live by the rules. The character becomes boring and the stories go off the rails. Before he knows it, the storyteller is trying to explain predestination to a skeptical congregation.

A NOTE ON "RELIGION" AND "PIETY"

Religion, for a word with a long future, had modest beginnings. Latin *religio* was far narrower than the modern word that comes from it and more or less overlapped initially with our word *scruple*—the small but firm hesitation in the face of constraint by a feeling of religious concern. With the passage of time, it could mean also a religious feeling of obligation to take some specific action. Gradually, it becomes identified with the performance of religious rites—presumably out of an initial feeling of constraint and obligation. It should remind us of the direct experience of godly power in the world in response to which the ancient senator or farmer or shoemaker was performing some ritual. There's no "sing praise to the Lord for he is good" about this word. That attitude can be found sometimes in various places in the ancient world, but this word is about need. If you do the things that *religio* tells you to do and you do them mainly well, you'll be

all right—whatever it is you may think about them or the jealousy, anger, or lasciviousness of the gods that makes them ask you such a thing. The poet Lucretius, who raged that *religio* was the cause of many and great evils, was an outlier but he made a good point.[10]

Piety has a similar history, for Latin *pietas* is a word for the discharge of a social obligation. The "pious" individual is one who does his duty to others. When the others are his betters, then this piety is obsequious, deferential, and obedient; when the others are his peers, then this piety is reciprocal, collegial, communitarian; and when the others are his inferiors, then this piety is generous, patronizing, magnanimous. English has derived from *pietas* two words, one for the deferential submission of man to the divine in "piety" and the other the general condescension of the fortunate and powerful toward those beneath them in "pity."

There's nothing about belief and nothing about inner disposition in these words. No more than there is in the waggish remark of the Catholic priest a generation ago who, when asked if he believed in canon law, said that he didn't have to believe in it, he just had to obey it. Romans discharged their religious obligations the way they obeyed the law—now happily, now unhappily, and with an eye on the outcome. If the gods were capricious or malevolent or stupid— well, that's just how it was. A "religious" or "pious" man just did what he had to do.

Chapter 5

DIVINE BUTCHERY

THE DISAPPEARANCE OF BLOOD SACRIFICE IN THE GREEK AND Roman worlds is almost as surprising as the disappearance of the gods. Sacrifice is harder for moderns to think about, for even unbelievers today have met real believers and have some idea what it's like to believe in a god. It's harder to understand what awe or anxiety could make a man slaughter a noble animal to honor the gods. Brutality aside, every sacrifice of a quadruped was a willed economic loss, the destruction of a significant asset—something like setting an automobile on fire. There was meat afterward, to be sure, and the sale of sacrificial meat mitigated the economic impact on a routine basis. (When the apostle Paul worries about whether it is permitted to eat meat devoted to idols,[1] he's thinking of the specials he's seen at the local butcher shop on the day after a festival. Meat was not abundant otherwise.)

We should not assume that humans have gotten beyond blood sacrifice. The Muslim pilgrim on hajj at Mecca still kills—usually by himself, for himself—a sheep, a goat, or even a camel and eats something from it. This marks the end of his period of austerity and

pilgrimage and leaves him free to dress normally, cut his hair, and return to modern life. (Saudi authorities have needed to supply bull-dozers to handle the resulting mass of carcasses.) Mohammed Atta, boarding the flight he would commandeer on 9/11, left behind notes that are full of the language of purification, ritual slaughter, and the unique suspension of feelings shown by the divinely authorized slayer. In the southern Caucasus and in Cappadocia, the slaughter of a sheep outside the church was still a part of Christian ritual well into the twentieth century and Soviet rule. The most conventional seder meal of Passover has outsourced the slaughtering, but depends on the fundamental idea, as does the even more abstract version of anthropophagy (to be almost polite about it) enshrined in the Chris-tian eucharist.

Most remarkably, every five years in Nepal, at a place called Bari-yapur, near the Indian border, what the *Guardian* newspaper called "the world's biggest animal sacrifice" is repeated, destroying a quar-ter of a million animals in honor of the Hindu goddess Gadhimai. Protest from outside did not deter the million or so participants on the last iteration. The number of animal victims is hard to confirm, but we have a report that two hundred fifty knife-wielding locals were put to the task of decapitating more than ten thousand buffalo.

> Frightened calves galloped around in vain as the men, wear-ing red bandanas and armbands, pursued them and chopped off their heads. Banned from entering the animal pen, hundreds of visitors scrambled up the three-metre walls to catch a glimpse of the carnage. . . . [A] Hindu priest [said], "The goddess needs blood. . . . Then that person can make his wishes come true."[2]

To capture the ancient tradition is harder than we might think, for sacrifice was practiced more than preached, and few explanatory documents survive.[3] Our best voice comes very late, from a fourth-

century CE scholar/statesman named Sallustius, probably a high official in the administration of the emperor Julian. His book, *The Gods and the World*, recapitulates the most philosophically sophisticated development of ideas about sacrifice, but he writes when many voices had already been raised to object to the practice.

> The divine nature itself is free from needs; the honours done to it are for our good. The providence of the gods stretches everywhere and needs only fitness for its enjoyment. Now all fitness is produced by imitation and resemblance. That is why temples are a copy of heaven, altars copies of earth, images copies of life (and that is why they are made in the likeness of living creatures), prayers copies of the intellectual element, letters copies of the unspeakable powers on high, plants and stones copies of matter, and the animals that are sacrificed copies of the unreasonable life in us. From all these things the gods gain nothing (what is there for a god to gain?), but we gain union with them.
>
> I think it worthwhile to add a few words about sacrifices. . . . the highest life is that of the gods, yet man's life also is life of some sort, and this life wishes to have union with that, [so] it needs an intermediary (for objects most widely separated are never united without a middle term), and the intermediary ought to be like the objects being united. Accordingly, the intermediary between life and life should be life, and for this reason living animals are sacrificed by the blessed among men today and were sacrificed by all the men of old, not in a uniform manner, but to every god the fitting victims, with much other reverence.[4]

His tortured rationalization tries to put philosophical logic around ancient practice. We needn't imagine that many people attending a real sacrifice could or would have spoken this way. Their wordless

assent showed the power of cultural forms that cannot be explained but cannot be given up abruptly.

Those rationalizations competed with long-established criticisms. Hesiod, at the beginning of the Greek literary tradition, already describes in the *Genealogy of the Gods* how Prometheus was responsible for inventing sacrifice while cheating the gods out of the best parts of the sacrificed animals. East and west ever after, there were always intellectuals as disdainful as those who object to the Gadhimai sacrifice in Nepal. Isaiah's YHWH, for example, notably shares that view:

> To what purpose is the multitude of your sacrifices unto me? saith the LORD: I am full of the burnt offerings of rams, and the fat of fed beasts; and I delight not in the blood of bullocks, or of lambs, or of he goats. When ye come to appear before me, who hath required this at your hand, to tread my courts? Bring no more vain oblations; incense is an abomination unto me; the new moons and sabbaths, the calling of assemblies, I cannot away with; it is iniquity, even the solemn meeting. Your new moons and your appointed feasts my soul hateth: they are a trouble unto me; I am weary to bear them.[5]

Both Hesiod and Isaiah spoke in societies with many centuries of blood sacrifice still in their future.

When Herod's great temple in Jerusalem was destroyed in 70 CE by the Roman general Titus, sacrifice ceased there permanently. Outraged, violated, and thwarted, Jews still made no serious attempt to restore the ancient practice. Sacrifice does survive to the present day on Mount Gerizim near Palestinian Nablus among the Samaritans, who since ancient times have been close religious cousins of the Jews. Mainstream Jews could easily have decided that, temple or no temple,

YHWH needed his public sacrifice, for the good of his people, but they didn't. In retrospect, the confinement of sacrifice within Judaism to Jerusalem had allowed for the rise of a very large and dispersed community of undoubted Jews whose connection to the sacrifice of the temple was mainly abstract. As long as that business went on in Jerusalem, all was well, and no ritual killing required beyond the Passover lamb needed be done.

Less drastic criticisms of sacrifice survive from the heart of classical times.[6] Aristotle's successor at Athens, Theophrastus, did not oppose the practice, but offered a damning theory: that animal sacrifice had originated as a substitute for cannibalism, to which people had been driven by hard times and shortage of food. In Roman times, fine learned gentlemen like Varro and Seneca thought that thinking well of the gods meant not claiming they were beings who cried for blood.

In the Roman *lectisternia* and *sellisternia* that we saw in the case of the *ludi saeculares,* participants and onlookers could only pretend that the sculptures of gods arrayed for the meal were consuming meat. What reached to the gods on high could only be the smoke. Calling attention to that fact made it easy to make fun of the gods, sniffing hungrily on Olympus. In the second century CE, the wit and satirist Lucian, from Samosata near the Euphrates, painted the necessary picture:

> When someone sacrifices, the gods all feast on it, gasping open their mouths for the smoke and drinking the blood poured on the altars—they're like flies! But when they dine at home, their menu is nectar and ambrosia. Once upon a time, men used to dine and drink together with them—Ixion and Tantalus— but they were full of themselves and talked too much, they are still being punished to this day, and heaven is closed to the mortal race—strictly forbidden.[7]

Habits of sacrifice were everywhere in the Greco-Roman Mediterranean world. The most conventional of these was the Greek and Roman practice of killing, butchering, cooking, and eating. Older traditions, many of them, had made do with burning up in sacrifice only choice bits, while the Jewish tradition of that part of the nearer east emphasized "holocaust," which was the burning up of the whole. Sheep, goats, and cattle were commonly the victims, donkeys and horses much less so, for reasons that attracted speculative but not particularly well-grounded explanation. The second century CE grammarian Festus tells us about this old exception:[8]

> The "October horse" was what they call the animal sacrificed to Mars every year on the Campus Martius in that month. The people of the Subura and their neighbors of the Via Sacra used to fight it out for possession of the head, the Suburans fighting to hang it on the Mamilian Tower in their neighborhood, the Sacra Via people wanting to fix it on the wall at the Regia. Then they took the tail as quickly as possible to the Regia so that its blood would drip into the sacred hearth there in a service for the gods.[9]

The victim was the lead horse on the winning team in a race, killed with a cast of a spear, then beheaded. The head was served up with loaves of bread, to make clear that the purpose was a good harvest. We may know a few other things; for example, that blood of the horse was saved for six months and used in the ritual of the Parilia festival on April 21. When we look for ancient explanations, we find only clumsy attempts at rationalization, like the one that makes this punishment directed against all horses for being complicit in the fraud of the Trojan horse and thus in the downfall of Troy, Rome's ancestor. The October horse has the smell of a very old rite, where the two neighborhoods fight it out for control of the pre-Republican kingship.

Not all ancient oddities remain obscure behind their legends. Sometimes we catch them in the act of being invented. Take the "bull slaying," or *taurobolium*.[10] This ritual attracted the scorn of ancient Christians of the fourth and fifth centuries and so earned a place of odd prestige in the hierarchy of ancient ritual, for all that recent research has now given it a more limited history. Here's the best ancient account, put in the mouth of a Christian martyr:[11]

> Romanus [the martyr] answered: I'm here and this is really my blood, not that of a bull. You know, don't you, you wretched pagan, about that sacred bull's blood you bathe in amidst sacrificial killing? So your high priest goes down into a trench dug deep into the ground to be consecrated, with a strange band around his head and then a golden crown planted there, wearing a silk toga bound up in the Gabinian way for sacrifice.
>
> Over him they lay a platform made of boards, loosely fitted, then they pierce it some more with a sharp tool so there are many small openings.
>
> Then they bring in a huge bull, fierce and shaggy-browed, crowned with flowers tangled in his horns, his forehead daubed with gold and gleaming, making his fur glow. When the sacrificial beast is in position, they open his chest with the consecrated spear. The gaping wound spews out a flood of hot blood, pouring down a fuming flow running wide on the planks below.
>
> Then the running rain pours down a filthy shower through a thousand yawning passages, which the priest buried inside takes in, putting his head under its full filthy force, the clothes on his whole body a disgusting mess. He even turns his mouth upwards and offers his cheeks to the flow, putting his ears, lips, and nose in its path as well, even bathing his very eyes in the liquid. He does even spare his mouth and wets his tongue until he has completely absorbed the dark blood.

After the carcass is stiff and drained, the priests drag it away from the platform and the pontiff comes out of there, a horrible sight to see. He shows them his wet head, his beard dragging down, the headband sodden and his clothing soaked.

Befouled with such contamination, filthy with the gore of the just-slain victim, all hail him and reverence him—from a distance—just because the vile blood and a dead ox have bathed him while he hid in his hideous hole.

Oh, ick, one may reasonably say. What awful people, what a filthy ritual, who can have done such a thing?

I recommend a pause. Three limitations impose. First, there is no attestation of this rite before the mid-second century CE. Religion had its fads. Second, the concrete evidence includes less dramatic and fainter testimony of the third century, which has the blood being caught in a bowl and handed over to the sacrificing officer, who then very probably used it as a purifying sprinkle, not an inundation. Third, the dramatic sources are too late and too partisan to be given full credit. One we've already met briefly, the prototype of the most zealous monotheism, Firmicus Maternus, writing around 350; the other two sources for this story are the Christian poet Prudentius in his poems about Christian martyrs of around 390 and another poem we'll see in a few chapters, called the *Carmen contra paganos,* that was written in the same period with the express purpose of mocking, humiliating, and condemning surviving "pagan" practice. These writers make the bull bath out to be a bizarre failed alternative to their own benign and clean baptism.

The preposterousness of this ritual has an eerie forerunner in a story told about Christians. The Christian Tertullian around the year 200 CE wrote an *Apology* attacking everyone who was not a member of his religious community and defending his own. He describes with outrage just how unjustly his people have been defamed. According

to Tertullian's account of the slander, Christians were said to meet in private orgies, where children were killed and eaten and where, when the dining was done, dogs were tied to candelabra while the Christian faithful looked about the room to be certain they knew where their siblings were seated. On a signal, the dogs were frightened, they leaped into a panic and in so doing overturned and doused the candelabra. In the ensuing darkness, brothers and sisters had sexual intercourse with one another.[12]

If this story came from a hostile source and spoke of a cult of which we knew little otherwise, we would probably take it all too seriously, even if it were even more flamboyantly exaggerated. As it is, it's easy for us to identify at least some elements. Christians addressed each other as brother and sister in a way that would surprise and scandalize observers trying to keep track of just who was living as husband and wife. There were secret rituals—for the "Mass" of that period was not open to nonbaptized eyes—in which they spoke of eating the flesh and blood of a god who had been brought into the world as an infant. It would not take much honest confusion to get from reality to that story, and we need not assume that the enemies Tertullian is attacking were only honest. (The dogs—I confess I do not know how the dogs got in the story.) If we doubt that Tertullian's mockers were describing Christianity accurately because we happen to know much more about that religion, should we not be equally skeptical in the face of Prudentius's version of what he despised and thought a pale image of true baptism?

If the beheaded horse and the bloody bull bath distract us, we need also to steel ourselves for the cases of human sacrifice of which we know. The topic makes every reader, ancient and modern, nervous. Well and good, it might be, that the ancients slaughtered masses of sheep in a particular way; so do modern farmers, omitting religious ritual. Killing and eating human beings on any grounds is repulsive to imagine. In myth, the examples were few, sometimes

horrifying, but clear: Thyestes eating his children or Agamemnon leading Iphigeneia to the altar are presented in drama as outlandish and shocking. The description of Patroclus's funeral in book twenty-three of the *Iliad*, where many animals *and* twelve captured Trojans are sacrificed, is harder to dismiss entirely because the act is presented as falling within reasonable social norms. Their slaughter expresses the wrath of Achilles, but he does not put himself outside the pale by his action.

The notorious case of the Persian victims sacrificed at the battle of Salamis is harder still to ignore or minimize because by now we have reached the kind of story most readily taken as factual. Plutarch writing under Roman emperors long after attributes it to the philosopher Phanias of Lesbos, writing one hundred fifty years after the battle itself:

> Three prisoners were brought to the commander's ship as Themistocles was making his prebattle sacrifices for omens. They were very handsome to look at, and they were adorned distinctively by their clothes and gold jewelry. . . . The prophet Euphrantides saw them and when at the same moment a large and widely seen fire flashed out from the sacrificial victims and someone sneezing off to the right was taken as a sign, Euphrantides grasped Themistocles' hand and ordered him to sacrifice the young men and to consecrate them all, with a prayer, to Dionysus the Eater of Raw Flesh. For so, he said, there would be safety and victory for the Greeks.[13]

Themistocles was shocked by this urging, but all who thronged around cried out their support.

Or so the story goes. Herodotus, much closer to the event, makes no hint of such a thing happening and elsewhere expresses his deep disapproval of human sacrifice as something that only the Persians

practice. We might observe that the deliberate murder of captives at the outset of a great battle that would send a great many men to their deaths is no huge surprise. What galvanizes debate is the idea that people thought such a thing could be pleasing to the gods. But why should the gods be so fastidious or so kind? A deep embarrassment leaves the subject undiscussed by ancients.

But when Julius Caesar tells us that the Celts of Gaul engaged in widespread human sacrifice, he likely knew it and meant it. The Roman disdain for such practice had its own limits, as when at least the possibility was acknowledged in a story of the killing of a vestal virgin by live burial in punishment for sexual transgression or the rare killing by such burial of enemy prisoners. It was only, the ancient sources tell us, in 97 BCE that the practice was formally banned.[14]

For cold-blooded killing in the name of the gods, there's nothing quite like what went on in a spooky place called Aricia and the story is worth dwelling on from its origins to its disappearance.[15] Aricia sits about a dozen miles south from Rome along the most ancient of highways, the Appian Way, just where the road passed between the Pomptine marshes (drained since in stages from Augustus to Mussolini) and an extinct volcanic crater on the inland side. A small lake fills the bottom of the crater. On the west side lies the town, on the northeast, down in the crater, the shrine to Diana. The lake was clear and deep—probably a hundred feet, so the water was cool and fresh and animals would come there regularly, and thus also hunters, from long before Roman times.

There was a king there, well into historic times, but not a very happy sort of king. The *rex nemorensis,* king of the grove, lived among the trees around the sanctuary, not a glorious monarch, but a lurking wild man. At regular ritual intervals, he was challenged by a runaway slave, who fought him to the death, killing the king. Orestes was said to have fled here with the bones of his sister Electra after

their revenge for the killing of Agamemnon. Electra's bones lay here until Augustus had them brought to Rome and placed in an urn that stood in front of the temple of Saturn. The king of the grove, on that reading, was somehow Orestes himself, but of course far more likely the bones were just the remains of some earlier kinglet and a local ritual whose origins no one understood had gotten rewritten into a grander Greco-Roman story.

The site is very old, where people came together for rituals of alliance as far back as c. 500 BCE, about the time the Roman community itself was coming together. It was drawn under Roman sway and its residents given citizenship in 338 and by 300 BCE they erected a monumental building there with a golden roof, when nothing like that had been seen yet at Rome. People left small figurines made out of terra-cotta as offerings from prayers for health, and richer people would give bronze figures of Diana, mirrors (always a luxury item), or other instruments for ritual.

By the last years of the Republic, crowds flocked to the rituals and the terrace built at the center of the site was a square something like 200 meters on a side. The "grove" was no longer a piece of surviving wilderness but a carefully cultivated stand of trees, something closer to theme park than forest primeval.

With the rise of the principate, the site saw more building and development. Augustus's first successor, Tiberius, seems to have sought support from this god for ensuring a smooth succession. It was a bustling place, its open terrace crowded with statues and shrines and gifts from donors over the years. There was a small theater used in the rituals that we know was rebuilt sometime in the hundred years after Augustus.

The end of the cult came on gradually after a landslide damaged the property around 200 CE. We don't know when the last "king" disappeared. A writer of the late fourth century says that the king had left for Sparta, of all places, but we cannot yet dig behind that

to know better the course of events. In this, as in many places, the end must have come by gradual steps when money was short, crowds thinned, and enthusiasm for keeping up the site faded. We don't have to imagine a religious choice *not* to worship Diana here. At most, people had other places to go for their religious needs, and the choice not to go to Aricia would be a choice not to go someplace where not much was happening anymore.

There were caves on the shore of the lake at Aricia. Eventually hermits came to live there and there are Christian burials from late antiquity in them. When things were quiet there, Servius, the great ancient scholar of Vergil's poetry from the late fourth century, made this site the location of the "golden bough" that preoccupied the first modern anthropologists. Vergil's book six describes the tree in the dark wood with a branch of gold, so Servius links that to Aricia and to the story of Orestes turning up there showing reverence to Diana. Servius's version runs thus: "In her precinct, after the sacrificial ritual was changed, there was a certain tree, from which it was not permitted to break off a branch. The right was given to any fugitive who contrived to remove a branch thence to contend in single combat with the fugitive priest of the temple, for the priest there was also a fugitive, in commemoration of the original flight."[16]

So what happened to blood sacrifice? Ubiquitous, unfazed by philosophical critics, deeply rooted in specific local histories, it had a very long life. What could bring that life to an end?

The old story of "paganism" had a clear narrative here, going back a long way in Christian usage. Sacrifice continued, blood flowed, smoke rose. A few pagan intellectuals like the philosopher Porphyry knew better but had not the courage of their convictions, so it took the intervention of Christian conversion, reinforced benignly or otherwise, by Christian emperors, to make change happen. Despite

imperial interventions through the fourth century, it was only finally with the decisive intervention of Theodosius in the year 391, with a law banning sacrifice, that the end finally came. We'll see in a few chapters how far all this is from the truth.

My last few stories emphasize that "sacrifice" was many things, not just the formal public offerings of magistrates like the *ludi saecu-lares*. Change in ritual and practice was constant, for all that every act of sacrifice was thought to be ancient and traditional.

Recall then the criticisms of sacrifice I quoted from early dates and be wary of them. We *know* that sacrifice ended, so we go looking for such snippets and let them distract us. They seem to offer positive evidence for active opposition to a doomed practice and thus some kind of explanation. There were theorizers of sacrifice throughout antiquity, regularly failing to find a good reason for doing what had anciently been done. Such voices swelled gradually, while other factors came into play. Real life is complicated.[17]

Public animal sacrifice was messy and expensive and best carried out in stable communities where the wealthiest and most influential people could sponsor and supervise the rituals. Bringing sacrifice with you as you moved was hugely expensive, a privilege for the rich who could endow a temple of their favorite god and people its rituals, as happened during Jupiter Dolichenus's heyday. Social mobility in the Roman world never achieved modern proportions, but in the middle and upper reaches of society it became more common. Most such people had to trust, as had the Jews in diaspora, that someone back home was taking care of the sacrificial business they had grown up with. Given that various unbloody substitutes for animal sacrifice were available, as modest as placing tiny votive objects before rough-carved images of a god, attachment to the flamboyance of the smoking altars slipped and faded as well.

Those unbloody substitutes, moreover, had been real life for most people for most of Greek and Roman history. The formal public reli-

gion of city-state, the kind of thing that got animals slaughtered in abundance, was of little personal concern to individuals of the lower classes—that is to say, 98 percent of the population. For them, religious adequacy had always been found in rites more private, less ostentatious, and less expensive. For sheer quantity of religious artifacts surviving to be found by archaeologists, modest tokens of individual and household worship vastly outnumber the remains of urban and imperial grandeur. The persistence of ancient religiosity, we will see, was through the unostentatious acts of the many.

Then an important contributing development. More and more as time passed, people paid attention to philosophers who would argue that right doctrine and right conduct were more important that religious observance per se. The *practice* of right thinking and right conduct, described by recent scholars with the provocative label "spiritual exercises," could include rite and ritual, but as an expression of what was essential, not as something essential itself.[18]

Even as people argued increasingly that getting the teaching right was essential to getting right with the divine, this more holistic approach was being pressed. Philosophers and preachers of different stripes could agree on this point even when they disagreed on all else. Augustine in the late fourth century CE wrote a groundbreaking book called *True Religion (de vera religione)*. To a modern reader, the choice of topic seems obvious, but to an ancient the juncture of the two words was a striking anomaly. It was novel to think that the things that a religious authority said had to be true, in a way philosophers could approve, and therefore that one had not only to hear them and be pleased by them but also *believe* them and draw conclusions for action from what they said. The old ways of sacrifice were gradually ceasing to be relevant to such people.

If we look to what went on in the ancient Mediterranean world over the several centuries after Augustus, sacrificial ritual was everywhere practiced but almost nowhere reinforced or strengthened.

Many ordinary people had long found that their interests were personally best served by a milder ritual. These rituals often took the form of a common meal, often taken at a place where family members were buried. Modest offerings of food to the divine protectors in such settings were commonplace and one could even say sensible, symbolic of a respect to hidden powers rather than in any sense a formal feeding. They could leave cookies out for Santa Claus without expecting Santa Claus to eat them.[19]

There were wise men on all sides of the conversation. Lucian in the second century was a performer and his satirical writings were easy to approach, but serious philosophers had their reservations as well. The highly influential Porphyry, disciple, biographer, and editor of the great Platonic sage Plotinus in the third century, wrote forcefully on behalf of abstinence from animal flesh—which meant *a fortiori* abstinence from sacrifice. He himself thought that some traditional cult came from demons not gods—though he attacked Christianity, he agreed with Christians in this—and his account of Plotinus had the sage decline an invitation to attend sacrifice with the rejoinder, "The gods ought to come to me, not I to them."[20] Porphyry had a contemporary argument to make, but his language and content were still influenced by Theophrastus from long before. He fell in with other fastidious practitioners from a variety of traditions who held that the best sacrifice was the most delicate and symbolic—a grain of incense burned for the god was held by many to be more than adequate.

Similarly in the third century, Philostratus, biographer of the sage Apollonius, had his hero staying away from sacrifice and making his own peace with the gods otherwise. He is credited with writing a book *On Sacrifices* that criticized cities that were hotbeds of sacrifice. *That* view relies on the reasonable belief that there were variations from place to place already. Variety only increased as new forms of worship short of bloody sacrifice were introduced.

By the late third century, disdain emerged in odd places. Didyma was a great and ancient religious site not far from flourishing Miletus on the Aegean coast of Asia Minor. There were oracles there from before the time there were Greeks there, but by the third century CE, there was no question it was Apollo who spoke: "What concern have I with bountiful hecatombs of cattle and statues of rich gold and images worked in bronze and silver? The immortal gods have no need . . . "[21] This god preferred to hear his faithful singing hymns.

Disaster reinforced this growing disdain. Alexander Severus, the last of the dynasty that had patronized Jupiter Dolichenus, was killed in 235 CE. For the next fifty years, the Roman world knew calamity on calamity.[22] The politics, diplomacy, and warfare of this period are all important for the future. In the middle of it, the first of only two real attempts to attack Christianity and check its growth and spread took place, but that was not the most important event in the religious history of the third century.

The crisis of empire and government ended when Roman government and wealth were at last concentrated in imperial hands and local wealth and power began to fade. Under the emperor Diocletian, who took power in 284 and succeeded in stabilizing the world after fifty years of turmoil, the size of the imperial military and civil service grew enormously, while taxes were imposed to support them. In many cities of the Roman world, the old wealth was no longer there and the power of the old aristocracy was sharply checked by the new imperial authoritarianism.[23] Given what we have seen about the lack of enthusiasm for the old, expensive sacrificial ways, it is at least no surprise that when and where old rituals had ceased to be practiced, because of disruption, distress, or lack of money, there was little impulse to bring them back. The best modern historian of late antique Athens thinks that the sack of that city traditionally dated to 267 CE and assigned to a roving band of attackers called Heruls gave the city a blow from which it never recovered.[24] Leaving aside

the melodrama of barbarian brutality, the fact of the fading of Athens, like that of Rome three centuries later when Roman forces gutted the city in order to make it part of the Roman Empire again, seems unavoidable. Altars, in such a moment, were destroyed or—almost as damaging—merely neglected.

Changing tastes, changing fashions, changing social structures: it would have taken a lot to keep the altar fires burning.

Chapter 6

WAYS OF KNOWING

Livy ends the first five books of his history, the ones that start with Romulus and Remus, with the near destruction of Rome by the Gauls in 390 BCE and the Roman escape under the leadership of Marcus Camillus, venerated as the second founder of Rome. Livy gives Camillus a fine long speech to say, in which he proudly claims that "Our city was founded with auspices and augury. There is no place in it that is not full of gods and cult."[1]

Augury was the science of bird-watching. Birds of the sky were closer to the gods, and the beauty and liberty of their flight reflected the thoughts and intentions of the gods on high themselves. A complex body of lore had built up to help magistrates read the skies, to determine whether a course of action already selected would meet with divine favor. Good signs meant approval, bad ones called for a change of plans. The lore and technique are all but lost to moderns and the process seems merely preposterous. Showing that the gods approved of what the magistrates and generals were doing made everyone—leaders and citizens—feel better about what was going on. With voting irrelevant and with no opinion polls beyond the

voice of a mob, a structured, solemn, ceremonial way of seeking and displaying divine favor was a mainstay of leadership.

With time, change. It was hard not to become cynical over time about the workings of this process. So arbitrary and subjective were the criteria of reading the sky that it became commonplace in the late days of the Roman Republic to say and think that anyone could see whatever he wanted, if only he would look. To declare that a magistrate was "watching the sky" was to declare an intention to obstruct another magistrate's course of action. Time after time in the late Republic, the declaration that one of the authorized magistrates was watching the sky was immediately taken as an effective veto on whatever course of action had been proposed. Surely he would find what he sought. If the distributed rule of magistrates had not ended with the authoritarianism of Augustus, augury would have had to be dispensed with, for it was only an obstacle and was rapidly losing its credibility. It survived as a showpiece ritual from which no one expected to learn anything.

Haruspicy, the reading of guts, was like and unlike reading the sky. Both depended on the idea that divine will manifested itself at a human scale in the diverse appearance and behavior of animals. As with augury, lack of sympathy and our lack of detailed information make the ritual seem fundamentally crazy. Groping around in the inner organs of a slaughtered animal to determine whether there are anomalies or misformations is a laughable way for a grown man to act, much less to think that he finds there a message from the gods. Worse, some of the reported anomalies they found are not merely anomalous but impossible: like the cases where an animal was said to have no heart.

Reading the guts had limited impact in an important way. The practice depended on sacrifice and was mainly interpreted in the context of the ritual. In ordinary cases, a bad reading required that the sacrifice be repeated until the gods showed they were satisfied.

Repeated failure would be bad news—but if the setting were ordinary, the result would only be anxiety. When sacrifices were being offered as part of some larger enterprise, like the ritual of new consuls or preparation for a military campaign, the impact of bad readings might be greater. Great enterprises would rarely be derailed this way, but the reassurance normally sought *and received* this way could be missed and the anxiety of missing it could be real. Gut-reading required a special skill; sky-watching was a task even the powerful could undertake. So sky-watching was corrupted, while the credibility of gut-reading persisted as long as the rituals of sacrifice did.

Both birds and guts went gradually away as markers of the future. The idea of sympathetic magic that underlay both—that is, that divine will and the material realities of the animal kingdom were in deep harmony—faded but did not disappear with time, not out of skepticism or disbelief so much as because competitors with stronger claims prevailed. Oracles and stars are no more likely to tell us true than a cow's liver, but their use was accepted as a sign of greater cultural sophistication.

That gods would speak through animals was one idea, but that they would speak through human beings was far easier to accept—and easier to manage. In simplest form, this meant going to the divine place to hear an inspired priest or priestess recite words from the god in response to a question. The imperfection of the medium was acknowledged by its form, for the messages usually came veiled in ambiguity and obscurity. We'll meet a general further on who went off to battle encouraged by oracular guidance, having been told his campaign would lead to the destruction of Rome's enemy, not expecting that it was he who would die. The message that takes interpretation and gets taken wrong the first time is common in oracle stories. The prophecy is always vindicated, for whatever reassurance that brought, and the human interpreter is always the source of error.

The speaking voice of the god through a human mouth was still a hard thing to find. A small number of places in the world (like Delphi in Greece or Hammon in Egypt—both locations a little out of the way) claimed and won the right to host a godly voice. Demand was much broader, and so we see then practices like those of the Sibylline oracles, the oracle frozen on a page. Books were written, notionally at some site of divine presence, then laid open to interpretation by local priests. The fifteen men in charge of rites at Rome could look at the Sibylline books and make up the answers to their own questions as they went along. As we saw, when the books were destroyed, it turned out they could be very easily replaced. What mattered more than where and how they got to be worthy of belief was that they were books people believed in. Keeping the book secured away in a temple and open only to the priesthood was a way of controlling the divine voice. With a sense of poignancy over time, many observed that the old oracles were fading away and speaking less than they used to, but at the same time, oracles had "gone public." Oracle texts came into wide circulation, texts the private user could employ to make his own estimate of the future. Those texts were often consciously written to advance specific ideological, political, or religious views, but for the most part that obtrusiveness of a very human voice was opaque to the readers. They *wanted* to hear the divine voice and could be easily persuaded that they did. Even the Sibyls, it turned out, found new voice in this way![2] The routinization of charisma, as the sociologist rightly says.

The desire to know the future was universal, and so universal means of hinting at it were developed. The stars above are beautiful and impressive. Night after night, they appear to orbit the earth in an entirely predictable fashion. The movement of the great and lesser bears in their dance around the North Pole is imperceptibly different from one lifetime to the next, and so the figures people thought they saw made the sky a landscape of stories and images. A Ptolemaic sky

had its oddities, so there were also the wandering stars (*planetes* is the Greek word for "wanderer") and sun and moon besides, more cyclically regular in their apparent movements but still, already in ancient times, predictable. Babylonian astronomy already saw a connection between the patterns above and the workings of the material and human worlds.

The campaigns of Alexander the Great in the east brought cultural borrowings on many levels. The city named after him in Egypt, Alexandria, was the first place to see the rise of the astrological horoscope—that is, a text that analyzed in detail and with accuracy the meaning of the position of birth stars for the life of an individual. By Claudius Ptolemy's time (in the age of Hadrian in the first century), the system of mathematically accurate astronomy as it related to human lives was essentially developed to its fullest extent. What charlatans now promote as astrology would be entirely recognizable to Ptolemy as astronomy.

That argument went roughly this way. We live in a messy, mutable, fragile world, the world of matter, life, and inevitable death. The messiness and vulnerabilities of that world ended, on clear astronomical observation, at the orbit of the moon. John Donne's "sublunary lovers" are thus lovers in this world of matter below the moon's orbit, not the ethereal world above. The world of the stars above, by contrast, was perfect, immutable. In this view, widely held among the learned, the spirits of the dead rose up from their bodies and fled beyond the moon to the world of gods and immortality. Astronomy/ astrology, undifferentiated at the time, was the science of that world of rationality, a subject to be studied precisely because it led the mind beyond dull earthly matter to the higher realm of order and spirit. The ancient "liberal arts" were laid out in a sequence meant to take the mind from confusion to order in the world of words (grammar, then rhetoric, then logic) and in the world of numbers (arithmetic, geometry, then musical harmony), and then in the order of the stars

and spheres. You pursued those arts in order to prepare yourself for contemplation of the divine order of the world.[3]

Astrology was then not just science—it was the very best and highest science. Within the lifetime of people who attended Augustus's games of the century, astrology became the fashion among Roman elites. Emperors mistrusted it, not because they thought it was false, but because they worried it was likely true, and therefore a tool that private individuals could use to learn threatening things about the lives and prospects of rulers. The "open-source" data of astronomical handbooks made them more threatening than the classified information in earlier sources like the Sibylline books. The *most* nervous religious prohibitions of the pre-Christian era were those against practices that could threaten an emperor, such as night sacrifice, magic, and astrology.

All these modes of knowing had their live and vivid critics in antiquity itself. Take Mosollamus, the Jewish soldier under the earliest Ptolemaic kings of Egypt recounted in Josephus's *Against Apion*. The Jewish scholar, who witnessed the sack of Jerusalem, is quoting a tale supposedly told by Hecateus three hundred years before him.[4] An army on the march comes upon an augur watching a bird sitting in a tree and commanding them therefore to halt. When asked why, he reports that the bird's movements must determine theirs. As long as the bird stays where it is, they must stay where they are. If it flies on ahead, they are to march ahead; but if it takes off and flies in another direction, even back along their line of march, then that is the direction in which they must go. The generals, as the story goes, are cowed into silent observation and prospective obedience. Mosollamus is impatient, so he takes out his bow, aims, shoots, and kills the bird on the spot. As it falls dead, he turns to his colleagues and says essentially, "If that fool bird was smart enough to know the future, why didn't he foresee *that*?"

That's a great joke, worthy of the Catskills in their glory, and

it was told well into the lifetimes of people who had met Jesus. It means less than it appears to, however. I could take it as proof that the smartest of the ancients were not taken in by augury. That Josephus attributes the story—genuinely or not—to an author who lived a generation after Alexander could be taken as evidence that their skepticism had a long history. But belief persisted.

Below, behind, beneath, and around all the other religious practices of the ancient world lay the often hidden domain of magic. No respectable person ever speaks well of magic, though a good many respectable and many less-than-respectable ones practiced it.[5] Serious contemporary writers made light of it. Pliny the Elder and Plutarch wrote about the motives of those selling magic curses and cures with disdain and suspicion. Apuleius wrote his novel *The Golden Ass* about a man who toys with magic, is badly bitten by his curiosity when he turns into a donkey, and then is rescued by the great goddess Isis. At the same time, Apuleius was himself accused of magic for having persuaded a rich elderly widow to marry him—so old at age forty that surely only magic could have won her to this younger man. It was a serious charge, but his surviving *Apology* manages the defense with wit, mockery, and misdirection. We're left with the strong suspicion that he'd been up to *something*. Archaeologists meanwhile find abundant evidence for the everyday use of charms, amulets, curse tablets, and the like, all employed to bend the world to the wishes of the practitioner.[6] Nothing in the sequence of events that brought an end to sacrifice, augury, haruspicy, and oracles seems to have disturbed these homely, reassuring, ineffective practices.

Chapter 7

THE SPECTER OF ATHEISM

A UGUSTUS GRANDLY REVIVED A THING THAT HAD BARELY BEEN invented in his own time: "old-time religion," rather like the nearly postmodern version of Christianity invented in nineteenth-century America and called "fundamentalism." Both offered fresh and tendentious packaging of carefully selected older beliefs and practices mixed with others as new as next week. What made it the *Roman* old-time religion was that the leaders of the new, improved, greatly expanded Roman Republic/Empire identified with it and propagated it under their authority. In all the welter of cults and practices and beliefs that in fact flourished in the lands where Roman armies prevailed, this old-time religion was a very modern sort of thing.

Did the Romans believe in their gods? The question needs a little more attention, for to "believe in god" is originally a Christian expression, having nothing to do with accepting the proposition that a divine being exists.[1] It takes divine existence for granted and emphasizes trust and confidence. A popular song lyric will say "I believe in you" not to mean "I have concluded through rational

argument and examination of the evidence that you exist," but rather something like "I admire and trust you to an extreme degree." It's a medieval development to debate endlessly whether the supreme being exists or not; and real "atheism" is a modern creation.[2]

To a Roman—to any citizen of the ancient Mediterranean world—the question of whether gods existed was either unvoiced or peripheral. The Platonic philosophers of later antiquity, like Plotinus and Porphyry in the third century, arguably had a higher opinion of "the divine" than did the enthusiasts of Augustus's *ludi saeculares* but were at the same time less fearful and less expectant of immediate intervention. They came to accept the idea that the gods people knew and dealt with were manifestations of things that lay beyond, while allowing that one need not take the stories *quite* seriously as stories. They didn't offer anything so vulgar as disbelief, but the divine existence had become something quite new—and recognizable to moderns. The most sophisticated form of such an argument would hold that the many manifestations of divinity corresponded to the interests, abilities, experiences, tastes, concerns, and cultures of individual people, but that some underlying power or small group of powers in the universe were behind such behaviors.

So even the intellectuals of late antiquity were believers. The only people who didn't, as a rule, honor and respect gods were the Christians.

Where gods were taken for granted, where many gods and many temples and many stories and many communities of interpretation coexisted, benevolent lazy indifference was the rule. I went my way, you yours. What you did might intrigue or attract me, or leave me uninterested and aloof. When I traveled, I would visit temples on my way, curiously and respectfully, careful not to *offend* any powers that lurked there, even sometimes pausing to curry favor. I wouldn't often meet a god I liked and try to take him or her home with me, unless I fell deathly ill or was a wealthy general who felt blessed by

a god's favor and built grateful temples to him wherever I went. The religious sites of antiquity are notable for tourists carving their "Kilroy was here" inscriptions in likely places around shrines. Placid, accepting curiosity was the norm.

To such people, all of whom quite plausibly thought of themselves as reasonable and devout, a community that took the trouble not merely to disbelieve in, but to deny and deplore the religious behavior of others was bound to be provocative. That community's claim to have a single god of unique power was self-evidently laughable—who could that god be, how old, how venerable, how powerful? Where has he been all this time? If there are many gods, people who claim to believe in exactly one god, a god few had heard of, a newcomer, a god without temples and signs of power—are, functionally speaking, atheists.[3]

The late-second-century philosopher Celsus paid Christianity the tribute of polemic, which offers the modern reader a valuable look at traditionalist views as well as an unsettling view of Christianity. He wrote close to the years 176–77, when Marcus Aurelius issued general dictates against extravagance and innovation in religion. Celsus knew Christianity and its tenets well, but he also seemed to know about Judaism and enough about Egypt to suggest that he'd spent time there. Celsus called his book *The True Word*, a title that hints at his intent to refute the Gospel of John, which claimed Christ was *the* Word. We don't have the book itself, but seventy years later, *The True Word* provided the immensely learned Christian exegete and theologian Origen the material for a large work called *Against Celsus* that quotes Celsus at length and in detail. If we tune out Origen, we can hear Celsus's second-century picture of a religion he thought would never amount to much.

Celsus's voice is clear and calm: "If you shut your eyes to the world of sense and look up with the mind, if you turn away from the flesh and raise the eyes of the soul, only so will you see god. And

if you look for some one to lead you along this path, you must flee from the deceivers and sorcerers who court phantoms."[4] These are words that many Christian theologians could well write. But then Celsus rejects the Christian claim that to worship many gods is to serve many masters: "This," he goes on to say, "is a rebellious utterance of people who wall themselves off and break away from the rest of mankind."

Christianity for him had the worrying marks of a secret society, barbarian (he means "Jewish") in origin. They kept apart from rituals others took for granted and kept the doors closed for their own rites—leading to the comical suspicions Tertullian reported. Their secrecy seemed to him a mark of cowardice, unlike the bravery of Socrates accepting the death penalty for his irreligion. It has no teaching that is new or impressive. For what Christians claim, he can always find precedents—as when Heraclitus centuries earlier clearly knew that idols are not themselves gods.[5] After all, "If these idols are nothing, why is it terrible to take part in the high festival? And if they are demons of some sort, obviously these too belong to God, and we ought to believe them and sacrifice to them according to the laws, and pray to them that they may be kindly disposed" (8.24).

They have their demons and their magic chants, these Christians—an argument exactly mirroring the Christian claim that the pagan gods were themselves demons! They remind him of other cultists he sniffs at: the begging priests of Cybele, the worshippers of Mithras, or the ones who claim to have visions of Hecate in their rituals. They got their doctrine from Moses, a magician who himself stole his doctrine from other nations. (This reversed a Christian claim that Moses was the source and other philosophers the beneficiaries, as when Plato was supposed to have visited Egypt and there met the prophet Jeremiah and learned from him.) Moses's successors fabricated a story of virgin birth out of the misfortunes of a poor country woman who earned her living by spinning. She was chased out of

her house by her husband when she proved to be pregnant as a result of adultery. The boy who was born this way spent time in Egypt, training as a carpenter but learning some magic tricks from the local wizards.

Celsus's primary grievance is not with the Christian religion, however. He just can't stand Christians.

Marketplace know-it-alls, that's what they are (3.50), never to be found in the company of truly intelligent men but always falling in with adolescent louts and slaves and fools (3.50). Their natural associates are wool workers, cobblers, laundry workers, and the most illiterate and rustic yokels who come and whisper their enticements to schoolchildren and silly women, all the better to overthrow the authority of fathers and schoolmasters (3.55). Did not the Christians' own Paul say (1 Cor. 1.18ff) that "wisdom" means nothing to these people? They are like a cloud of bats or ants swarming out of a nest or frogs croaking sagely in their marsh. Like worms crawling about a filthy corner, they quarrel with each other about just who is the worst sinner—taking pride if they *are* the worst (4.23)! For them, his favorites, their god forgets about the sun, the moon, and the stars, and the whole world, and just keeps sending them special messengers to show his favor. They can barely get along with one another. So perverse are they, Celsus says, that "if all men wanted to be Christians, the Christians would no longer want them" (3.9).

Jesus is a second-rater for Celsus, a colleague of riffraff, a perpetrator of truly second-rate miracles, skulking about in shadows to avoid punishment, unable to inspire in his followers even the loyalty of a robber band, wallowing in pain and self-pity in Gethsemane, and surely never behaving like a god (1.62, 1.68, 2.9, 2.12, 2.24). "What fine action did Jesus do like a god? Did he despise men's opposition and laugh and mock at the disaster that befell him?" (2.33). "Why, if not before, does he not at any rate now show forth something divine, and deliver himself from this shame, and take his revenge on those

who insult both him and his Father?'" (2.35). The crucifixion was just the moment when you would expect some glorious manifestation of divine power, but there was none. Real gods are not to be messed with: "You pour abuse on the images of these gods and ridicule them, although if you did that to Dionysus himself or to Heracles in person, perhaps you would not escape lightly. The men who tortured and punished your God in person suffered nothing for doing it, not even afterwards as long as they lived" (8.41). Resurrection? There have been plenty of people rising from the dead, like Zalmoxis, the slave of Pythagoras among the Scythians. What about Rhampsinitus in Egypt, who went down to Hades and played dice with the queen of the underworld, returning with the gift of a golden napkin from her?[6] Orpheus and Protesilaus and Hercules and Theseus: Why should anyone take Jesus and his pallid story seriously?

Zalmoxis, of course, was a god for barbarians, admired by the Getae, as was Mopsus among the Cilicians, Amphilochus among the Acarnanians, Amphiaraus among the Thebans, and Trophonius with the Lebadians. According to Celsus, these are the gods Jesus resembles. Celsus even carries over a sneer of a different kind, comparing Jesus to Antinous, the beautiful young man with whom the great emperor Hadrian had fallen in love. After Antinous took his own life, Hadrian had him treated as a god, to the disdain of the Roman upper classes (3.34–36). Surely there were nobler examples of godly men, like Heracles, Asclepius, and Orpheus, or even more admirable philosophers, like Epictetus. Even the Sibyl has more to be said for her than Jesus does—no, even the Jews' own Jonah and Daniel (7.53)!

Try reading this passage as though you knew little or nothing about Christians but were well disposed to hear what a wise philosopher had to say about them: "Reason demands one of two alternatives. If they refuse to worship in the proper way the lords in charge of the following activities, then they ought neither to come to marriageable age, nor to marry a wife, nor to beget children, nor to do

anything else in life. They should depart from this world leaving no descendants at all behind them, so that such a race would entirely cease to exist on earth. If they are going to marry wives, and beget children, and taste of the fruits, and partake of the joys of this life, and endure the appointed evils (by nature's law all men must have experience of evils; evil is necessary and has nowhere else to exist), then they ought to render the due honours to the beings who have been entrusted with these things. And they ought to offer the due rites of worship in this life until they are set free from their bonds, lest they even appear ungrateful to them" (8.55).

Origen had plenty to say in response to Celsus, but we'll visit more gods instead.

Chapter 8

GODS AT HOME

APOLLO WAS A RELATIVELY YOUNG GOD IN THE PANTHEON AND had many homes. In the *Iliad* he was still an enemy of the Greeks, and there is reason to think that his worship dates to a time not long before written records, to approximately 1000 BCE. In the *Iliad* he is a god of plague and healing, but by the fifth century BCE he had picked up his role as de facto god of the sun. Because he is just "prehistoric" enough for us not to be able to see him emerge, we can easily take him for granted. Augustus promoted him with a privileged home and a starring role on the Palatine and in the *ludi saeculares*. Well before that the Greek island of Delos, meeting place of merchants, had been a special place of his. No religious site of the ancient world, however, was more remarkable than Delphi.

Delphi is just out of the way enough to be mysterious, just close enough to other major Greek sites to be accessible and important. A little more than one hundred miles from Athens and Corinth, rather farther from Sparta, it sat in a valley on the southwestern side of Mount Parnassus (where the muses were supposed to live), commanding a dramatic site. To get there, one traveled about ten miles up

a narrow valley from the Saronic Gulf, ascending to plateaus and terraces. The last couple of miles of the winding path ascended steeply, giving pilgrims a sense of accomplishment and some lovely views back toward the water.

The site came into religious use as recently as 750 BCE with an annual festival of the god's arrival early in the year, when rushing freshets of water in the Castalian spring signified his presence. The pilgrimage to this site became so popular that three resident priestesses—called Pythias—were needed to handle the duties. A Pythian priestess, selected as a young woman and dedicated to the god for life, took the lead role in the famous ritual of oracular proclamation.[1] On an appointed day she dressed as a maiden, bathed in the spring, sacrificed a goat, and made her way into the inner sanctum of the temple. There the burning of laurel and barley was meant to purify the air. Making her way to the back of the shrine, she took up what had to be a ludicrously uncomfortable position sitting atop the lid of a great cauldron, where vapors collected—from volcanic fumes? She shook a fresh branch from a bay tree, in this ritual of powerful smells, and worked herself into a trance. Once entranced, she, as the Delphic oracle, spoke clearly enough for the priests to understand—or say they did—and write down what she said in Homeric hexameters.

From its very early days, visitors came from afar to seek wisdom from this oracle. Delphi's political power and influence sagged when the oracle predicted defeat in the Greco-Persian wars and recommended surrender. Marginalizing its public function made seemingly no difference to the site's popularity, however, and we hear for many centuries of people taking long journeys to hear what the oracle might say. By Roman times, it was a tourist destination of enduring prestige.

Pausanias, who wrote his guide to the Greek world in the middle of the second century CE, offers us a vivid sense of what it was like

when the wealth of the ancient world was at an apogee.[2] The place was a gaudy mess.

According to Pausanius, the first thing you saw was the Phokikon, where the Phocians, natives of Delphi's region, had built themselves a prominent meeting hall featuring a statue of Zeus, enthroned, and flanked by Athena and Hera. Farther along the road, the tourist was obligingly shown the spot where Oedipus had murdered his father. (So too in the fourth century CE, Christian visitors to Sinai were shown the exact place, conveniently nearby, where Moses had encountered the burning bush.)

Pausanias tells us that the oracle had gotten there first, belonging to the earth goddess, Gaia, and the nymph Daphnis lived on the mountain and served the goddess with prophecy. Other gods may have lived there, but it was an earthquake that opened the chasm in the earth to give the place its distinctive atmosphere and make it a suitable site for the temple of Apollo. Was it maybe, he wondered pragmatically, some shepherds who came there, fell under the spell of Apollo's vapors, and began to tell of their visions? He doesn't entirely care, but he knows the first priestess to sing the hexameters was called Phemonoe. (He's a tour guide, not a historian.)

What we know from other sources (notably Herodotus) is that the classic temple was built around 530 BCE by exiled tyrants from Athens, with funds collected from the league of cities who maintained the site and got privileged prophecy in return. Subsequently, it had its disasters in the fourth and third and first centuries BCE. In Pausanias's time, Nero was remembered as the last great donor to have reshaped the space, even as it filled with clutter, enough that Nero could have his forces steal five hundred bronze images of gods and men. From the sixth century BCE, the Pythian games at Delphi were funded by the league and the usual assortment of contests and races and musical performances was laid on. The league long outlasted its political origin; in Pausanias's time, there were thirty sup-

porting communities, from as far away as Macedonia and Thessaly.

Temples, including ruined temples, struck the eye first, and then a larger temple devoted to Foresight—the goddess of providence. Given by the city of Marseilles—a colony whose first settlers came from this region—that temple had a large statue of Athena outside, a smaller one within, and a story of a golden shield once placed there by Athena but stolen later. The oracle was centerpiece to a throng of these places for sacrifice, and the air around was doubtless often heavy with smoke and odors.

The precinct of Apollo himself was at the very top, and guides had not enough patience to describe every treasury and shrine, whether given from Thebes, Athens, Corinth, or by various Roman visitors. As you went into Apollo's enclosure, you saw a bronze bull sent by Corfu, with a story of its own about sacrificing a bull to restore good fishing on the island there.

If the traveler's attention had wandered by then, he would be jolted awake by the story of the seven wise men whose names and words were recorded there, including the two most famous Greek maxims of the good life, both already here, supposedly, in the sixth century BCE: "Know Thyself" and "Nothing in Excess." Both are mottoes trite enough for a schoolmaster to drum into his students, meaty enough to distract a philosopher.

After Delphi, the valley of the Nile, not surprisingly, was the most popular place with religious tourists. They flocked to the giant talking statues of Memnon for two hundred years until restoration activities around the year 200 CE seem to have stifled the crash or cry or twang often heard shortly after dawn. Until then, men made oracles of what they thought they heard.

The old Egyptian goddess Isis proved immensely popular beyond Egypt, and the story of her transmogrification goes hand in hand with the historically known, datable, and preposterous creation of her sidekick Serapis. Our best source for the baldfaced cooking up of a

major god is the account we get from the historian Tacitus, supplemented by his near contemporary, Plutarch.[3]

It happened in the days of an early king Ptolemy—which one is not clear. Alexandria was newfounded and needed temples and gods. A divine young man appeared to the king in a dream and told him to send faithful men to find and bring his image from the lands of the Black Sea. Awakening, the king called his priests and told them the story, being sure to interrogate Timothy of Athens, who had been brought from Athens to establish and supervise the Eleusinian rites in Egypt and so now was asked what to make of this claim of divinity from the Black Sea.

You can see where this is going. Emissaries will be sent, they will find a temple, they will negotiate with the locals (for three years in this case), they will bring back an image, and the king will be happy. Did the image of the god not climb spontaneously and miraculously into the ship sent for him, and did the trip from the Black Sea back to Alexandria not take a miraculously swift three days?

With that scanty fig leaf of legend, a great new god was given his backstory. The legends authorized a fact: that under the earliest Ptolemies, a great shrine was erected in Alexandria in honor of this factitious and entirely new god Serapis, the famous Serapeum that would fall only centuries later when imperial law condemned old religions in the late fourth century CE. For all that the god was a cooked-up divinity, this was a mighty place. The temple itself was in the middle of a huge complex of buildings occupied by temple personnel, hangers-on, and people seeking cures who stayed near the god to spend the night in hopes of divinely inspired dreams. The giant statue of the seated god was praised for its precious materials (golden scepter, silver clothes, and shoes) and its gleaming colors—even the hostile Christian accounts go on and on about the wonders of the place. Was the great library of Alexandria there as well?[4]

Tanit, the presiding goddess of Carthage during its long war

with Rome, got a name change and went on as before. When Rome finally prevailed and the city was destroyed, the goddess was made the object of the special ritual of "evocation," where a Roman general summoned the god of a city under attack to abandon that city and take a better deal, as it were, with the Romans. When the goddess changed sides, as Tanit reportedly did, then Roman conquest was nearly inevitable—which offered one explanation for the final defeat of Carthage in 146 BCE.[5]

Tanit now became Caelestis, "the heavenly one," and went right on being worshipped in Carthage. (Worship of Tanit originated in the Carthaginian homeland of Phoenicia and was tied up there with the cult paid to goddesses known under the name Astarte.) Caelestis's temple had a long and powerful history in Carthage. In the 370s and 380s, the young scholar Augustine from African Tagaste a hundred fifty miles inland, already associating with Christians but with an eye for all religions, was deeply impressed with the richness and tenacity of her liturgy. In his *City of God,* written twenty-five years after her rites were formally banned, he still had to debunk her. His account of her rites emphasizes the spectacle and notably lacks account of blood sacrifice.

> When I was young, I used to go to the sacrilegious shows and games and watched the deranged worshipers and the dancing choristers and really enjoyed the filthy shows performed for the delight of gods and goddesses, especially the virgin Caelestis and mother Berecynthia. On the day devoted to her ritual bathing, they performed things so filthy with such disgusting actors that it wouldn't be right for the mother of the gods or the mother of any senator or indeed of any honorable man to hear them—or indeed for the mother even of any one of the actors. . . . I don't know where the people devoted to Caelestis ever got any instruction in chastity, but in front of her shrine,

where they set up her image, we all stood, swarming from everywhere, watching her shows, taking turns looking at the image of the virgin goddess and the parade of whores honoring her. They really knew what a virgin goddess liked![6]

Honorable women blushed to watch, or rather to be seen watching, and still stole sidelong glances at the unseemly proceedings. As a goddess in Roman Africa, Caelestis had retained some old traits (were her temples not most often at the foot of hills, rather than the top?) but acquired some new ones (e.g., more interest in rain than she had needed back on the Levantine shore of the Mediterranean). She was regularly compared to Juno, but we see Augustine and others reporting she was worshipped as a virgin, as Tanit had been. Romans living in Africa made her a sign of their Romanness and took her with them to other parts of the Roman world, though she remained, primarily, an African goddess.

Our last, and perhaps surprising, stop on this tour of "paganism" is Jerusalem.[7] Judaism's entanglement in the origins and history of Christianity is well known, but I'd like to try, here, to see Judaism with fresh eyes, as just another religious community in the Greco-Roman world.

From early in recorded history down to the reign of King Josiah in the seventh century BCE, the cult of the god called YHWH in the lands between the Dead Sea and the Mediterranean and between Galilee and the Negev was powerful but far from exclusive. There were other gods in the region and many, if not most, people paid attention to more than one. The insistence that YHWH be worshipped alone is quite early, but the real monocult emerges only slowly. In the seventh century BCE, three things mark this transition: King Josiah led a movement to encourage the exclusive worship of YHWH, the exodus story emerged to define a community of blood and heritage, and parts of the Torah come into something like their later shape—and with

them the insistence that sacrifice to YHWH should happen only in Jerusalem.

Within a few decades of Josiah's rule, the Babylonian captivity intervened. Jerusalem fell to a conquering power, but some who were deported to Babylon survived and even prospered there. The return of exiles and the beginning of "Second Temple" Judaism marked the beginning of a Judaism moderns might recognize, with insistence on the Sabbath, circumcision, dietary rules, and endogamy. The scribe Ezra, flourishing c. 460 BCE, is credited with establishing the scriptures in their standard form—that is, credited with having miraculously restored them. His time is also that of the first ethnic cleansing of the region and the attempt to create a monolithic Judaism.

This attempt was not entirely successful. After Alexander's conquests, Greek ways of living and thinking pervaded the world the Jews lived in. By the time of the Maccabees' revolt in the second century BCE, Jews had been assimilating with fair enthusiasm into Greek culture. Their revolt successfully staved off the more complete Hellenistic absorption seen elsewhere and effectively created an island of modest cultural distinctiveness at the geographic edge of the Hellenistic world.[8] (Judea was the last frontier of Hellenism, moving south from Asia Minor through Syria; beyond in one direction led to the Arabian desert, while in the other lay Sinai and beyond it the isolated culture of Egypt that Greece best approached by sea.) The immense reconstruction of the Jerusalem temple in the age of Augustus is an indication of that island's prosperity.

From this period we get the possibility of hyperobservant Judaism, embodying itself in the Pharisees for example, and the eventual rise of small sects—call them Essenes or call them Christians—of people with their own take on heritage and obligation. These movements have in common an awareness that the "old-time religion" of Jerusalem and its surrounding population had become different in a world where many Jews went abroad and the integration of Jeru-

salem itself into the Greek world had brought strangers and wealth even to Zion. The growth in numbers of Jews living abroad, especially in Alexandria,[9] while honoring and respecting the rulers and temple of Jerusalem, made this post-Maccabee Judaism unique in the Mediterranean world. The story ended badly with the destruction of Jerusalem in 70 CE, but that ruin was far from inevitable and came only after centuries of remarkable success on the part of those who would preserve Jewish identity and cult and culture while participating actively in the booming world of Hellenism.

So were the Jews "pagans"? When Christians constructed the category of "pagan," they designedly omitted the Jews from it because they were Christianity's forerunners and siblings, worshippers of the same god, so the terminologically correct answer is "no."

On the history I have outlined, however, the distinctive features of Judaism are few, their god and their practices are very similar to others of the region, and their *claim* to separatism and distinctiveness is very different from the one Christians would advance in centuries to come. In many ways they were little different from their neighbors. The emergence of Judaism as something genuinely unlike its ancient neighbors is a story played out in post-temple times and very much in a dance of adversity and imitation with Judaism's Christian and later Muslim siblings and cousins.[10]

Chapter 9

DIVINE EXALTATION

SOME HISTORICAL CHANGE IS INVISIBLE, OR NEARLY SO, ESCAP-
ing the kind of virtual tour we have been taking. One whis-
per spreading slowly, haltingly abroad from philosophical
seminars in the third century was remaking the entire universe—and
almost no one noticed.

In a world that put great stock in bodies and appearance, Plo-
tinus the philosopher seemed—according to the first line of his
biography—almost ashamed of having a body at all. He refused to
have any portrait made of him, and though he wrote extensively,
he took no care to have his writings published. Very possibly
Egyptian in origin, he certainly studied at the schools in Alexan-
dria there in the 230s. He joined an army campaign against Persia,
hoping to use the opportunity to go on to India to meet the sages
mentioned by ancient philosophers. All he got for his trouble was
an introduction to the brutality of ancient warfare. He arrived in
Rome around 240, where he taught for the rest of his life and died
in approximately 270.

Plotinus was a student of Plato about six hundred years after the master lived and died. Plato had other followers—few enough in Italy, more in Athens and Alexandria—but Plotinus was touched with a creative spark that made his work distinctive. He would have lived and died obscurely if his student Porphyry, an Athenian, drawn to Rome by Plotinus's reputation, had not taken things in hand. Porphyry was a far less creative figure than Plotinus, but he was fluent and persuasive and wrote books summarizing his master's teaching, taking up polemical issues in contemporary philosophy, and incidentally producing a scathing denunciation of Christianity that some think was partially responsible for the climate that led to persecution in 305.[1] It was Porphyry who put together the *Enneads,* Plotinus's surviving collection of essays, appending a biography, and thus made Plotinus's lasting reputation. Plotinus's version of Plato stands at a considerable distance from Socrates's homely wranglings with his contemporaries, but not so far from the later works of Plato, such as the *Timaeus.* Plotinus spins out a subtle, complex web of theory whose hallmark is its confident description of the structure of invisible reality. I won't try to summarize him in a paragraph or chapter given that others have done it already—and amazingly well, given the crabbed and complex style in which he places often forbiddingly abstract ideas.[2] He is what is nowadays called a neo-Platonist, but he and his friends would have said simply "Platonist." After Plato and Aristotle, he is the most important ancient western philosopher.

Plotinus spoke of divine forces in the universe both simpler and more vast than anything conceived before. Disentangling the emergence of these ideas and assigning each contributor his own part is a complicated business, bringing in anachronistic notions of "monotheism."[3] The revolution was not unlike the revolution in modern cosmology. Few people today can explain physicists' current theories

accurately, but their work has widened educated peoples' conception of the universe, nonetheless.

So too with philosophers' doctrines of divinity in Plotinus's time. To speak of a "god" in the time of Varro and Cicero meant one thing. Gods weren't all that big or—a few lightning bolts aside—all that powerful.[4] The philosophers' talk about them had none of the angst so vividly on display in Dostoevsky or so assiduously papered over in C. S. Lewis. By the time Plotinus died in 270, however, language about the divine had begun to make many assumptions familiar to us. Godliness had experienced a significant upgrade. It was now possible to imagine that there was only one source of divine power, even if manifested in the appearance and actions of many individual gods. This "modern" divine of Plotinus is increasingly spiritual, eternal, omnipotent, and omniscient. The deity portrayed in the writings of the Jews and early Christians had many excellences, but scarcely had all these qualities, any more than did Juno and Diana. If Christians of the third century and after had no trouble assuming that their god superexcelled all older notions of divinity (even if the assumption would eventually lead them into great doctrinal difficulties), they were not alone. Enlightened and reasonable people of all persuasions and practices found themselves thinking in new ways.

This transformation had deep roots. The early Christians we call "Gnostics" had already sensed a great gap between the divine and the human and sought to fit it into the Christian picture, in a way that was unconvincing to many.[5] They contributed to the restlessness of other philosophers and church people who gradually found the divine growing larger and receding further.

With the exaltation of the divine, even history changed. The tales of gods and men from Homer were now easy to interpret in ways that left the earthly presence of Athena and Apollo and Aphrodite behind. Philosophical interpretation of Homer became

commonplace, interpretation in which, for example, Odysseus came to stand for the soul of a man on pilgrimage from ignorance to enlightenment and his encounters with divine beings were stages on his progression toward a grander philosophic and religious encounter than the old Greeks could have imagined.[6]

The philosophers did not challenge or deny the old gods. They simply made them smaller. No one was offended.

II

THE
HISTORY
OF
PAGANISM

Chapter 10

CONSTANTINE IN HIS WORLD

S TEP OUT OF A FRESHLY LANDED TIME MACHINE AND TAKE ASIDE a very learned Roman in the year 300 CE. Ask him to explain the history of religious belief and practice, and he won't know where to begin. Amid the many gods, cults, and local histories, marked by small-scale fastidiousness, local pride, spasms of exuberance or violence, and some famously ostentatious sites of display, religion was part of the continuo, the background, the ordinary fabric of life everyone took for granted. It had no story of its own.

The Roman world in that year was like an athlete or warrior whose breathing was returning to normal after heroic exertion. The collapse of the Roman government in the third century and the disarray of its leadership had been weathered and then reversed by iron-willed generals. The Roman Empire was now a very different place from what it had been: much more centralized, much more frankly a military dictatorship, and much less dependent on the city of Rome and its old families.

Nor were regional religious beliefs and practices what they used to be. Philosophers and fashion had brought forward new ideas of high gods and bloodless ritual. Among old-fashioned religious groups, the

ragbag of communities who professed loyalty to Christ[1] had kept up with the times and grown modestly in size. Enough of them were settled and respectable enough to catch the eye of an emperor. (It really is necessary to see the Christ followers of this time as at least a little old-fashioned. Two and a half centuries is a long time, and this was by now a settled and familiar group, however marginal.)

By 337, something else had changed. In May, an emperor died and his very Christian publicist, Eusebius, bishop of the wealthy port city of Caesarea on the Mediterranean coast between modern Tel Aviv and Haifa, wrote his biography, inflecting it to make the deceased ruler into the first Christian emperor. His *Life of Constantine* tells us something about Constantine and much more about the politics of his time. It was in Constantine's lifetime that religion rose from the quotidian to the epic, taking a leading part in great historical developments.

Constantine was a border rat. His father, Constantius, was a senior army officer who rose high in the ranks, so his own origins were likely military. The family came from the Danube regions between modern Serbia and Bulgaria. Constantine himself was born in about 272 at Naissus (modern Niš), the last major, and last Latin-speaking, town through which travelers passed on their way east through the Balkans before arriving among Greek speakers in what is now Bulgaria. Army families of the mid-third century lived in uncertain times after fifty years of warfare—both internal and external—that followed the death of Alexander Severus.

At his son's birth, Constantius was a senior officer in the bodyguard of the emperor Aurelian, one of the more successful of that century's failed rulers, enjoying significant military victories east and west before being assassinated in a court intrigue, which Constantius survived. In 284, his senior colleague Diocletian, another of Aurelian's men, gained the throne and stabilized his regime. His was a real revolution.

Diocletian strengthened imperial control by creating a college of four rulers, two with the senior title of Augustus, two appointed a few years later with the subordinate title of Caesar, each with approximately a fourth of the empire to control. The college was made up of Diocletian's colleague Maximian as senior ruler in the western provinces, Constantine's father responsible for Britain, and his own junior colleague in the east, Galerius. The two Augusti remained close to the central regions of empire as much as possible, the Caesars ranging more widely. Diocletian put himself under the protection of Jupiter, Maximian of Hercules, and Constantius most likely of Apollo. Knowing that tells us nothing about Constantius's own religious ideas, or if he had any at all.

Diocletian substantially enhanced the size and thus the governing capacity of the military and its bureaucracy. Some estimates suggest that the imperial government at its height under Diocletian and his immediate successors counted as many as ten times the number of personnel, military and civilian, as did the successful regimes of the Antonines a century and a half earlier, with less territory (after the loss of Dacia, modern Romania) to cover.

With this change in leadership came a change in the nature of empire. Government and military protection and power were centralized and officialized. Local elites, the backbone of the older, more federated empire, were increasingly marginalized. From earliest times until the third century, the highest manifestation of rank and status had been the generosity and philanthropy of wealthy men, who governed cities, collected taxes, and funded construction in the emperor's name. Diocletian all but made this ruling class obsolete.[2] Centralization was successful through much of the Roman world for the next three hundred years and laid the foundation for a millennium of further Roman rule from Constantinople. It also left the empire less able to protect its localities against depredations foreign and domestic.

Young Constantine spent his adolescent years not with his father,

but at the court of Diocletian. You wouldn't quite call him a hostage, but you might call him an insurance policy. He rose, naturally, to officer status of the first rank. He was in his thirties, in 305, when Diocletian and Maximian took the extraordinary step of retiring from office (Diocletian leading, Maximian reluctantly following) allowing Constantius to take on the role of senior Augustus for the western empire. Galerius (hated by surviving contemporary sources) took the east. Constantine stayed briefly at Galerius's court in Rome but felt endangered there and was, at any rate, of an age to think of striking out on his own. Galerius most likely was driven by a zeal to be not just first among equals but first and only. This made Constantine's stay there precarious, and he shortly joined his father in Britain.

A year later, Constantius was dead, improbably enough of natural causes, at his capital of York in northern Britain. His troops acclaimed his son to succeed him, and Constantine accepted, shredding the Diocletianic idea of partnership and succession among Augusti and Caesars. For the next eighteen years, the empire was once again at war with itself, though, with few external pressures, it was able to maintain prosperity and reasonable civil order while indulging the luxury of feuding generals.

One of the best modern Roman historians[3] argues that the Roman Empire "had never had on the throne a man given to such bloodthirsty violence as Constantine," measured by the systematically brutal enforcement of much more comprehensive programs of law than the empire had ever known. He was well suited to the new age of big government and went after his rivals for power unsparingly.

By 324, he had eliminated or merely outlived all the other claimants to the throne as Diocletian's idea of a four-way partnership collapsed into a lake of blood. He maintained his position as the lone Augustus for thirteen years until his death in 337, the first to do so successfully in a century.

Constantine belongs in the very short list of the most compe-

tent and successful Roman emperors: Augustus, Trajan, Hadrian, Diocletian, Valentinian, Theodosius, and Anastasius fill out that list, a distinguished few from over five hundred years. He had the ability to lead men in battle, to sustain his position with aristocrats and bureaucrats, and to use killing and plunder to strengthen his position relentlessly.

Monarchs have a great weakness, however, for their own sons, no matter how feckless and inept. A statistical study should be done across cultures assessing the relative frequency of the bizarre outcomes to which monarchical succession is prone: failure to provide an heir or successor, provision of an heir completely inept, or division of rule among several incompatible ones. Orderly succession followed by a successful reign is the exception. The great Antonine emperors of the second century succeeded because they were childless and could select competent successors, until Marcus Aurelius had the misfortune to have a son, the awful Commodus. At no point in Roman history before or after Constantine do we see as many as three consecutive competent rulers in one family line. Constantine almost offers an exception.

He chose to divide his legacy, leaving his throne to three sons by his second marriage, Constantine, Constantius, and Constans. (Wordplay on "constancy" is certainly there—the names would resonate as "reliable, faithful, dependable.") Constantine had prepared for the political blunder of overlooking his first son by his first marriage by putting him to death in 326 (poison was suspected). He then murdered his current wife, Fausta, the mother of the three sons to whom the throne would be left. Motivation for these putative murders is debatable. The most bizarre suggestion—removing the son of the first marriage to satisfy the second wife, then removing *her* to remind other observers that the monarch would kill impartially—is also the one most consistent with the fragmentary surviving evidence.

Dynastic violence can be inherited, and indeed shortly after

Constantine's death, his sons fell to quarreling. By 340, Constans had engineered the murder of Constantine II, then shared rule with Constantius for a decade until Constans was assassinated by agents of a general seeking the throne for himself. Neither Constantine II nor Constans would be regretted by any but the most sympathetic and forgiving of intimates. Constantius, meanwhile, had further secured the throne by conducting a purge of uncles, aunts, cousins, and other descendants of Constantine's father. But he unwisely spared two of them, young boys named Gallus and Julian, to live in internal exile, with a bishop for their tutor. We will meet them later.

Now we must speak of something new, the "history of Christianity." That history pulls Constantine out of the ranks of fellow emperors and tempts people to make a saint of him. For Constantine made a very ordinary kind of political choice during the years when he was fighting off his rivals for the imperial throne, one that turned out, quite unexpectedly, indeed unexpectably, to have long-lasting effects.

Most emperors were unremarkable for their religious thoughts and deeds. Conventional piety interpreted with a bit of philosophical education was common enough, as in the case of Marcus Aurelius (161–180). Conventional piety with moments of enthusiasm, turned to account by generous expenditures, was quite common when opportunity allowed—as in the case of Hadrian. Indifferent, garden-variety attention to obligations was much the commonest. At the extremes, zealotry was possible, but in the three centuries since Augustus, the only one to exceed Augustus himself in religious devotion was the emperor formally known as Marcus Aurelius Antoninus Augustus, who reigned from 218 to 222 CE.

This emperor came from Emesa in Syria (modern Homs), a city at a crossroads of great highways where the road from Aleppo down to Damascus crossed the direct route westward from the caravan city of Palmyra to the sea at Tripoli. His grandmother's sister had given the reasonably successful emperor Septimius Severus a son

named Caracalla, who became another hearty brute on the throne. When Caracalla was killed in a Syrian uprising, the grandmother, Julia Maesa, pulled strings with a compliant legion to arrange for the grandson to be raised to the throne at the more or less pliant age of fourteen. Wary of the army, hearing no better offers, the Roman Senate elevated him, and the army accepted the news placidly enough.

He lasted four years, until 222, which is, to be sure, a fair long time for a puppet numskull. His particular form of cerebral insensitivity arose from his decision to become a priest and devotee of his hometown sun god. The lands east of the Mediterranean knew to worship or at least placate the sun that dominated their lives. Baalbek, in ancient times Heliopolis ("city of the sun"), was perhaps the most notable such site, with a vast temple whose surviving twenty-meter columns give an idea of the awe they were meant to inspire. The sun god of Emesa was El-Gabal, known and worshipped there under that name, even if Greek speakers prudently identified him with their own Helios.

That the new emperor had himself made a high priest of his sun god and at some point accepted circumcision was not exceptional. That he constructed a huge new temple on the Palatine for his god was no more remarkable than Hadrian's construction of the Pantheon. His temple contained no graven image of the god. As was consistent with practice in his homelands, the cult object was a black stone—reputedly a meteorite sent by the god. He may even have thought he *was* the god he worshipped—but emperors since Augustus had been divine in some sense of the word.

It was his worship itself that was not to the taste of local dignitaries. Their disapproval comes through in the judgment of the historian who reports that they were shocked to see him dancing with his god. The general population was more tolerant when the midsummer's festival in honor of the sun's apogee was the occasion for great gifts. We can hope that Herodian's account is accurate:[4]

The festival featured shows and races and theaters, in buildings erected specially for the purpose—all done to please the people. He placed the sun god (that is, the black stone) in a chariot covered with gold and jewels and brought him out in procession. The chariot was pulled by six horses, spotless white and huge, harnessed in gold and expensive riggings, and it moved ahead without charioteer or guide, as if the sun god himself were driving. The emperor made the whole procession walking backwards before the chariot, holding the horses' reins and gazing upon his god. To keep him from stumbling or falling, the path was sprinkled all along with gold dust and bodyguards shepherded him.

When the sacrifices were done, he climbed a high tower and began tossing preposterously expensive gifts to the crowd—gold and silver goblets, elaborate fabrics and garments. Some bystanders were killed in the scramble to grab what was on offer.

He was wittily traditional. He took to wife a vestal virgin, strictly a great sacrilege, but in the deepest Roman tradition the vestals had belonged to the household of the ancient kings. He brought together important religious objects in the house of his god, "so that no other god except his would be worshipped." If we let him have his god, the collocation of gods in one place is as much a sign of respect as of contempt. What if the fire of Vesta burned on a hearth there? Or what if the Palladium—the wooden statue of Athena that Aeneas had brought to Rome—was cherished there alongside the shields of the Salians, the very ones that had fallen from the sky in the reign of King Numa, the great legendary founder of Roman religious practices? One man's reasonable and respectful adaptation was another man's sacrilege. Between those positions, some doubtless found the goings-on excessive but untroubling. Perhaps he only lacked for piously like-minded successors to make him seem normal.

This, then, is what a truly religious emperor looked like. Whatever private thoughts he had are inaccessible to us and do not matter. When the Praetorian Guard grew tired of him and decided his cousin Alexander Severus was more to their taste than this flamboyant airhead, he and his mother were summarily murdered and he had the opportunity to do what he did best, live on in the outraged stories of a voyeuristic public. That's when he was given the name Elagabalus.

How would Constantine measure up to Elagabalus? He never thought he *was* the god of his choice; he never put himself forward as a priest (or "overseer," that is, *episkopos*, that is, bishop); but he was not shy about intervening in religious affairs. Like Elagabalus, he had a favored god. It is not easy to say what a "typical" Roman officer or senator of the time of Constantine would have thought or known about the followers of Christ.

How many of those followers were there? This is deeply controversial, but the range of possibilities runs from small to modest—there were not communities of Christians everywhere, nor were the communities large. For at least two hundred years, they had cherished the idea that they were despised or feared or outlawed or persecuted by the Roman government—a view that had just enough truth to it to shape behavior.[5] They had never engaged in blood sacrifice of any kind, and they made disdain for other people's ways a trademark. They were not poor but neither were they wealthy, and they had made few efforts to give their communities permanent or impressive buildings to inhabit.

The narrative of persecution grew in value over time. Years after it was not only safe but profitable to do so, the African writer Lactantius, comfortably living on Constantine's patronage, told how the most notorious wave of harassment began. The emperors Diocletian and Galerius, rulers in the east, it seems, were performing sacrifices one day in the year 299 when Christian bystanders performed the sign of the cross in some ostentatious way. When the

entrail-reading omen tellers went to read the guts of the sacrificial animals, something was wrong—the normal markings were missing. They said that "profane men" were to blame, and the Christians were hounded away.

Now, such a story cannot be taken simply at face value. Whose is it? It comes from a Christian writer presenting his coreligionists as bravely loyal to their faith. It can well be that the story has a basis in truth, but if the source were originally a hostile one, then the whole affair can have the air of a setup. Were the Christians something closer to the usual suspects and was there connivance in making them responsible for a sacrificial failure, the better to make them the explanation for other failures on other days? We cannot know.[6]

Whatever the reaction to that event, nothing happened quickly. We hear of a blast of repression directed against one branch of the Christian communities, the Manichees, in 302, with some victims (and their books) burned alive, others put to the sword or, if they were of the more privileged classes, sent to work the mines—and likely to die there. Religious practice could be dangerous and could be treated as dangerous by force of law and arms. Eventually word came that the oracle of Apollo at Didyma (who had been so particular about sacrifices in the third century) reported that people he called "the just on earth" were hindering him from giving true oracles. The emperors, likely here with Galerius in the lead, determined that the annual feast of the Terminalia, in honor of the god of Rome's ancient city boundary markers, would be the right time to issue an edict against the Christians. On that day, the praetorian prefect (essentially the prime minister of the empire's government) presented himself at a Christian church in Nicomedia (modern Izmit), one of the emperor's residence cities not far from the site on the Bosphorus where Constantine would erect his own magnificent new capital. He posted the edict, seized scriptural books for burning, and had troops plunder the church. A Christian of the upper classes boldly tore down the edict

and made fun of it, for which he was arrested, tortured, and burned to death all on the same day.

The edict itself was ingenious in its working. Its main provision was not to ban anything but to require something: worship of the traditional gods by some form of sacrifice. The author of this edict knew that devout Christians would be too horrified by this provision to comply. Technically, public service and the legal system had required sacrifice all along, but this edict made slithering evasion harder. It was equally obvious that there were plenty of people among and associating with the Christians for whom the requirement in itself would not be so distasteful. Some would surmise that the requirement proved the weakness of the Christian god and would, out of a pure self-interest unmixed with any personal religious experience or commitment, happily perform some mild form of sacrifice, most likely bloodless, as a condition of continuing in normal life. And then— here is the clever bit—the internal dynamics of Christianity would at this point put the zealots at odds with the hedgers. Expelling the "lukewarm" and the "semi-Christian" from their group, the zealots would do the persecutors the favor of making the original problem smaller and easier to manage.

This concerted action suggests that Christians had become, to those in power, not merely annoying but a positive nuisance. If Constantine's retinue already contained people favoring the Christians, as some surmise, the edict may even have been aimed at him, though the victims were more widely distributed.

Emperors issued many orders, many of which were ineffective. This one had some success. Bishops and other Christian leaders were arrested and jailed. Scriptural books, in particular, were seized and destroyed in many places. This tells us both how Christians valued the written words of their community and that there were not other comparably sacred objects in quantity and character to allow for the ostentation of seizure and destruction. There weren't many churches

to burn. Books were certainly expensive and elaborate enough to qualify for making an example. The repetition of edicts through 303 and 304 suggests that the emperors remained determined. The culmination of that series of edicts was one requiring everyone—men, women, children—to participate in public collective sacrifice. This was ingenious again—mere attendance would suffice to rouse the fury of the zealot Christians—and desperate. We know the order was enforced in some places and are sure it was not enforced everywhere. In some cases, collusion of officials with Christians would give a community a free pass; in others, the "Christian problem" would not have been worth attending to.

At any rate, the emperors seem to have thought that progress was being made. With the retirement of Diocletian and Maximian in 305, the enthusiasm for persecution continued in the east, under Galerius and his new colleague Maximinus, while Constantine's father's western realms seem to have let it quietly lapse. When Constantius died and his son had claimed his role, a formal declaration of amnesty and restitution for the Christians quickly won him their support. Things seem to have calmed from this point. In 311, Galerius, much beset by opponents, took to his deathbed, where Christian opponents describe with relish a cancer of the genitalia and its barbaric premodern surgical treatment. They gloat when his appeal to Apollo for healing only seemed to make things worse.[7] The dying monarch had the grace, possibly self-serving, to suspend the persecution and issue an amnesty:

> Among all the other arrangements that we are always making for the benefit and utility of the state, we have heretofore wished to repair all things in accordance with the laws and public discipline of the Romans, and to ensure that even the Christians, who abandoned the practice of their ancestors, should return to good sense. Indeed, for some reason or other,

such self-indulgence assailed and such idiocy possessed those Christians, that they did not follow the practices of the ancients, which their own ancestors had, perhaps, instituted, but according to their own will and as it pleased them, they made laws for themselves that they observed, and gathered various peoples in diverse areas. Then when our order was issued stating that they should return themselves to the practices of the ancients, many were subjected to peril, and many were even killed. Many more persevered in their way of life, and we saw that they neither offered proper worship and cult to the gods, or to the god of the Christians. Considering the observation of our own mild clemency and eternal custom, by which we are accustomed to grant clemency to all people, we have decided to extend our most speedy indulgence to these people as well, so that Christians may once more establish their own meeting places, so long as they do not act in a disorderly way. We are about to send another letter to our officials detailing the conditions they ought to observe. Consequently, in accord with our indulgence, they ought to pray to their god for our health and the safety of the state, so that the state may be kept safe on all sides, and they may be able to live safely and securely in their own homes.[8]

The confession of his own clemency, the use of the passive for the killings of Christians without acknowledging his own part in those killings, and the nice hint that perhaps if the Christians had just worshipped their *own* god in traditional ways all might have been well—all these are lovely touches for the student of the history of brutality. He had, of course, just done the Christians two favors—by giving them martyrs, and by ceasing to do so.

Chapter 11

A NEW LEAF

G ALERIUS'S PASSING AND HIS DEATHBED AVOWAL OF TOLERANCE meant that the question of Christianity was now in play. A reasonable general grasping for the throne would have to consider whether there was more advantage in posturing against the Christians or in showing them generosity. Constantine is distinguished among the various claimants for the throne in the next few years by the clarity of his choice in favor of Christianity and by the moderation with which he worked out the implications of that choice.

Some famous stories obscure his motives—a bridge and a battle await us in a few paragraphs. When we ask about Constantine's own religious activities, we know very little that we can trust. Scholars divide over the intensity and date of onset of Constantine's piety, but the debate is mostly irrelevant. What an emperor might be in the privacy of his soul is of much less interest and importance than what he presents himself to be and how he performs his role. In these respects, we know enough about Constantine to make some judgments.

Whatever his private thoughts, he began by accepting homage and loyalty from people who honored the traditional gods, who saw

him and his behavior in traditional ways. A fine and formal speech made in his honor in the military capital of Trier in 310, honoring his fifth year of rule and the anniversary of the founding of that city, describes him as already seeking to draw closer to the gods, who invited him to join them—as any court flatterer of the last centuries would have said.

The orator proudly reveals the story of a godly vision—also perfectly ordinary. There was a grand shrine in northern Gaul dedicated to the Celtic god Grannus, patron of healing hot springs, known ambitiously by then as Apollo Grannus. The shrine was a walled sanctuary covering some 175 acres around the springs, built up since the first century CE to include a basilica and an amphitheater and a little plumbing to manage the springs. Pilgrims came from afar, and inscriptions in honor of this site appear as far away as Spain, Turkey, Romania, and Sweden.[1]

Constantine arrived with much pomp and was, apparently, favored with a vision of Apollo side by side with the goddess Victory. Like his father, Constantine put himself under the patronage of the glamorous sun god, even when the god had gotten a little mixed up with a local healing deity. Here's the local orator telling the story of this visit to . . .

. . . the most beautiful temple in the whole world, . . . to the deity made manifest, as you saw yourself. For you saw—I believe it—O Constantine, your Apollo, joined by Victory, offering you laurel crowns, each signifying a portent of thirty years. This is the number of mortal years owed to you to live, beyond the age of Nestor. And indeed, why do I say "I believe it"—you saw him and you recognized yourself in his image, the one to whom (so sing the divine hymns of the prophets) all the kingdoms of the world belong. This happens now because, I think, you are like him, a happy and beautiful youth, a savior, our general. You

rightly honored that most sacred shrine with such wonderful gifts that the ones there of old are unnecessary. Every temple now beckons to you, especially those of our Apollo . . .[2]

Traditional stuff of the most predictable kind, you would say, and rightly so. That was in 310. Two years later, all the stories, ancient and modern, agree, something changed.

As Constantine had accepted the throne from his father's soldiers, so Maxentius, the son of Maximian, had been acclaimed to high power by the Praetorian Guard at Rome in 306. Neither was officially recognized by Galerius and Severus, the linear successors of Diocletian and Maximian. The state of affairs in 306–312 was a common one during the Roman Empire, rule divided among several claimants.

Constantine and Maxentius first squeezed Severus from opposite sides and overthrew and murdered him. Ungentle cooperation ensued, with Maxentius controlling Italy and Africa, Constantine Gaul, Britain, and Spain. By 311, east and west, the empire was in an uncertain state, with Maximinus and Licentius, the eastern rivals, each jockeying for alliance with the westerners and Constantine and Maxentius considering their own positions. In 312, Constantine brought matters to a head by crossing the Alps and working his way through skirmishes with Maxentius's troops to reach Milan and stay there for a few months. Maxentius remained in Rome.

Late in the fighting season, Constantine began to move south. Reasonable observers expected Maxentius to stay within the city walls, confident that it was easier to defend the city than besiege it from outside. Maxentius instead foolishly marched out about three miles north of the city on the Flaminian Way, the main highway to northern Italy, and gave battle just across the Milvian Bridge. Backs to the river, Maxentius's men fought their way to disastrous defeat, Maxentius himself, either in flight or in despair, plunging into the river to his death. His body was fished out and decapitated.

Constantine now ruled the west. Another decade of patience, deceit, cooperation, and betrayal would see him triumph over his eastern rival Licinius and achieve sole rule by 324. For now, a pan-egyric speech like the one that celebrated his vision of Apollo greeted his formal arrival in the city:

> As you deserved, Constantine, the senate has just dedicated an image of the god to you, and a little while back Italy gave you a shield and crown, all made of gold, to pay back a little of what we know you are owed. Such an image is and always will be owed to *divinitas,* as the shield is owed to strength and the crown to loyalty.[3]

Divinitas by now was a word regularly used of emperors, to speak of them in their special godly or god-favored role.[4] Nothing new or surprising here. It's even said, probably correctly, that Constantine then ascended the Capitoline Hill as part of his grand entry to the city and offered a sacrifice at the temple of Jupiter.[5]

To celebrate the event less rapidly, but more grandly, the mighty Arch of Constantine that still stands a few yards from the Colosseum in Rome was erected in honor of the now dominant ruler. Just as emperors were most successful when they imitated and borrowed from those who had gone before, so too with architecture and sculpture. This example was more direct than most, reusing physical pieces of sculpture and images from earlier memorials and other circumstances. The assemblage gives us a sequence of images of Constantine, first approaching Rome in a carriage drawn by four horses alongside an image showing Apollo as sun god rising from the ocean in his own chariot-and-four. Another panel shows Constantine at the siege of Verona in northern Italy, armed and trousered among his soldiers, but the scene for the Milvian Bridge surrounds him, now in armor, with ambiguously divine figures—Victory among them—

and then he appears before the Senate and people appropriately dressed in the old toga.

The language of the great inscription on the arch is impressive.

TO THE GREATEST, LOYAL, PROPITIOUS, SACRED EMPEROR

CAESAR FLAVIUS CONSTANTINE:

BECAUSE BY DIVINE INSPIRATION[6] AND GREAT WISDOM,

WITH HIS ARMY IN ONE JUST MOMENT

DID HE AVENGE THE REPUBLIC WITH HIS ARMS

FROM BOTH A TYRANT AND ALL OF HIS FACTION,

THE SENATE AND THE ROMAN PEOPLE

HAVE DEDICATED A SPLENDID ARCH TO HIS TRIUMPHS.

All of this, with names changed, could have been said and done for a success of Vespasian or Hadrian or Septimius Severus or Diocletian. Then, gradually, in the 310s and 320s it got about that something else had happened just before the battle of the Milvian Bridge.

There are two main versions of this. Nearly contemporary, in an entirely polemical history of which Constantine is the hero, Lactantius in his *Deaths of the Persecutors* tells it this way:

Constantine was cautioned in a dream to mark the heavenly sign of God on the shields of his men and only then engage battle. He did as he was told and he marked Christ on the shields with a turned letter X with the very top bent around. The army took up weapons under that sign.[7]

Soldiers putting protective designs on their shields was nothing new; if this one weren't Christian, we would have no second thoughts calling the practice magic or superstition.

Then this Christian writer tells us how Maxentius came to make

his strategic blunder in marching out to face Constantine and in so doing gives us a classical rendition of a misread oracle.

> The city was in an uproar and the emperor was mocked for neglecting the people's wellbeing. Then all at once the people attending the circus in honor of the emperor's anniversary cried out with one voice that Constantine could not be beaten. Embarrassed, Maxentius calls together a few senators and orders the Sibylline books to be examined. In them is found the claim that on that day the enemy of the Romans would perish. Seduced thus to hope for victory, Maxentius went out to join his army.[8]

Each competitor gets his own divine advice. Constantine's turns out to be the right advice and his god is the sponsor of victory. The story of divine approval probably began to circulate immediately. Constantine and many others would certainly remember *which* god had favored him. The god in question emerged in time as the one true monotheistic god of Christianity, but the mode of thought that Lactantius represents and accepts is still entirely traditional. A good emperor picks the right god, is protected by that god, and prevails.

Twenty-five years later, Eusebius, in the official *Life of Constantine* published at the end of Constantine's life, has the story of the vision a little differently. This was how Constantine had told it to Eusebius—Eusebius says—long after the fact.[9]

Just at noon one day, Constantine saw with his own eyes, standing over the sun in the sky, the image of a cross formed from light and a text attached to it that read, "By this conquer." He and his whole army were astonished by the sight. He wondered what it meant and took that wonder with him to bed that night. While he slept, the "Christ of God" appeared to him, showing again the sign that had shone in the sky, and told him to copy it as protection against enemy attacks.

When he awoke, he told his colleagues what he had seen, then called in jewelers and goldsmiths to make a copy of the design for him out of precious materials. This he carried with him ever after and had shown it to Eusebius once. It was a tall pole covered with gold and crossed with a bar forming the image of a cross. At its top, they fastened a wreath made of gold and precious stones. On the wreath now appeared the two letters from the beginning of the name of Christ as a monogram, Greek *rho* intersected by *chi*. The emperor also used to wear these letters on his helmet in after years. From the transverse bar of the cross there hung an imperial tapestry covered with precious stones, glittering with their rays of light, woven with gold. Everyone who saw it (and wanted to stay on the emperor's good side) agreed it was beautiful beyond description.

Also mounted on the pole was a central golden portrait of the emperor, flanked by the images of his sons. In later years, the emperor always carried this image into battle, and he commanded that copies of it be carried at the head of all his armies.

At the moment of the vision, Eusebius says, Constantine was baffled and wanted to worship this god. So he called upon "those who were expert in his words." They told him that the god was the only-begotten son of the one and only god and that the sign represented immortality, an abiding trophy of victory over death. Then they told him the story of Jesus's life. Impressed by what he heard, he took those priests as his advisers and chose to honor with every appropriate ritual the god who had appeared to him.

This vision is dated not on the eve of battle but at the outset of the campaign against Maxentius. What Eusebius recounts of the campaign adds little to what we already have from Lactantius and other less detailed sources, and Eusebius's account of Constantine's arrival in the city of Rome is concise. Eusebius does say that Constantine erected his new standard in the middle of the city to impress both the Senate and the people. He then had a statue built of himself holding

the standard. On it was posted this message: "By these saving insignia, the true sign of bravery, I set free the city from the tyrant's yoke, restoring senate and people of the city to their ancient glory and brilliance."

This second story obviously differs by elaboration from the first but it is still theologically ambiguous. By the 330s, Constantine and his spin doctor know better how to describe their Christian god, but even at that distance and with those advantages this is still a very traditional scene. The priests and advisers tell him that what he sees is a sign of immortality and victory over death—which does not *quite* insist on resurrection in any Christian sense and certainly allows a traditionalist interpretation. Both the banner and the precious trophy speak to good-luck charms and what we might still be crude enough to call superstition and magic more than to any influence of the gospel narrative and teachings of Jesus. So even when the mature Constantine sets out to tell the story of his conversion through the pen of a Christian bishop, the form and substance are traditional.

Does what I've just recounted, now, amount to a story of "conversion"? Did Constantine "convert to Christianity" as history books say he did?

What if we make the question a little more specific? Did he accept Jesus as his personal savior? Did he become a Bible-reading Christian believer? Did he accept baptism and join the sacramental community? Did he have a fundamental transformation of heart and mind? On available evidence, the answers are maybe/maybe not, probably not, certainly not, and probably not. What kind of conversion is it if it doesn't measure up to modern Christian definitions of that phenomenon? Perhaps we need to leave the word *conversion* aside.

What we do know is that Constantine found the Christian god sufficiently powerful to attract his allegiance. If the war with Maxentius and the battle of the Milvian Bridge had gone differently, the implicit bargain ("wear my insignia and I will support you") would

have been null and void, but Constantine himself would have been most likely dead and irrelevant in that case. People gave their allegiance to gods who showed their power. A god who failed to show his power would not expect allegiance. Taking on Christ as his god, then, is not quite what a modern Christian would mean by conversion; at best it was a provisional contract. What an emperor expected of his god wasn't so much a personal relationship as a diplomatic one. Nothing suggests he needed to have a particular emotional disposition about religion. The bargain sufficed.

Nor did he have to be an "active churchgoer" in anything like a modern sense. Constantine himself, whatever happened to him in 312, did not take baptism until his deathbed in 337. On strict theology, he was not a Christian—a "faithful Christian" was sometimes the expression—until that baptism. His status as catechumen, a candidate for membership, associated him with the community but kept him distinctly on the outside. So he was never eligible to attend and participate in the formal eucharistic ritual of the Christian church.

Postponing baptism made perfect sense. The ritual of water and blessing washed away the guilt and stain of sin, a necessary cleansing in order to be admitted to the presence of God in the afterlife. A young person who underwent that ritual—which could only be performed once in a lifetime—was then at risk for the rest of their life of falling again into sin. Waiting, cautiously, till the last possible moment was an effective guarantee of salvation, at risk only in case of sudden unbaptized death.

Christianity's opponents in this period found this practice shocking. It seemed to offer a divine license for living an immoral and irresponsible life. For traditionalists, gods and morality had little enough to do with one another. One worshipped for the benefits worship brought; one conducted oneself appropriately for the benefits such conduct brought in society. To use religion as a pretext for immorality was unseemly. There were surely people angling for that deathbed

baptism who made those accusations only too credible. A powerful and occasionally bloodthirsty emperor would have contributed to the problem.

Constantine did offer his support to the new god. He commissioned churches and poured money into the coffers of Christian clergy—at the clear expense of other gods and communities. Taking care that his god was appropriately worshipped was his job, but that did not mean that *he* personally had to engage in the worship with any depth or personal agency.

Sometimes that patronage worked to the disadvantage of existing religious practices—but infrequently. The handful of documented measures that Constantine took against traditional religion were few and self-serving. In a law of 320, he made it clear that nocturnal consultation of soothsayers was to be forbidden—but emperors had always been nervous about such behavior, hoping to prevent soothsayers from prophesying against the reigning emperor.[10] (That same law calmly told the prefect of the city of Rome to consult the traditional haruspices on the meaning of a disturbing recent lightning strike that had damaged the Colosseum.)

Scholars have long asserted that Constantine banned traditional sacrifice, but the evidence is slight.[11] Four years after his death, two of Constantine's sons, including the peremptory and unpleasant Constantius, issued a short decree banning "superstition" and "the madness of sacrifices" and claimed the authority of a law of their divine father (*divi principis parentis nostri,* where *divi,* the same word used to speak of Julius Caesar as a god in the phrase *divus Iulius,* is rendered in the standard modern translation from 1952 as "our sainted father"—a stretch, to say the least). This is a flimsy basis for the claim that Constantine banned sacrifice. "Superstition" is the first marker in that law that whatever was in question was not the general run of public religious behavior but religious activities that were commonly, by traditionalists and Christians alike, thought to be beyond the

pale—magic, curses, and fortune-telling about the emperor's pros-
pects. The surviving law from Constantius and his brother, more-
over, cannot have been as brief in its original form as the single short
paragraph it now presents; but the copy we have was made a hundred
years after the fact in a devoutly Christian court at Constantinople.

If we *do* accept the testimony of that law (and there are exem-
plary scholars who do[12]), it changes little, for the range and reach
of that proclamation was not great. Calling these imperial declara-
tions "laws" overstates their impact. Most "laws" of this period are
statements from an emperor, responding to one or another request
for guidance and usually addressed to a governor or prefect of a sin-
gle region of the empire.[13] Many had all the legal effect we attribute
to presidential proclamations about "Be Kind to Your Web-Footed
Friends Week" and the like. Constantine himself clearly abhorred, or
came to abhor, blood sacrifice—but so did many other people.

The evidence that Constantine supported attacks on temples as
some have claimed is *very* limited: four temples, one the temple of
Aphrodite on the site of Christ's tomb and two other temples of Aph-
rodite where ritual prostitution was practiced. That evidence comes
from Eusebius's *Life of Constantine* written after Constantine's death
with a great eagerness to portray him as a fierce enemy of paganism.
If even that source can only find four examples, there can scarcely
have been any concerted campaign. Campaigns would come later.
(The traditionalist orator Libanius writing almost half a century
later made it clear that he believed Constantine starved the temples of
money but did not interfere in ritual.[14])

What we really know about Constantine's religious attention is
what he did for Christianity, not what he did to restrict or eliminate
other practices. His most ambitious construction project—the city of
Constantinople—was built to advance not a particular religion but
an emperor. Religious consistency took second place to his political
ambitions.

When Constantine did set out to advantage his cult, he encouraged the idea of the "holy land" in and around Jerusalem. Constantine's own mother, Helena, was the first real pilgrim to Jerusalem, but she was soon followed by other believers seeking the original sites of the Christian faith. The problem that Jerusalem already presented in the fourth century was that there were no original Christian sites to view, only rumors and traditions. We do see Constantine sponsoring the destruction of temples in that region, but only to create new tourist attractions. The temple devoted to Aphrodite built on the site that Constantine, or Helena, or their ministers determined to be the authentic site of the burial of Jesus was merely inconvenient. What Constantine's men built in its place became the Church of the Holy Sepulchre that now stands in Jerusalem.

Constantine likely did not fully realize the strengths the Christians already had. When an earlier general had favored a god—think again of Jupiter Dolichenus—he might introduce that god to new places. Christianity's early adaptation of the written word—an imitation of Jewish practice—offered those who would spread Christianity yet keep it theologically unified a particular advantage.

The books of the old religious communities were in the main special and secret. The Sibylline books, concealed in one temple or another in Rome, were veiled in a mystery which gave them their power. Books that could be freely copied, read, and preached from publicly, books that were debated in other books that were themselves copied and transmitted turned Christianity into something resembling the loose but tenacious organization of a philosophical school. Disciples of Plato could quarrel with one another, but they were reading the same books as their fellow students hundreds of miles away. Christians in the great cities of the east, especially Alexandria, built a community of consciousness on that model. Nothing but tradition and conservatism prevented other cults and religious communities from using books that way.

As long as the formal practice of Christianity was officially disregarded or discouraged, this broad common Christian consciousness was nebulous. When money and imperial support were added, the Christians' common trove of books and ideas animated a lively, extensive community unlike any the ancient world had ever known. Call it the high-tech religion of late antiquity and call their papyrus books and letters the social media of the time and you won't be far wrong.

Specific Christian communities were still locally organized and managed, with big cities taking the lead over small, towns over country villages. Bishops were elected by the clergy and the people they would lead. A neighboring bishop would come to lay on hands to ordain the new bishop, so smaller towns looked to large neighboring cities for influence and guidance. A charismatic or unscrupulous city bishop could exercise significant influence well beyond the bounds of his own community—and that influence would be increasingly accepted and codified as churches became public, official, and authoritative.

Just the word *church* is a marker here. The Greek word for it, *ekklesia,* means something like "assembly" or "convocation"—a group of people called together for a purpose. Decisively, the word came to be applied *in the singular* not only to specific local communities, but to the wider Christian community of a province, a region, or the world. From strikingly early on, Christians could refer to the community of people who revered Christ, wherever they might live, not as "churches" but as "church." It is not far from that point down the path to speaking of "the church" or to recognizing the insight of Lenny Bruce, who envied the Catholic kids in his neighborhood because "they belonged to the only *the* church" going. That definite article is a sign of immense power that Christianity would discover for itself in the years after Constantine.

With governmental approval, money and influence began to flow

toward Christian communities, especially in the larger cities. The emperor gave gifts, so other dignitaries followed suit. Wealthy men offered support for building fine new buildings and left gifts in their wills. Gifts to the church of productive agricultural property were a kind of endowment, guaranteeing continuing income. Just as an old master painting, once it gets to a museum, is unlikely to move again, so as wealth flowed to the ancient or medieval church, it stayed there, undivided by descendants.[15]

People began to join those communities in greater numbers, some because they heard and accepted the message. Others followed suit because this god seemed to be a powerful god with whom they were better off maintaining good relations. Still others joined because they frankly wanted to be seen in the right religious places to curry favor with other, more powerful people. As these communities grew and flourished, they became more aware of one another and the reputations of their leaders and teachers spread. This sudden influx of money and power would seem to be good for a religious community on the make, but it had its costs.

Christian communities had emerged out of a sense of history and out of the books that recorded that history. The stories of Jesus and his disciples were central, and this kind of wealth was antithetical to many of Jesus's teachings.[16] The heritage of Judaism was vital to the new religion, but it was very much an open question which elements of Judaism to integrate into new doctrine. In a world that had known not so much a unified church as a collection of communities, prosperity brought such schisms to light and made building a real unity of doctrine and practice difficult. The theological quarrels that followed were intense and reverberate even today.

Chapter 12

THE BIRTH OF PAGANISM

LEXANDRIA OCCUPIED A MATCHLESS SITE ON ITS MAN-MADE
harbor facing the Mediterranean at one of the mouths of
the Nile. Easily the most cultured, sophisticated, and con-
tinuously wealthy city in the Mediterranean world, Alexandria was a
home to many cultures, each newcomer enriching rather than displac-
ing the others. Even while the old temple stood at Jerusalem, Alexan-
dria had been a capital of Judaism. The earliest significant Christian
writers and thinkers studied and worked there. By Constantine's
time, Alexandria was a hotbed of Christianity, and Christian doc-
trine had been established for more than a century when controversy
erupted over the head of a priest named Arius.[1]

The church of Alexandria had been divided during the years of
persecution between those who faced persecution without wavering
and those who were more accommodating to the emperors' norms.
Peter, the bishop of Alexandria, felt some Christians had compro-
mised their faith by participating in sacrifice. If they avoided sacri-
fice, he was prepared to be forgiving. If Christians, acceding to the
authorities, had merely handed over Christian property—and par-

ticularly the books of scripture they cherished—Peter let them be. If they fled to avoid persecution—as he apparently did himself—there were no repercussions. Others, particularly the bishop Melitius of nearby Lycopolis, held out for excluding or disciplining those who had lapsed. These different approaches to the common oppressor became grounds for mutual hostility and recrimination within the community of Christians, in Alexandria as elsewhere.

The forgiving Peter was martyred in November 311. A new bishop was elected, but died himself of natural causes within a few months. The third bishop in a year, Alexander, inherited an unstable situation, in which external persecution had ceased but internal recrimination had not. Into this tense environment came Arius, probably from what is now Libya, preaching a controversial doctrine.

What Arius was *thought* to have said, in simplest terms, was that there was a difference and a distance between "Christ" and "God." Diverse opinions had been ventured in many places over the last century. At one end of this spectrum, Jesus was Christ was God—from the beginning of all time and forever. At the other end, Jesus was a carpenter's son from Nazareth with whom God was well pleased and who was thus exalted in stages to high esteem and standing. This Jesus remained a creature not creator, a divinized human being, not god from all eternity. Had he been "adopted" as a son by God? There was biblical language to support that view, as there was for every view on the spectrum.[2] In a world where godhead had been growing in prestige and uniqueness in the hands of philosophers and theologians alike, subordination of Jesus to the mighty Father respected the feelings of many.

Challenged as unorthodox, Arius reacted cannily and candidly, proclaiming his views in a way that most found entirely orthodox. If you suspected him already, you thought this was cunning; if you supported him, you thought him well intentioned, seeking harmony within the church. Whatever he said only fueled the flames already

burning. The controversy, flaring in the most populous and wealthy city in the world and the most Christian city in the empire, would take on a life of its own well beyond the city. The fires arguably still burn today wherever doctrinal clarity is made the dominant issue in a Christian community.

Over time, Arius's position was narrowed and sharpened and clarified further until the substantive distance between the two sides was small. But the significance of the disagreement thus erected on Arius's unwilling good intentions was, for doctrinal purposes, great; and the fact of both sides persisting was a greater fact still. The further the debate moved away from Arius himself, the more "Arianism" became a clear target.

Arius himself was a cradle Christian, long trained in Christian schools, well traveled among his coreligionists. A little older than Constantine, he had lived to see Christianity emerge as something fashionable and normal at the same time. His seniority drove him to hew close to scriptural meaning and to be as conservative as possible amid the new buzz about his faith. But what he said with every intention of orthodoxy had the effect of opening a window into the world of traditional religion.

The exaltation of a human being would have been familiar to traditional religions. Many people could recognize, accept, and respect a very wise teacher endowed with divinity, who coexisted comfortably with an ineffable, distant, immaterial, all-powerful god who stood behind him. There's nothing remarkable about people in that age wanting to preserve the distance between man and the ultimate godhead.

To insist on the alternative, however, was controversial. The anti-Arian position that emerged insisted on seeing Christ as fundamentally and essentially divine. The Greek philosophical concept of "substance" was invoked in due time to provide a way of saying what Arius's attackers felt was important: that in Jesus,

the fullness of godhead was present in a unique, distinctive, irreproducible, and irrepeatable way. *That* view posed many logical and exegetical challenges, but it had the merit of many of making Christianity unique and—most importantly—Christian salvation uniquely powerful.

And so, inadvertently and no doubt to his great unhappiness, Arius came to represent a set of views increasingly under attack by people whose zealotry he mistrusted and thought superfluous. They were, in his view, the heterodox innovators, not he.

His view nearly succeeded. If we turn our attention back to the emperor Constantine in the period before 325, when the controversies around Arius's teaching grew more intense, we see a man exasperated by the unreconciled quarrels around Arianism. Absent formal church governance structures above the local level, Constantine, who was the church's patron, decided—or was persuaded—to offer Christianity the unifying structure it lacked.

So in 325, he brought together in the city of Nicea (modern Iznik, a little south of Istanbul) all the bishops of the world. The 318 who came were those who could receive his invitation and make the journey, at state expense, to a place more accessible to the populous Greek east than to the Latins from the west. There were a few strays from beyond Roman territory, a "Goth" from modern Romania, for example, and two bishops from what are now Abhkazia and Iraq. Arius's views were not the only object of attention, but they held the floor when issues of practice and procedure were resolved. (There was still the question, for example, of how to treat those who had lapsed in time of persecution. In some parts of the Roman world, notably Africa, fierce disagreement and even schism would continue for almost a century on those points.)

The event was unprecedented. Constantine himself appeared in his full regalia of purple robes and gold and gem-encrusted insignia and chose to sit among the bishops. Bishop Ossius of Cordoba in

Spain, one of the few Latins present but Constantine's close adviser, presided, with lively debate and interventions by Constantine himself. Within a month, the fundamental issues had been resolved well enough to evoke consensus from the bishops present. The emperor's presence doubtless encouraged consensus, while the leadership and doctrinal commitment of Ossius could find and drive through the specific resolutions agreed upon.

The debates focused on very precise expressions. On the attack, Arius's opponents had a word they wanted enshrined in the council's decrees: *homoousios,* "same in being." Jesus was "same in being" with God—"one in Being with the Father," in the translation until recently current in the Roman church.[3] This word in the Greek was the simplest and most direct way to affirm the divinity of Jesus. Whatever was divine about the "Father" was divine about Jesus. This being was unique and he was radically unlike, say, a Hercules.

Resistant but assured of their own orthodoxy, the opposition fell into two camps. There were those who simply opposed the word of the day as a dangerous novelty—not used in the scriptures at all and, we know today, in some use among communities of dubious orthodoxy in Alexandria in the century before. Between outright resistance and agreement, a middle ground emerged. What about using the word *homoiousios?* If you are not familiar with these quarrels, you should rub your eyes now and look closely at the tiny difference, the insertion of a single letter, the "iota" that was proverbially the least of letters, in the middle of the word. The meaning was unmistakably different from the other word: not "one in Being" but "similar in Being," "similar in substance." For those seeking to preserve the exaltation of the divine, the notion of similarity and resemblance introduced just the tiny window of difference and distance they needed. For those fearing any deviation, the single letter was itself the introduction of all the poison of heresy.

Historians would dearly love to have the protocols and transcript

of the Council of Nicea, as we do for some later church councils of the period.[4] What we have is only the formal statement of faith that the council published, the so-called Nicene creed. New baptismal candidates recited a short statement of the main Christian doctrines in order to demonstrate their faith as they approached the baptismal font. The Nicene version of such a statement was meant to emphasize tradition—with the careful addition of the critical word. The new text was prescribed for use and was to be memorized and recited as a testimony to orthodoxy, fidelity, and support for emperor and council.

No one stood in that hall in Nicea and proclaimed this moment of doctrinal affirmation as the birth of paganism. All present would have been united and wholehearted in their rejection of false gods and the old ways. There came out of that place one form of Christianity that was easier for traditionalists to understand and accept. That momentarily dominant form of Christianity would pursue the exclusion of all error, inside the church and out, as fundamentally polytheistic and wrong by comparison to the unique truth of the one godhead present in Jesus, the Christ. The fathers of Nicea thought they were stating a correct doctrine. They were in fact establishing a new way of thinking about the world and religion's place in the world.

A long history of controversy lay before them on the day they proclaimed that doctrine, some of it coming very soon. The young priest Athanasius of Alexandria, who attended Nicea as a member of the party of Alexandria's bishop Alexander, would receive and defend the new teaching *contra mundum,* "against the world," for it would turn out that the more moderate, as one could say, position of those who resisted the Nicene doctrine would have a powerful appeal in many parts of the Roman world and beyond. The unscriptural nature of the shibboleth word would work against its acceptance as well.

Constantine would not especially help. For as long as he lived, having called, sponsored, and approved the council held at Nicea, he

did very little to ensure that its creed would be accepted. We have no window into Constantine's mind at this time, but he always expressed his support for orthodoxy without much caring what orthodoxy was. In the months before his council he had written a letter to Alexander and Arius, exhorting them to mend their thoughts and ways.[5] His first and last thought was for peace and harmony among Christians. He was distressed that they had taken to public disputation over issues that he thought "unprofitable." Arius had insisted on ideas that should never have been thought and, if thought, should have been quickly buried in silence. People who cared about these things had too much time on their hands, giving scandal to the faithful when they ought to be offering unified leadership. Give me back, he pleads with them in this letter, quiet days and peaceful nights; spare me the tears I must shed at the sight of God's people divided among themselves over matters such as this.

Because this was the beginning and not the end of conciliar disputes and flamboyant public controversies over doctrine among the most senior leaders of a state-sponsored Christianity, it is easy for moderns to be hard on Constantine here. There has long been a kind of sly gloating over the ignorant lout who could not understand just how important these metaphysical subtleties were, or a different kind of silent reproach to the Christian emperor so poorly taught that he could not appreciate what was at stake. He deserves more credit than that.

First, he could hardly have imagined that the terms of engagement he was laying down would remain in force for seventeen hundred years among the Catholic and Orthodox successors of his contemporaries. Second, in a world that had recently condemned Christians of every stripe and that was only just achieving civil order after two decades of intermittent civil war (the seemingly obtuse letter was written when Constantine's last opponent, Licinius, had just been defeated and captured, to be hanged a few

months later), peace and harmony were of more importance than *any* disputation on a point of undoubted theological interest. The fact that serious people could disagree about such a point was good evidence that fighting it out to a single resolution would be pointless. (If we look forward, say, fifty years from the time at which he wrote, he was absolutely right: the points at issue were *not* resolved in that time.)

When Ossius of Cordoba left Constantine's court not long after, he was replaced by the Greek bishop of Nicomedia, one of the regular residences of the emperor. He is called "Eusebius of Nicomedia" to distinguish him from "Eusebius of Caesarea," the church historian on whom we rely for much of what we know of this period. Eusebius of Nicomedia was a partisan of moderate views, ready to help Constantine interpret the events that followed the council.

The decrees were not well received. There was widespread resistance, particularly in the populous, prosperous, and increasingly Christian eastern provinces. Astute maneuvering carried the day. Within two years, Arius himself had appeared before Constantine, persuaded him of his orthodoxy (without using the word *homoousios*), and Constantine called a further council at Nicomedia in late 327 that absolved Arius firmly and, probably, justly. Alexander of Alexandria held out against Arius, however, and when he died a few months later, his colleague Athanasius was railroaded to election to replace him. There began with this election a half century of dispute, when Athanasius was repeatedly exiled from his city and bishopric and repeatedly returned.[6] The religious struggle that mattered in the decades that followed was the one to control Christianity rather than that between Christianity and traditional religion. Athanasius's party eventually prevailed at a council held in Constantinople in 381 with the support of imperial dictate and not as a result of astute theological argument.

Constantine for now had succeeded in his goal of enforcing ortho-

doxy and in establishing "the church" in Roman society. His personal religious views need never have advanced beyond what we have seen. When in 324, just winning his last critical battles, he planned the glorious new city on the Bosphorus that would bear his name, no one would criticize him if the city's layout followed the model of the old capital on the Tiber. Were there, as later reported on good scholarly evidence, temples built for the new city? The evidence is slender but cannot be dismissed out of hand.

There is also the case of the small town of Hispellum on the main highway north out of Rome. Applying to the emperor to build a temple in honor of Constantine's family, so that their priests (*sacerdotes*) could manage the games and gladiatorial contests that went with such a place, they were given "easy" (*facilis*) permission. Constantine's only reservation was that in the building dedicated to *him* there should be no stain of any of the "deceits of contagious superstition." Modern readers divide fiercely on whether to interpret this as forbidding sacrifice in *his* temple.[7] More striking is the easy permission that allowed as much of the old ways as possible and looked only to respect the emperor's own personal beliefs. No traditionalist in Hispellum should have been put out about this provision, and certainly none would have felt threatened.

The city of Constantinople was dedicated in 330 on the anniversary of the death of a recent martyr, Saint Mocius—a man Constantine himself may have known. The crowning image of Constantine in his city was a statue taken from nearby Phrygia that had originally been created as an image of Apollo and was then reworked to represent the great emperor. Was this a devout Christianization, or was it a subtler statement that Christ, Apollo, and Constantine had an intimate relationship, or that Constantine was now the more astute devotee of a truer Apollo? There was surely no one reaction to such an image. The world was less harshly delineated than it would become.[8]

But what did emerge from Constantine's reign, and through little choice of his own, was the *idea* of Christian hegemony, the idea that Christianity could try to define itself against a pagan world from which it was fundamentally different. Working out the implications of this ambitious exercise in self-image-making would take decades, but the foundations were now laid. This was the birth of paganism.

Chapter 13

THE BAPTISM OF PAGANISM

T HE NAMING OF CATS, AS MR. ELIOT SAID, IS A DIFFICULT matter. How did paganism get its name? Here I have to speak about one of the slipperiest and most misleading words I know.

If you wanted a biblical word for "people not like us," for "the other," you could draw on, for example, Matthew 6:7, *ethnikoi,* "people of the [other] nations," which imitated Hebrew usage. It equates roughly to "gentile"—which is to say, people of another nation, another tribe, who live somewhere else and have other customs from ours. When all religion was local, that was a plausible way to talk about people unlike yourself.

But the successful Christians of late antiquity chose to go beyond the Bible for the word they needed, and so we get the entirely nonbiblical "pagan" from Latin *paganus,* alive to this day in, among others, English and the Romance languages. It's a critical, and dangerous, part of how we think about ancient religion.

"Paganus" to a classical Roman was something like "peasant," and indeed the English word *peasant* descends to us from the same

root as does *pagan*. A *pagus* was a country district, a *paganus* someone who lived there; so Cicero tosses off a phrase about *pagani et montani*, "peasants and mountain-folk."[1]

Two things happened to get this word to where we see it now. First, a sharp-tongued Christian used it to make a point.[2] In early Christian metaphor, the true Christian was a "soldier of Christ," *miles Christi*, which made good sense especially among those communities that were insisting that Christians could not serve as real soldiers in earthly armies. At about this time (call it 200 CE), with a Roman army distributed from Scotland to Jordan to Algeria to Moldova, occupying forts and camps in country districts to protect the borders of empire against the illegal immigrants they called barbarians, the word *paganus* had become in ordinary usage something like the everyday word for "civilian." If you weren't a government-paid, well-dressed, well-fed soldier in those parts, you were a "civilian," a *paganus*—and the word wasn't any more kindly meant than its equivalent on modern military bases. You just weren't serious, weren't strong, weren't a fighter; you were just ordinary, tedious, gutless, and poor.

In the Christian usage, you were then either a soldier of Christ or a civilian, a *miles Christi* or a *paganus*. Most of the people expected to hear this language were either Christians or heading toward becoming Christians. The goal was to flatter both groups that they were the few, the proud, the brave, the martyrs-in-waiting. The *pagani*—they got a sniff and the back of a hand and nobody thought any more about them. It's the story of an ordinary speaker's and preacher's trick, using familiar vocabulary and images to make a point.

Time passed. By well into the 300s, Christians were everywhere. Christianity was fashionable, it had state backing, new church buildings were going up, and bishops were now men of substance with permission to use the imperial system of fast relay horses to get from town to town. After a very long period in which Christianity in the

Latin-speaking world hadn't produced theologians or developed a culture of dialogue and debate, now there were many Christian writers. Some were Roman dignitaries and scholars who got religion, such as Ambrose or Jerome, while some were provincial intellectuals, such as Augustine. The newly invigorated and confident literature of sermons, treatises, and poems that they produced constitutes one of the golden ages of Latin literature. We have more surviving Latin literature from this century between 350 and 450 than for any comparable period before that, including the more famously golden age of Caesar, Cicero, and Vergil.

Some of these Christian writers imitated the larger and more sophisticated Christian literature already available in Greek and read what they could find of earlier Latin Christian writing. We can't pin down its origin, but in a few writers beginning around 370 we see the word *paganus* crop up again.[3] It was handy, now especially, for Christian writers full of themselves and the success of their tribe, to have a word for *them,* the old school folk. Here was a good word ready to hand.

There was only one problem. The slightly precious point of the way the word was used, where *paganus* was the un-*miles,* got lost. The Christian writers of the fourth century just knew it was a word that older Latin Christian writers had used to label their enemies and took it up to use themselves. When they had to explain its origin and meaning, they did what they often did when faced with an etymological question: they made stuff up. Sometimes they'd get things right by accident, but they had little way of knowing that. One of my favorite of these explanations is the root they find for the word *lucus,* a thick stand of trees in a forest where a god might lurk, where spooky darkness reigned in Tolkienesque woods. Etymology? *"Lucus a non lucendo"*: roughly, "we say *lucus* because there's *no* light there." A silly thing to say, but it sufficed.[4]

By that measure, the fourth-century Christian etymology of

paganus is quite sensible. Country districts, the argument went, were the places where Christianity made slowest progress, and those still stuck in the old ways were *pagani*. The part about country districts wasn't true, but it had the great advantage of mocking the traditionalist values of city people who prided themselves on their urbanity. For an *arriviste* Christian polemicist to point to some perfumed gentlemen and call him a *paganus*, a countryman, was just witty.[5] When Christians wrote in an earnest attempt to convert these people, they stayed away from the word for fear of giving offense.

So pause there. This word isn't an analytical term from philosophy or even sociology. It's a stereotype, a club to hit people with. The speaker has drawn a line of his own choosing between them and us. What "they" think of it is not as important as what the word does for building a common consciousness for the in-group. (The lesson of the Pharisee in Luke 18 hadn't entirely sunk in.) Team-building, we call it nowadays, and the unlearned lesson is the one from Robert Frost's poem about wanting to know what he was walling in or walling out and to whom he was likely to give offense.

Use a word often enough, and you begin to think it describes reality. You begin to think people you've labeled and lumped together are an actual tribe deliberately organized to thwart your own. Not only have you made *pagans* seem like a real group, you have, in distinguishing yourself, become an un-pagan, with special qualities.

Until that label was created, though, *pagans* didn't exist. There were people who lived here and there, people who spoke this or that language, people who were rich or poor, people who attended this or that festival because they enjoyed it, and people who were so tired and poor and ill that they just got through the day as best they could. It was the Christian who came along and called all those people by one name. Christian common identity was strengthened by the shared conviction that the us/them relationship was real. "They" didn't much care.

Centuries at least would pass still before anybody firmly outside the Christian community ever used the word to describe himself. Even more time would pass before anybody would not only use the word but accept it and take a little pride in it. Yes, eventually, the word would begin to have a functional meaning independent of its original polemical usage. When one community dominates the conversation long enough, even people who do not belong to it begin to accept its categories and shape their behavior according to them. In Israel and in Utah, I've understood myself to be a gentile, but I had to work at it.

Notice now the most important part of this discussion. The usefulness of the words *pagan* and *paganism* grows genuinely strong *after* the nominal "triumph of Christianity" in the time of Theodosius. Julius Caesar wasn't a pagan. He wouldn't have understood what you could possibly mean by getting out of your time machine and calling him one. No one else would have understood either.[6] People became pagans when it was convenient *to Christians* for them to do so. Calling the others by that name made it clear just how special, unique, and different Christianity claimed to be.

There's one oddity to all this that's worth bearing in mind. The Greek language, still the language of the most prosperous and populous regions of the Roman Empire, essentially the language for every city east of Belgrade and Benghazi all the way to the Euphrates, did not take up the term *paganus* or one like it. In those parts, the settled term even among Christians for traditionalists in matters of religion— and not just of religion—was *Hellenes,* a word that did mean something. Hellen was the mythical progenitor of a tribe whose name eventually expanded to be the everyday Greek word for "Greek," and at least by the test of language it was easy to tell to whom the term pointed. The natural opposite of "Hellene" is not a religious term but a linguistic/ethnic one: "barbarian." This opposition points to a very different kind of us/them polarization, one with its own pathologies.[7]

The story of the word *pagan* has important implications. We use "pagan" and "paganism" habitually and unthinkingly and they leave at least the idea that once upon a time there really were such people locked in a mighty struggle with the Christians. There aren't good alternatives, and for good reasons. I know scholars who insist on saying "polytheist" instead—but that has the same problem as "pagan," because nobody ever thought of himself as a polytheist *until* some other person began to make a large fuss about monotheism. I incline to say "traditionalist" and use that word from time to time, I hope when it's clear what I mean.

When Christianity came to war with skepticism and unbelief in the eighteenth century, the pagan-Christian story became a kind of proxy war for modern attitudes. An intense debate over Gibbon's infamous fifteenth chapter of *The Decline and Fall* on the rise of Christianity had little to do with history and everything to do with Gibbon performing and devout readers attacking his own passage from Anglicanism to Catholicism to skepticism. From approximately that time forward, the war between pagans and Christians offered believers a place to demonstrate the exaltation of Christianity and offered unbelievers a chronicle of its hypocrisy and corruption.[8]

In the end, the creation and propagation of the term *pagan* succeeded in making Christianity seem a unique un-pagan, modern entity. Just how true was that claim? Excepting Judaism, was Christianity essentially different from all the other religions of Mediterranean antiquity?

Chapter 14

THE FIRST CHRISTIAN EMPEROR

I F THE EMPEROR JULIAN HAD NOT EXISTED, GORE VIDAL WOULD have had to invent him, not merely write a slightly scandalous and excellent novel about him.[1]

Julian is so useful, as hero or villain, that we should be suspicious of him—and pay close attention to what made him tick. This is the old story about him: orphaned and raised by a clergyman, he went off to university studies in the still pagan city of Athens and there fell in love with the old ways in philosophy and religion. Concealing his sympathies, he made his way to the throne, threw off his mask of conventionality, and took on the hero's task of restoring religion and culture to the ways of old. Cut down too soon on a battlefield, he left his task undone and others soon smothered his memory. Young, witty, wise, skeptical, passionate! It is likely only the profound conservatism of the American film industry that has kept him, in Vidal's near-screenplay-quality version, from becoming a hero of modern cinema. Plays about him by Ibsen, Kazantzakis, and Regis Debray attest to the appeal Julian has for modern sensibilities. Perhaps this portrait is too perfectly molded to our contemporary tastes to be accurate.

Julian was Constantine's nephew, his father a much younger half brother to the emperor. Julian's mother, Basilina, was a well-connected bride for a prince, related somehow to the same Eusebius of Nicomedia we have seen at the side of Constantine in his later years. Julian himself was born in 331 or 332 and thus was too young to have any useful memory of the great emperor in the family. He saw family only through the lens of murder.

We saw the rivalry that ensued when Constantine died and left his realms to be divided among his three sons, Constantine, Constantius, and Constans. Constantius's subsequent murder of the surviving kin of Constantine spared Julian and his half brother, Gallus, as they were considered too young to kill—Gallus, about twelve; Julian, only six or seven. Initially brought up by Basilina's mother and supervised by Eusebius of Nicomedia, when the latter died they were put away to a remote imperial estate in central Asia Minor, there to be looked after by a local bishop in gilded exile. The six years there brought Julian to advanced adolescence at a critical time for the empire.

Constantius and Constans had maintained an equable balance of power, but revolt in the west cost Constans his life and in 350, Constantius found himself sole emperor, childless, heirless, and, because of his purge, short on relatives. He summoned Gallus, now a thug of twenty-five, to court, invested him in the purple, and left him to govern the east while he, Constantius, went west to deal with the uprising. Constantius was successful, Gallus—who proved to be a brute without imagination—less so. Julian at this moment might have escaped attention.

Still considered young enough to be harmless, Julian found himself first in the capitals of Nicomedia and Constantinople, receiving a firm religious education in the style of the prevalent Arianizing Christianity of court circles. He remained under imperial supervision for the next few years, while undertaking a serious study of philosophy. In 354, Constantius had Gallus executed and turned

his attention to Julian (now in his early twenties), summoning him to appear at his court in Milan. Constantius was unimpressed with what he saw and, after some skeptical examination, let Julian have his way and go off to Athens for further studies. There his associates included the future Christian bishops of distinction we know as Saints Basil and Gregory Nazianzen, acquaintances likely made already during Julian's exile in their home province of Cappadocia. Julian would have made as plausible a bishop as they and a quiet appointment as such in a remote city would have been a good way to remove him from the temptations of power. We are also told that he was at this time taking an active interest in traditional religion and had himself initiated to the mysteries of Eleusis.

Here pause and consider how our own expectations are swaying this story. For many in Julian's world, participation in Christian services and an interest in philosophy and traditional religious practices was neither forbidden nor of much interest. The most eager Christians struggled to claim the exclusive devotion of their followers, but with only moderate success. A generation later, Synesius of Cyrene would settle comfortably into a bishopric with an education very similar to Julian's.[2] Such men could be satisfied with the new Christian god as long as he prevailed, but were not deeply attached and surely not easily shocked or distracted if someone maintained a broader range of religious interests. Constantius continued most of the restrictions and constraints that Constantine had placed on traditional practices, but that was an inconvenience and foible of the throne, not something people read as a great turn in history. Julian had his idiosyncrasies, which his enemies and idolizers love to dwell on, but he was far more normal than legend can let him be.

If Julian was distinctive in any particular way, it was for that Christian upbringing, at court and in Cappadocia. Julian would be the first man ever to come to the throne of the Roman Empire with a long and deep experience of Christianity, closely supervised by

bishops. Whatever he believed and practiced when he came to the throne, he brought his Christianity along with him as well. When he came to places where traditional religion was practiced, he saw it with an eye tutored by Christians. Conceiving traditional culture as holistic paganism, as if it had essential features that differentiated it from Christianity: that lesson Julian had learned well from his Christian teachers. In that fundamental way, Julian was always a Christian.

Athens did not have long to work its magic on him. Recalled to court in 355, Julian was sent out to be Constantius's figurehead on the Gaulish frontier with Germany while the senior emperor attended to business on the Persian front. With no military experience and no expectations to live up to, Julian was bundled off to the front with a team of minders and watchers. Generals would do the work, while Julian represented Constantius and performed the role of a Caesar, or junior emperor.

Julian's great advantage, and eventually his downfall, lay in his unexpected display of ability in Gaul. He turned out, against all odds for a bookish young man with no military experience, to be shrewd in military matters and, better still, successful in them. The soldiers took to him and he, wisely, to them, for all that he spent his nights reading and writing in his tent, for all that he lived a life considerably more abstemious than might be expected of a general. (His books are well worth reading, from high theology to satire. His *Hymn to Helios* can be solemnly read as evidence of a solar cult in late antiquity, but those who do so rarely remember to link Julian's enthusiasm for the sun god with Constantine and Constantius's affinity for Apollo.) With some early signs of success, this lately bearded boy charmed many. In a campaign of two years, he drove marauders and would-be settlers back across the Rhine, sealing his reputation with an underdog victory at Strasburg in 357.

Perhaps more intelligent and better educated than most, he soon

turned his attention to the most difficult matters of civil government, taxation and the enforcement of taxation, a vital necessity for keeping troops provisioned and happy. In short order, he had both improved tax collections and consequently lowered tax rates. By cleaning up corruption, he effected the neat trick of leaving people happier paying taxes than they were before.

Julian was in Gaul for five years, as successful a general and ruler as had been seen in those parts in the fifty years since Constantine and his father had left the region. Success among high-ranking generals could lead in only two directions: the throne or the grave. Julian's troops were loyal and took it badly when a command came from Constantius on the Persian frontier summoning most of them to join him in a war that had become appreciably hotter. Rumor whispered that Constantius's move was driven partly by jealousy and a desire to make sure that the young general did not become a real contender for the throne. The inevitable—among Roman armies—consequences followed, with acclamation of a new emperor, reluctance (feigned or not), and eventual acquiescence. By the end of 360, still fighting on the western front, Julian had assumed the title of Augustus and thus claimed equal standing with his cousin. Constantius could have chosen to bless this accession, but he condemned it instead. In 361, with both frontier wars in remission, the two adversaries turned their armies toward each other.

Julian took a northern route, along the frontier and close to the Danube, while sending some of his forces in parallel through northern Italy to alert, recruit, and pacify others. He came as far as his grandfather's native town of Naissus and paused to watch events elsewhere. Constantius's forces were coming west, the emperor at their rear, and the first skirmishes had begun at Aquileia, in northeastern Italy.

Then Constantius died. He had made it back to Roman territory from the difficult camp life on the frontier, but fell ill and died

before he could confront his cousin. With no realistic alternative, he declared in his will that Julian should succeed him.

Julian had thus sustained his possession of the most important of an emperor's resources: sheer dumb luck. What could have been a wasting campaign turned into a triumphal procession from the Danube down to Constantinople. It was 361 and Julian was the thirty-year-old master of the universe. Hosting Constantius's very Christian funeral in Constantinople confirmed Julian's power.

At this point, still confident in the luck he would call the favor of the gods, Julian began to rely on his education and intelligence to carry him forward. He did several of the things new emperors needed to do, like prosecuting and executing a few of Constantius's courtiers for corruption. He also pursued ambitious reforms that were probably better left undone. Relying on an old idea of the dignity and independence of the cities and citizens of the empire, he sought to reverse the same "big government" centralization that had made it possible for Diocletian and his successors to bring order back to the huge shapeless empire after half a century of chaos. When Julian took power, the division and redivision of Roman provinces had seen these administrative units grow from 46 two centuries earlier to 121 now with the same or slightly less territory under administration. The tax man was everywhere and the wealth and initiative belonged to the emperor.

What Julian might have tried to do to unsettle this arrangement is largely a matter of speculation, because he remained in Constantinople only five months before beginning in early 362 to make his way east toward the Persian threat—and the opportunity for his own glory.

Julian had a bumpy time in the great city of Antioch, where he paused to gather his forces along the way. His personal style played badly with some there and tetchy displays of imperial crankiness did not help. Within a few months he was horsed again and heading east to defeat the Persians. Great military success in the east would

consolidate his power and give his other ambitions vital support. He wasn't the first Roman general heading in that direction thinking he might become the next Alexander the Great.

It's hard to know what might have happened. As it was, he left Antioch in March 363 and three months later lay dead in his tent, the victim of an abdominal wound in battle that no contemporary physician could heal. Early rumor, opposed by early testimony, thought he might have been killed by one of his own men; later and more sober discussion and report made it clearer that it had been an enemy weapon that reached him; still later legend would try to give credit to his religious opponents. Writing sixty-five years later, the church historian Theodoret, bishop of Cyrrhus in Syria, claimed that when Julian realized the gravity of his wound, he "filled his hand with blood and cried, 'You win, Galilean!' "³ Scholars now criticize the strategy and tactics of his fighting, but some credit must be given to the end of his lucky streak. A general fighting in any ancient battle was taking a huge chance with his life, and that chance sometimes had to turn out badly.

When Julian was dead, his philosophical praetorian prefect, Saturninus Secundus Salutius, was offered, but declined the office.⁴ Instead, a senior officer named Jovian was quickly selected to take the throne, and he led the armies back out of Persia to Antioch and to safety. Jovian died of mischance or malfeasance en route to Constantinople a few months later and another general, Valentinian from Pannonia (roughly modern Hungary), was selected to replace him. He ruled till his death in 375 and his brother and sons ruled after him for another seventeen years. By then, another general, Theodosius the Spaniard, had been selected and had shared rule from 379, dying himself in 395. His dynasty would last halfway through the fifth century. All these men were Christians.

These transitions illustrate the stability now achieved by the military aristocracy. Rome in the fourth century knew how to do its

business. What is beyond striking is the mismatch between the ordinariness of this story and the flamboyance of what we think we know about Julian. Did he not struggle to overthrow Christianity? Was it not a struggle to the death? How could that not have affected the succession?

One answer might be simply that the Christians had the power and exercised it coldly in the debate among generals the morning after Julian's death, but that possibility—itself a sign of the entrenchment that Constantine and Constantius would have had to achieve to make that so—is at least somewhat undermined by the eyewitness testimony (of Ammianus) that holds that the throne was offered to Salutius. If anyone around Julian would be of a mind to continue his campaign in matters of religion, it was Salutius. He not only declined the position, pleading illness and old age, but retained his office as praetorian prefect through Jovian's reign and into that of Valentinian. If Julian had *any* support for his supposed campaign of eradication, it is hard to believe that this particular transition story would have played out. Instead all we hear is that when Jovian, some kind of Christian, took command, he consulted the soothsayers before choosing his course. In the circumstances, no one would either have objected or placed much weight on his doing so.

Stay with Ammianus Marcellinus for a moment. An officer and a gentleman, he had had a solid midlevel career in the Roman army, serving in Gaul and in the east with Julian. In retirement he wrote a vivid and incisive history of his own times, modeling himself on Tacitus and incorporating his own eyewitness testimony. (His account of escaping from the city of Amida on the Tigris when it was besieged by the Persians is breathtaking.) His sympathies were *not* with the Christians, whom he gently and sometimes not so gently lampoons in his history. (Their bishops went to so many conferences via the public system of relay transport for high officials, he said, that the system threatened to break down.) He shows every rea-

sonable sign in his language and his inclinations of sympathy with traditional ways of thinking about religion. He supported Julian as emperor wholeheartedly.

The *one* thing about Julian that Ammianus demurs at is precisely Julian's religious enthusiasm, and he demurs strongly. At one point he has an outburst: "but it was *really* extreme of him to forbid Christians from serving as teachers of rhetoric and grammar—that's something to be buried in eternal silence!"[5] That ban was one of Julian's faltering steps against Christianity, to which one witty Christian intellectual reacted by writing up the Christian story in traditional genres—epic, tragedy—to make them teachable texts.

Ammianus's attitude confirms for us that whatever was at stake in 363 at the death of Julian, a die-hard struggle between religions was not it. What Julian was about had everything to do with Julian and his demons and little to do with the wider religious history of his time. If we stay at the level of external and verifiable events, he did try to reverse the campaign Constantine had begun to make Christianity the primary religion of the Roman world. He restored funding to temples and priesthoods and removed privileges from Christian churches and Christians. He undertook to revive specific rituals and temples, not always successfully.

In one case at Antioch, things had gone too far. It wasn't just that the oracle of Apollo at Daphne, a resort suburb of Antioch famous for its elegance and infamous for its decadence, had ceased speaking. When Julian went to reawaken it, he found that Christians had buried a martyred bishop of a century earlier on the site, rewriting its sacred geography in the same spirit with which the louche Clodius had built a temple on the site of Cicero's house. When Julian went to restore the old normal, a mob protested and shortly afterward the temple, forcibly reopened, went up in flames. Julian, whose knowledge of the ancient ways seems to have come heavily from books, had misread the place, the people, and the times. If there had been a long lapse in

patronage of places like this temple in the third century, and now a long advance of patronage for Christianity, Julian could seem to be a century out of date to his contemporaries. What he faced was not so much hostility or opposition as incomprehension.

Julian had also decided to show his support for traditional religion by authorizing the rebuilding of the temple at Jerusalem, now three hundred years destroyed. This story comes from the usually reliable Ammianus, who nevertheless offers a miracle to explain how the effort came to nothing. When workmen began to dig, "fearful balls of fire burst forth with continuous eruptions near the foundations, burning the workmen and making the place unapproachable."[6] A modern who does not believe, goodness gracious, in great balls of fire has to note that the supposedly pagan source is offering us a story that sounds either very Jewish or very Christian.

Then there was outright competition. Christian churches had become notable for their "charity"—organized redistribution of the resources of kindness and sustenance and money to the disadvantaged members of their community. Such practices went back a long way in Roman fraternal organizations, but with the elevation of Christianity to the rank of a state religion and the flow of riches that came with that, the opportunity to be generous was greater and was noticed. The men of old had been looking to demonstrate how wealthy they were; the churches were looking to demonstrate how kind they were. Julian observed all this with admiration and so began to promote the organization of similar benefactions through traditional religious organizations. This was paganism remade in the image of Christianity—not a bad idea, but hardly a restoration of lapsed tradition.

By this time, Julian should be reminding us of Augustus. Both of them found a political situation that they wanted to remake for their own benefit, both declared a failure of religious loyalty that few others had detected, and both set out to remake religion in the name of restoration—for their own benefit. The simplest way to com-

pare them is to observe that Julian survived two years on the throne after the defeat of his last adversary, Augustus forty-four, and that makes all the difference. Julian further did not recognize how well entrenched religious novelty was and how apathetic traditional devotees tended to be. Had Julian survived the Persian war and returned to make good his claims to restoration, he had a long, potholed road ahead of him.

Julian's own personal ideas—given that we can approach him so closely—have attracted intense interest for many years, though they are only marginally relevant to his public actions. The reigning scholarly orthodoxy for a century and until quite recently made of him a romantic hero. Some simply lionized him, while others belittled his naïveté and quirks of personality. Most recently, less biographically intense scholars have eschewed speculation to give us a more realistic picture.[7]

Julian did not believe in the Christian god or attend his services any longer, but the effects of his Christian education and upbringing still determined how he thought about religion. His education consisted of conventional readings in the ancient classics and the ancient philosophers, but these were accompanied by their more recent commentators who had rewritten the ancients into modern dress. The philosopher Iamblichus, in particular, perhaps some kind of descendant of the relatives of Elagabalus, had died around the year of the Council of Nicea. His work interpreted Plato and contemporary neo-Platonism very much in the spirit of Alexandria—that is, of the spirit of Christian philosophical speculation. Neither his hostility toward Christianity nor Christian hostility toward him should conceal just how closely the two schools resembled each other in how they thought about religious ideas.

What the "moderns" of this period shared with Christian intellectuals was a converging sense that philosophical doctrine and religious practice were entwined and that fundamental spiritual forces

were to be engaged by that practice. The rising status of the divine was accompanied by disagreement about how best to commune with it. Where the factions differed was on precise matters of doctrine, not least because the Christians acknowledged the authority of special books that no philosopher outside their tradition would deign to respect. They differed as well on questions of which religious practices best connected votaries with the divine powers of the world. *Those* questions were eminently empirical. That is, and we are still on traditionalist ground here, the true god was one who responded to the call of your worship. The divine practice that Iamblichus favored has come to be called "theurgy," depending for extraphilosophical guidance on a set of books called the Chaldean Oracles. These commentaries on mystic verse, supposedly from Persian Babylonia, had been increasingly in vogue since they were first circulated in the second century CE and had taken shape mainly in neo-Platonic circles.

Platonic or Christian, divine power loomed larger and scarier than ever before. Right and wrong, truth and falsehood had intruded where a rude pragmatism had formerly sufficed. It was no longer enough to boast of what worked for you (whether or not it worked for your neighbor) and no longer possible to detach philosophical reflection from the realities of the cult—as Socrates had, at the opening of the *Republic,* when he attended a festival at the Piraeus. Now these things mattered fiercely.

By his every action, Julian paid tribute to the Christianity he never escaped. The old rites he tried to revive were too consciously in competition with Christianity; the organization of cult and service no less so. It made great political theater for him to be seen as a reviver of the old ways, but in every important way he was modern and his revival superficial. It is no wonder that when he was gone, it dried up and blew away as easily as a desert tumbleweed.

Chapter 15

THE SERVANT OF CHRISTIANITY

I WISH I COULD TELL THIS PART OF THE STORY THE OLD-FASHIONED way. It had such charm . . .

Wedded to a past which was gone for ever, absorbed in the cold and stately life of a class which was doomed to political impotence, struggling to ignore the significance of a religious revolution which was already triumphant before his death, Symmachus may appear, to a careless reader, a mere fossil, a shadowy and feeble representative of an effete order. Yet the man's very faithfulness to that order gives him a pathetic interest. And his faithfulness, and that of the school to which he belonged, is the sign of a certain strength and elevation of character. . . . Commanding such universal respect, and surrounded by family affection, Symmachus enjoyed a certain subdued happiness. He was the witness indeed of great changes, which shocked and wounded old conservative and patriotic feeling. But he never lost his placid faith in the destiny of Rome. Although he was a devoted pagan, he would not deny that his Christian friends had

found another avenue to "the Great Mystery." And a true charity will not refuse to him the same tolerant hope. He is almost the last Roman of the old school, and, as we bid him farewell, we seem to be standing in the wan, lingering light of a late autumnal sunset.[1]

I copied that last sentence carefully into a notebook when I first read it forty-some years ago, for Samuel Dill's book was then still the most easily accessible account of the affairs of these years in English. He captured the romanticism of high liberal culture in Europe, patronizing toward every kind of religious view and particularly the official Christianities of its time. This high liberalism—very likely a churchgoing liberalism—sees the story of Christianity's rise as a story of lost opportunity, of a moment when enlightenment almost prevailed and milk-and-water paganism, so enlightened, so nearly innocuous, displayed an elite and tasteful population very nearly free of the scourges of superstition and religion. Julian's idiosyncratic zealotry was lumped in with the attitude of men a generation later to tell a wistful tale of Rome's last pagans.

That story has now all but completely collapsed.[2] Where once was portrayed a struggle to the death, now we see a world in which one side—the Christians—was fighting hard against a fabrication. It's not that there were not traditionalists and traditional practices. It's not even, as we saw with the *taurobolium*, that there were not novelties. Routine alone provided momentum, however, while philosophical elevation took many curious minds away from site-specific rituals and their stories. Serious people—philosophers, intellectuals, theologians of whatever stripe—now viewed all religious practice from a loftier plane. Porphyry and Iamblichus did as much to weaken traditional practices as did Constantine and Constantius.

Brute force played its part as well. When in the last decades of the fourth century, a new generation of Christian rulers emerged who

were willing to enforce the new religion, many enthusiasts for tradition would melt away.

Viewed in the long term, the fourth-century empire's insistence that Christianity replace traditional religion was patient, persistent, and strategic. It began with a governmental preference for the new. Then, gradually, financial support for the old traditions diminished. New rites, new buildings, money, social position, and imperial example increased the pressure on the old ways. Then after almost two generations came a comprehensive ban on practices, a more systematic withdrawal of funds and enough deployment of official and unofficial temple-busting to make the old ways go away all but completely.

For most of a century, this combination of exhortation and financial starvation was left to do its work while the reins of power fell into the hands of Constantine's officers, then their children, and then their grandchildren—who knew no other world. By the time of Julian, half a century after Constantine's victory at the Milvian Bridge, support for *anti*-Christian action was thin to nonexistent. We have seen Julian's successors now not merely Christian but Christian in a matter-of-fact way, with no axes to grind and no special attention to religion as a matter of public policy. This was the state of affairs for twenty years through the reign of Valentinian and the reigns and regencies of his brother and sons. A leading senator, middle-aged by ancient standards, in the early 380s would have been born after Constantine himself was dead and would not yet have achieved manhood when Julian came and went. He was entirely a creature of the world Constantine had made. Demand for divinity is never universal, rarely intense. Christianity was good enough.

When I imagine that senator, I am thinking of the very man, Quintus Aurelius Symmachus, whose autumnal praises I quoted.[3] In every traditional account of this period, he is the spokesman for

paganism and the follower-in-chief of a "last pagan revival" led by his older friend Praetextatus. I tell his story here to show how he was in fact something very different.

He could boast of old family, but this was common and these could be empty claims. By the late fourth century, wealth and influence in the city of Rome told a story of ancient heritage depending on new money and new position in the world remade by Diocletian and then Constantine. The great families of this age emerge blinking into the light of celebrity and influence under Constantine and after, perhaps marrying a daughter off to some rising colonel as insurance of continued social standing. The first stellar member of Symmachus's family was his grandfather, who served as consul in the year 330. His own father never reached quite as high, but our Symmachus gave his name to the year 391, and his grandson did the same in 446, and *his* son or grandson was honored in 485 as a young man. The family evaporated after his execution in 525 for conspiring against the throne. From the time of that first consulship, the Symmachi were wealthy and well-fed, quite happy with their own social exaltation, eager and active participants in the rituals of public life at Rome, comfortable as well in their country estates. With the Palatine Hill now effectively swallowed up by the palace complex—even if there was rarely an emperor in residence—the Caelian Hill a few yards away past the Colosseum and the Arch of Constantine was the best address in town and the Symmachi had made it firmly there.

Elite men of this stripe could imagine two kinds of lives. Some were creatures of the court, closely aligned with emperor and courtiers, rising from office to office and shaping the events of empire directly. These people were mostly the newcomers, the officers from the provinces, the first-generation arrivals. Those who had reached the heights were more cautious and detached. For them, a turn or two in office at court, lasting a few years in all, was enough to secure the

favor of the emperor's countenance, but wealth and home were more appealing than the inevitably volatile life at court. The emperor who favored you could be gone tomorrow, or those whom the emperor suspected could be gone and dead tomorrow. Symmachus and men like him emerge into view in the late fourth century as the leaders of the senate of Rome, by and large comfortably and carefully detached from life at court.[4]

Rome remained the conceptual center and capital and source of empire, but emperors were rarely seen there. It was a geopolitical backwater, not on the road from anywhere to anywhere. Constantinople had become the real capital of all the empire, but Milan was, if less grand, still important, the commonest residence of emperors looking after the western frontiers. Further from the center, Antioch in Syria and Trier on the Rhine were bases of operations for active emperors, and even elegant courtiers would visit them there periodically.

Rome remained suffused with a sense of itself and its past. Constantius had visited Rome once, in a grand ceremonial procession carried out with a sense of obligation and great obeisances to the past. He left as soon as he reasonably could and never returned. Julian never saw the city.

The forms of ancient life continued. The consuls entered their formal year of office with games and shows, pleased to give their name to the year, as a particular sign of favor from the reigning emperor. He himself might take the office once or twice himself, as pretext for showing particular generosity in the shows and spectacles he sponsored. The games and shows in honor of the new entrants to the more junior rank of praetor could be used by wealthy fathers to introduce their sons to public life. We happen to have a brace of letters from Symmachus describing how he undertook that generosity on behalf of his son. Hear how he reacts to a setback in mounting the games for his son:

They say that Socrates always thought it was useful when things turned out contrary to his plans or wishes. Secure in his own virtue, he thought that the gifts of chance were more valuable than the things he had been hankering after. I'm following his example now . . .

He needed his philosophical calm, because twenty-nine expensive Saxon gladiators had anticipated the violent deaths they were expected to inflict on one another in the arena—likely the Colosseum. In a murder-suicide pact they had strangled one another with their bare hands in their cells ahead of time, to find a less awful end for themselves. Symmachus's thinly veiled anger and contempt are those of a wealthy man who *needed* these games to display firmly the merits of the family before anyone could suggest that they were too newly advanced and too recently wealthy to be taken quite seriously. Inferior Spanish combatants had to be rustled up on short notice, an embarrassing and inadequate alternative. (The Saxons were blond-haired and blue-eyed, and therefore in Symmachus's eyes not terribly bright, but they made great natural fighters for the arena.)

We know Symmachus well because an extensive collection of the often jejune but always stylish and well-written letters that he wrote to family and friends survive, but we care about him because of a single episode in his life. In 384, Symmachus did a stint in public office as prefect of the city—elected leader of the Senate and chief of government of the city of Rome. From that year or so of office, we have a collection of his formal reports to the emperor, bundled together as one book of his larger collection of letters. He thus imitated the collection of letters Pliny the Younger had prepared almost three hundred years earlier, which Pliny had concluded with his correspondence with the emperor Trajan.

That collection makes clear that his time in the prefecture did not sit easily with Symmachus, mainly for the friction he had with the

professional staff that managed affairs for whoever might be temporarily in office as prefect. It was perhaps unfortunate that Symmachus chose thus to preserve the evidence that his skills in composing elegant prose outran his ability to manage public affairs.

One of his reports is famous for what came of it. Writing to the emperor in the late summer of 384, Symmachus represents himself as speaking on behalf of the whole Senate in requesting that the emperor reverse his order removing the "Altar of Victory" from the Senate house. The altar displayed what was ostensibly a trophy of the war with Pyrrhus of Epirus fought in the 270s BCE, a gold statue of the goddess Victory, winged above a globe. We have to assume that everyone believed the statue was authentic, without worrying too much about the assured continued custody of that artifact for a period of time as long as that which separates us from the childhood of Chaucer. Nor should we slow down to consider that the attribution to *Victoria* as a goddess may not have exactly represented how the original Greek artist had intended the object to be read. Instead, we need to see and feel the attachment to the antiquity of the object. That it had been placed in the Senate house by Augustus at the moment of his victory over Antony at Actium only added to the veneration it might attract. Anxiety was high because, when Symmachus wrote, worrying warfare was afoot in the Balkans.

The statue had already been in dispute when Constantius had it removed from the Senate house in 357 on the occasion of his one and only visit to the city. Quietly preserved, it was restored under Julian in 362. Now in 382, the young emperor Gratian, son of Valentinian and ruling in the west in his own name at the ripe age of twenty-three, had been prevailed upon by Christian advisers at court to take steps to make his own faith and loyalty to Christianity clearer. Like every emperor before him, including Constantine and Constantius, he had inherited the title of *pontifex maximus*, the one that Julius Caesar had used to his political advantage and that Augustus reclaimed

on the death of Lepidus in 12 BCE, a few years after the *ludi saecu-
lares*. This made him the formal leader of the college of pontiffs of
the city of Rome and thus the city's senior religious official. When
emperors came rarely to Rome, or not at all, the religious business of
the city continued, but when emperors were present, their robes and
function had been held for them. We do not know exactly how Con-
stantius handled this form of his welcome in 357, though the removal
of the Altar of Victory suggests he may have demurred.

Now a quarter century later, Gratian had been prevailed upon
to lay aside the title of *pontifex maximus* and direct the removal of
the altar from the Senate house.[5] Constantine's concern that Chris-
tians be able to participate in public life and his introduction of many
Christians to the Senate would have more or less eliminated the reli-
gious *use* of the altar half a century earlier. In a moment of stress and
fear, the goddess Victory might be thought of or invoked, but apart
from this one site in the Senate house, her Roman life would mainly
have been with the military.

Gratian died in August 383, killed for his throne by rebels in Gaul
led by Magnus Maximus, a general leading forces from Britain. He
left only his younger brother Valentinian II on the throne in the west,
a child of twelve. (We will meet soon enough the other emperor now
in service, Theodosius the Spaniard, added to the imperial college in
379 but for the moment far from Milan, ruling over the eastern half
of the empire.) Valentinian II was even more a courtiers' plaything
than was his older brother. His Arianizing mother, Justina, came to
the fore at a court still threatened by the rebellion of Maximus. By
early 384, then, there was a Christian claimant for the throne in Gaul,
Maximus in revolt (Symmachus, we think, praised him while it was
safe to do so), a child emperor and his mother on the throne in Milan,
and an opportunity for remonstration.

When Symmachus took up the pen to report the Senate's desire
to see their altar restored, another leading senator was at court

serving as praetorian prefect, Vettius Agorius Praetextatus, so Symmachus likely expected his colleague to supervise the report to a favorable reception. This was not revolt or struggle, but a statesman's gesture.

The document Symmachus wrote is handsome in its generosities. When that old account I quoted above refers to his views on the "great mystery," it evokes the most famous line of the report: *"uno itinere non potest perveniri ad tam grande secretum"*—"one cannot approach so great a mystery by one path alone." He sounds like an ecumenical modern, eager to claim that all religions, ancient and contemporary, are really the same, expressions in different cultural form of human awareness of and respect for divinity.

The handsome inclusiveness of Symmachus's sentiment was so striking that two years later a neophyte Christian intellectual, about to undergo baptism and full of the intellectual and spiritual excitement of his conversion, said something so similar that it had to be an echo. That young convert had been given a dramatic boost by Symmachus in his worldly career only two years earlier, just at the time of report about the Altar of Victory. They embody together the common culture of an upper class still finding its way to what it meant to live in a Christian empire. The same young man, forty years later, expressed regret for the too-inclusive nature of his remark, evidently embarrassed by the tolerance of his youth. By then he was an elderly bishop with a worldwide reputation as a fierce defender of Christianity against all the *pagani* of the world—he was Augustine. The elderly bishop's embarrassment might have been greater had he recalled that a few years later, in about 391, writing his book about "true religion" in which he claimed that if Plato were alive then, he would certainly have converted to Christianity, he, Augustine, had echoed the same phrase of Symmachus's again.[6] Symmachus and the young Christian convert Augustine had more in common than the aged Augustine could happily admit.

Unfortunately for Symmachus, his report to the throne misfired. Worst and first, his colleague Praetextatus died before he could engineer a positive response. If the fix was in, his death broke the chain of intended events. Then, rather than being forgotten, the report was taken up instead by the fire-breathing bishop of Milan, the famous Ambrose, and Symmachus lost all control of the situation.

Ambrose was no stranger to high politics, for his own father had been praetorian prefect and Ambrose himself had started on the fast track to political power. In his thirties, he was made governor of the province of Aemilia-Liguria—that is, of the province in which Milan was situated. Called in 374 to supervise an election of a new bishop at a time when Arians and anti-Arians in Milan were at every moment likely to take to the streets to cudgel each other, he found himself instead facing an anti-Arian crowd that invited him to take the office of bishop himself. He resisted for a week, succumbed, and became one of the most striking figures of his time. He used his office and his education to make himself the quintessential public intellectual. His abundant literary output as bishop is elegant, sophisticated, and deeply learned. Among other things, he was the first serious Christian writer in the western church to take the teachings of neo-Platonism seriously and incorporate them in his own doctrine. His ability to give Christianity a cultured and philosophical face, the better to create the role of Christian philosopher, gave him a broad audience and deep prestige across the Latin Christian world.[7]

He was related to everyone, including Symmachus himself at some distance. He combined in one office the advantages of his education, his social position, his ecclesiastical position, and his access to court and throne. As long as the western imperial throne was held by not one but two children, Gratian and Valentinian II, power was a thing of courtiers, among whom Ambrose moved easily. Had Symmachus's friend Praetextatus survived, Ambrose would have been an astute opponent in the matter of the altar. Absent Praetextatus, the

publicity bonanza around the letter was a walkover in favor of the Christians.

Ambrose responded to the report from Symmachus before he had seen it, with a stern letter to Valentinian that turned the gentle approach of the Senate into a gauntlet thrown down in the face of all sanity and religion. "They dare to complain of *their* losses? They never spared *our* blood and they tore down our very churches!"[8] Ambrose heaps on gentlemanly, quiet, tolerant Symmachus responsibility for all the persecutions and martyrdoms inflicted, in inflated historical memory, by all the hostile governors and emperors who ever were. The letter ends with Ambrose putting words in the mouth of the emperor's dead older brother Gratian: "I did not feel I was defeated, because you were there to succeed me; I did not lament my death because I had you for an heir; I did not lay down my command with sadness because I was sure that what I had commanded— especially in matters of religion—would endure forever. . . . Now I am wounded worse than before, for my brother despises my laws. . . . That was only the death of my body—this is the death of my good name!"[9] Soft words are met with a rhetorical hammer.

When Ambrose had a chance to read the actual report from Symmachus, he wrote a second letter, no more temperate but much better informed and transparently learned.

"One cannot approach so great a mystery," says he, "by one path alone." He lacks knowledge; we have it from the voice of God himself. He seeks wisdom by vain imaginings, but we have it from the wisdom and truth of God himself. Your paths are not our paths. You ask the emperors to grant peace to your gods, but ask Christ to grant peace to the emperors.[10]

The altar remained out of the Senate house, Praetextatus was dead, and Symmachus stepped down as prefect of the city. That was that.

188 *James J. O'Donnell*

The affair lives and distorts the telling of the history of this period. Almost twenty years after the quiet and slightly embarrassed end of the Symmachan approach, the Spanish Christian poet Prudentius picked up the controversy to make a moralizing poem of it. His two books of hexameter verse took what Symmachus and Ambrose had written and pounded the rhetorical hammer again. There have been efforts at various times to claim that the altar itself came back into play—requested again, perhaps even briefly reestablished in the Senate—but this is most unlikely and has only been believed because it has been so agreeable for moderns to watch this imaginary death struggle between pagans and Christians play itself out. What had been a modest request in a very narrow context became an opportunity for a full-out attack on all the old gods, with all the rhetorical tools that worked well against the mythic deeds of Saturn and Jupiter and their divine family.

Here I will stop for a bit, of fixed purpose, because the traditional melodramas that moderns have written about pagans and Christians in this period don't stop. They string together a series of assumptions and fragments into a story they already know before they begin to tell it. Stop your time machine in the year 385 and look around you.

No one by this time remembers the age of persecution first-hand. Remembered grandparents may have recounted the bad days of failing Roman government more than a century earlier, before Diocletian. But present frontier skirmishes are of greater concern in a wealthy and comfortable empire. Sixty years have passed since Constantine began construction of his great new capital city on the Bosphorus and formed his council of Christian bishops. He has been dead for almost half a century and few remember him. In all that time, two years of unsuccessful anti-Christian policy by an isolated and ineffectual prince over twenty years ago represent the sum of challenges to the new god's domination of empire. Many old rites, rituals, and places have suffered, both from the wars and economic

disruption of the third century, and by the conscious policies of Christian emperors to deprive the old ways of their sustenance. New churches are abuilding on all sides, some having already been in place as long as anyone could remember—like the large church in honor of Saint Peter built by Constantine on the Vatican hill just outside Rome, a few hundred yards beyond the site of Augustus's *ludi saeculares*.[11] Government and society are increasingly dominated not by Constantine's men, but by the grandchildren of Constantine's men. Many are still attached to traditional ways, but not everyone who praised the old ways did so out of high religious sentiment. Nor was it clear to everyone that such high sentiment needed to be exclusively given either to the old or to the new. Moderation and open-mindedness did not seem unreasonable.

The Symmachus who has been taken in many modern accounts to be the die-hard opponent of Christianity disappears from view when we look at him squarely. He emerges as a man of his time, calm, reasonable, with no great ambitions beyond those of a gentleman and father looking to secure a place for himself and his family. He made himself, inadvertently, into the ideal target for people whose religious enthusiasms he did not understand. These opponents were not all Christians by any means.

Symmachus will have known a good many Christians for whom the zealotry and antipagan ideology of Ambrose and Prudentius were undesirable. This was not because they were "lukewarm Christians." Rather, the votaries of Christ showed in that time as many different dispositions as they show today. The people whom zealots thought lukewarm thought themselves quite reasonably faithful and privately believed that they were showing better manners than some of their coreligionists. Symmachus corresponded with some such people, like the poet of Bordeaux, Ausonius, who had turned his academic career into a path to the praetorian prefecture a few years earlier, under Gratian. Christian in every way, Ausonius was not a man for con-

frontations or ostentation. The Symmachus who corresponded with a few such men formed his judgment of what Christianity might be from those who would be distressed by Ambrose's vehemence; but he would accept that distress and go back to his life sadder and wiser and fundamentally unmoved.

In that way, Symmachus was the perfect servant of Christianity. He gave them their whipping boy, but no opposition. They were the ones who profited from dramatic tales of duels with pagan madness—not least by the way they made those tales live on into our own time.

Chapter 16

THE TRIUMPH OF PAGANISM

Y OU HAVE READ THIS CHAPTER TITLE CORRECTLY, THE "TRI-
umph of paganism." If you already know some of this story,
this should be where I speak calmly and admiringly of the
triumph of Christianity. I should take the long view and recall the
humble beginnings, daunting opposition, deep faith, and perhaps
divine intervention that made Christianity the supreme religious cult
and experience of the later Roman world. There's still some truth to
that old story, but not enough. Again, the real history is elsewhere.

The first dynasty of Roman emperors, the Julio-Claudians,
expired with the spiraling descent of Nero in June of the year 68 CE.
Half a century later, the historian Tacitus, recounting the "year of four
emperors" that followed in 69, discerned what he called the "secret
of empire": the realization that emperors could be made in places
other than Rome. That year saw the contest fought by Galba, Otho,
Vitellius, and the successful Vespasian, each heading an army of his
own. Tacitus contributes to the practice of using the word *imperator*
to describe the supreme ruler of Rome, a word Augustus had shied
away from. The *imperator* from which we get the English word *emperor*

means "general, commander," ideally one holding authority over the Senate and people of Rome. (It was a title strictly to be conferred after the fact, on a returning victor.) From 69 onward, the military supplied the greatest number of rulers for Rome. The preponderance of exceptions came when existing emperors chose relatives to join them on or near the throne. It is not fashionable to speak of Diocletian's "tetrarchy" as a "junta," but our fastidiousness about words should not blind us to the great resemblance to modern societies where generals rule.

After Julian's demise and Jovian's brief moment, Valentinian's family took control. A generation ago it was fashionable to compare the flood of officers from Valentinian's native Pannonia who quickly surrounded the throne to the presence of Georgians in Jimmy Carter's presidential administration, but in such a system tested loyalty is essential. Valentinian, reigning from 364 to 375, needed help and so brought along after him his brother, Valens, and then his sons, Gratian and Valentinian II.[1] None of those three merits our respect. Valens was killed when his bungled handling of a refugee crisis turned it into a disastrous military campaign.[2]

With only the youngsters Gratian and Valentinian II surviving, the army urgently needed leadership. The choice fell on a successful officer from Spain, living in retirement back home but still in his early thirties and ready to come when called. Theodosius took the throne alongside Gratian and Valentinian II at Milan in 379 and proceeded immediately across the Balkans to take responsibility for the eastern frontiers of empire. He would later bring to the throne after him his own two unripe sons, Honorius and Arcadius, and Arcadius in turn would continue a dynasty in Constantinople. What they did after Theodosius was gone was often inept and sometimes dangerously so. With Arcadius begins the long tradition of emperors more often chosen in the palace than in the army, and often better left unchosen.[3]

Theodosius was a success, no question. He was also firmly Chris-

tian. He was not chosen for his religious views, but religion had a powerful influence in his rule. He intervened decisively in the simmering theological controversies that lingered from the council held at Nicea. In February 380, he made his own position clear in a slashing decree that firmly espoused Nicene theology as it had survived and reshaped itself by that time. Where Constantine had backed away from Nicea under prudent ecclesiastical advice, Theodosius enforced it. He had been raised on Nicene piety in a world where Christianity commanded respect, his military career postdated Julian, and he was himself from the Nicene far west. He engineered another council of the church's leaders, to be held at Constantinople in 381, under imperial supervision.

This council firmly reasserted Nicea and its slightly revised formulation is what is now recited in churches as "the Nicene creed." Where the last fifty-odd years had seen imperial vacillation tending toward the Arian end of the spectrum, henceforth Theodosius was unambiguously in favor of Nicea and the term *homoousios*. Now we begin to hear first the word *Catholic* (*universal*) used consistently as a proper adjective, to claim universal authority for the emperor's brand of Christianity. The word had long been in use by all as a generic descriptor of one of Christianity's excellences, but now it was claimed aggressively and put to use as a brand name for a faction.[4]

It took time, but the creed and the word *homoousios* won out. Accepting the identity of godhead with a human figure would raise other questions, questions that became the focus of equally heated dispute in the fifth century over questions of Christology, giving rise to the labels of "Nestorianism" and "Monophysitism" for variants from orthodoxy that subsist in some parts of the world even today.

Theodosius's world had internalized the idea of paganism that Constantine's revolution had given rise to. For him, it was clear that beyond the pale of orthodox Christianity lay Jews and heretics, and beyond there in outer darkness practitioners of an undifferentiated mass of cults of false gods. We can't know just what religious instruc-

tion the young officer Theodosius had, but we see in his years an increasing emphasis on the makeshift Christian interpretation that held the pagan gods to be demons or fallen angels. That gave them a place in the Christian story as beings partaking of divine qualities but of lesser quality and a diabolical insubordination. If you believe that, then it is a short step for a Christian imperial leader to decide he must do something about the paganism problem.

The Theodosian program against the pagans took two forms, overt and tacit. Tacit repression took the form of tolerated local violence that could flare up and die down in spasms over many parts of the empire over decades. To call it terrorism rewrites it into a modern idiom that may mislead, but the connection must be seen. Temples were sacked by imperial soldiers in some places, while in others soldiers turned a blind eye as local zealots did the dirty work.[5] Violent suppression of religious practice was occasionally employed by emperors and governors in what Christians would recall as the age of persecution to achieve relatively modest tactical ends and usually petered out in a few weeks or months into healthy relapsed tolerance. The religious violence of Christianity and Islam, Abraham's two younger children, had a deep religious motivation and a high religious goal—salvation for the terrorist and even for his victim.

Take one of Theodosius's most ardent and closest followers, Maternus Cynegius, unknown until he showed up in the retinue of Theodosius and quickly achieved power.[6] By 384, five years into Theodosius's orthodox times, Cynegius had become praetorian prefect, the highest officer of the imperial cabinet. A couple of years later, he began a grand ceremonial tour of the eastern provinces. This was a routine imposition on the main provincial cities, when they had to be gracious and welcoming to the prefect and his huge retinue, laying on speeches of welcome and listening to polite expressions and occasional barbed directives in return. In this case, Cynegius sent clear signals about the behavior he was prepared to tolerate, and so around him

and in his wake broke out the worst cascade of antitemple assaults yet seen in the Roman world. In a whole series of cities along the Euphrates frontier, Edessa, Apamea, and Palmyra, temples were destroyed by bands of monks—and it's a Christian source a generation later, the historian Theodoret, who proudly tells us this. A contemporary gentleman of the old school, the distinguished professor Libanius of Antioch, watched this progress with acute dismay, offering a public oration in protest. It was Cynegius's awful wife who egged on the even more awful monks, Libanius said, on a campaign of pillage ostensibly in the name of religion but really conducted out of motives of vulgar greed. Libanius knew the emperors had proclaimed a policy of tolerance, but could not admit that such policy could be undermined by connivance in high places. He would surely have protested the more if he had read, as we can today, the law of Theodosius from 382 that declared the great temple in Edessa (modern Urfa, Turkey) should be protected not for its religious significance but for its art. Cynegius likely saw to that one's ruin nonetheless, among many others. Ugliness was abroad.

In 391, Theodosius grew more decisive. His first enactment along these lines strictly forbade public officials from any participation in sacrifice on penalty of a fine of fifteen pounds of gold—with the sting that the official's professional staff would *also* be fined the same amount *unless* they could show that they had resisted and opposed the official's actions. Where Constantine had been sure to enable Christians to participate in public life, this enactment went much further to prevent traditionalists from carrying out public office in a traditional way. This again is a sign not of hostile resistance on behalf of the old but of hostile affirmation of the new. The penalties are substantial, but nonviolent. Violence was left to vandals in the streets.

That law was followed in 391 and 392 by a series of increasingly general prohibitions. By November 392, this general edict went to the praetorian prefect Rufinus:

No one at all, of any family or rank, in office or out of office, powerful by birth or born in a low condition, in no place at all, in no city, is to slaughter a victim before senseless graven images or venerate the lares with fire by lighting candles, the genius with wine and libations, the penates with sweet smelling garlands.[7]

This was the first time that Roman government formally banned sacrifice and in all its forms, even modest ones, for all people and everywhere. Theodosius would not have ventured it if he weren't certain he could make it stick. The implementation of such a law tells us that there was something to forbid, though the facts of Roman law enforcement meant that no such law could imagine being universally or consistently applied. The most direct impact was likely on the behavior of high officials, as many or as few as still practiced habitual traditionalism.

There is a dog in the nighttime to hear here, snoring very softly. Everything I have said in these last chapters about the steps taken to support and advance the cause of Christianity has had to do with the material circumstances in which the church operated. The flow of money and support and prestige toward the Christians, the flow of these same resources away from traditional cults, and the increasing interdiction of perfectly ordinary traditional behavior: this is how empire worked. What's striking is the absence of missionary activity.[8] Certainly there was recruitment and adoption of new Christians at a local level, but the rise of Christianity to near-universal adoption in the Roman world of the fourth and fifth centuries occurred without great missionary efforts, or what we might call "outreach." To hear a Christian preacher, even a great one like Ambrose or Augustine, you had to go into his building to listen—only then to be turned out in midservice while the baptized faithful remained for their eucharistic rite.

Then suddenly for a few years in the 390s we hear more about paganism—from Christians. Christians then and many modern read-

ers have been at pains to construct the necessary story of pagan survival and resistance out of very heterogeneous materials. It's hard to trace, but real resistance happened—away from the bright light of day. People continued to practice their traditional religions, out of habit and loyalty to one's ancestors. The ordinary persisted where it could.[9] Meanwhile, Christians constructed a gaudy story of struggle, resistance, and triumph. Taking the latter seriously tells us little about the former.

Life went on. Wealthy families raised children, threw weddings, and bit by bit, as the times and pressures changed, found themselves more and more associated with the new church and its practices. "Who could have believed," Jerome crowed, "that to the heathen pontiff Albinus should be born—in answer to a mother's vows—a Christian granddaughter? That a delighted grandfather should hear from the little one's faltering lips Christ's 'Alleluia', and that in his old age he should nurse in his bosom one of God's own virgins?" A generous observer would find the scene charming and unexceptional.[10] Albinus has perhaps the distinction of being one of the last known surviving members of a traditional Roman priesthood, for the old offices died out amazingly quickly after 391, and by 400 all had vanished.[11] The other lastling recorded was Flavius Macrobius Longinianus, known to have been a member of a priesthood but also named prefect of the city under Theodosius's government in the 390s. Scholars who insist on dividing the world into pagans and Christians acknowledge that he may have gone over from the one to the other by that time. They exaggerate what it took for a distinguished gentleman to find a convenient and unobjectionable way to make himself harmless to the regime in power.[12]

Old conservatisms sometimes ran foul of each other. When Praetextatus, the praetorian prefect whom Symmachus had counted on for support in the matter of the Altar of Victory, had been buried, there arose a question whether a statue would be erected in his honor by

the vestal virgins. To the surprise and unpursued bafflement of modern enthusiasts for the story of the great clash of pagan and Christian cultures, his friend and supporter Symmachus, likely because of his overall conservatism, was the one who opposed the erection of that statue.

When the emperor Gratian had given over the robes and title of *pontifex maximus,* the surviving college of pontiffs at Rome would have had to decide how to respond. There were two main possibilities. First, they could recognize the action and proceed, in very old ways going back eleven hundred years, to select a new *pontifex maximus.* Alternatively, they could hold that the emperor was temporarily misguided and hold the chair open for him out of respect for throne and empire and tradition. Both sides stood for conservative and traditional views. To one school of thought Praetextatus himself would be the natural and logical successor, the first nonimperial *pontifex maximus* since 12 BCE. The statue the vestals thus wanted to erect to his memory would have been in honor of him in that role. The opposition was based in the view that he had not officially held that role, but that it still inhered in the throne and would be restored when the emperors came to their senses. Even a decade later, few would have cared so much.

Those vestal virgins of the 380s were still supplied by willing families to a life of service and withdrawal, but it's far from an accident that the same families in this period also saw daughters and widowed women withdrawing from the world of marriage to take up the life of Christian asceticism instead. The persistence of this tradition lay both in the recognition that husbandless women of a certain class deserved a seemly life and in the habit of that life being divinely approved. When Theodosius finally took away the last public support—financial support—from the old religious practices, the vestals vanished. Surely there was a poignant story we do not know of, on the last day in the house of Vesta, when the fire thought to

have been kept burning for centuries went out for the last time, but poignancy is the rule of human life. If the vestals, moreover, managed to persist as long as the year 410, their vanishing would most likely then have resulted from the sack of Rome by the Visigoths. The end would have come when no one lifted a finger to restore what had been.[13]

In the 390s, we have often been told, people did still care about keeping the gods and their worship alive. In 392, there was a coup. Theodosius had quashed the uprising of Magnus Maximus that cost Gratian his life, took effective command of the whole empire, and supervised the padded-cell regency of Valentinian II in the west. A general beholden to Theodosius named Arbogast managed affairs at Valentinian's court. Valentinian, rising age twenty-one, rebelled, feebly. He professed to dismiss Arbogast and invited Ambrose from Milan to come to his own court in Vienne in southern Gaul to baptize him in the ways of Nicene orthodoxy. What Valentinian was thinking, if thinking is the right word for it, we will not know, but on the fifteenth of May 392 he was found by his courtiers in the palace in Vienne, dead by hanging, agent or agents unknown. Ambrose was polite enough to write a eulogy, but prudent enough not to let politics or moral judgment intrude on his words.

Ambrose had just had his own dustup with Theodosius two years earlier, launching an excommunication against him after the reasonably commonplace horror of a mass murder. A local uprising had angered Theodosius and so he sent in troops; thousands were killed; the emperor (professedly) repented and tried to send a command to countermand his first order, but failed; and the bishop saw a chance to intervene by appealing to the emperor's vulnerable presentation of himself as a devout Christian. Theodosius was the first baptized emperor who might take such a punishment seriously. Excommunication led to a few months' standoff, but then emperor and bishop made their peace with each other.

So Valentinian was dead: what then? The western general, Arbogast, at first proclaimed that Theodosius's son Arcadius, all of fifteen years old, would be emperor for the west. When that proclamation went unanswered from the east, Arbogast saw a chance and selected an emperor of his own, the kind chosen by a general unsure of himself. (Arbogast was a "Frank" and generals with "barbarian" heritage did not push themselves forward to the throne.) His choice, Eugenius, was clearly a puppet. Moderns emphasize that he had once been a teacher of rhetoric, like Ausonius who did become praetorian prefect, but that meant little to Arbogast. Eugenius's great features for Arbogast were convenience and pliability. At first Theodosius reacted with equanimity, but then saw that the future succession of his own young sons was at some risk and so in January 393 formally named Honorius, then all of eight years old, Augustus for the western empire. Arbogast and Eugenius were now to be seen as usurpers and so their only choice—to their dismay and perhaps even surprise—was to fight.

To give him a regime and some strength, Eugenius and his handlers selected a new "cabinet," featuring most notably Nicomachus Flavianus, a well-connected senator at Rome, to serve as praetorian prefect. Flavianus had served in the same office under Valentinian from 390 to 392, and so he knew the job and the staff and presumably had Arbogast's trust. The rump regime, fighting from necessity rather than purpose, had no chance. In 394—Theodosius was patient and careful—in a battle on the river Frigidus (the modern Isonzo, at the head of the Adriatic), Eugenius and Arbogast were killed. Flavianus committed suicide a few days later.

Chapter 17

WHAT REMAINED

W ITH THE SPLUTTERING OF THAT COUP, WE ARE BACK FIRMLY in the realm of the ordinary events and mischances of emperors, generals, and those who played their hands wrong in seeking to influence imperial succession. These events of 393–94 have long been puffed up into that "last pagan revival," with no more than shards of evidence and lashings of wishful thinking.[1] The focus is on Flavianus. He was a friend of Symmachus around whom cling wisps of sympathy for traditional religious practices. He had literary pretensions and so wrote jejune history and translated the life of Apollonius of Tyana into Latin. Except that we know about him and that he came to a bad end, he is unremarkable.[2]

Just enough of the old school clung to him that a series of slanders exploded in a thunderstorm in the writings of Christian polemicists. Ambrose, first of all, lamenting the loss of Valentinian so lately joined to the church, took the indifference and traditionalism of the new regime and blew it up into accusations that the usurper Eugenius was "soft on paganism." As imperial bishop and seasoned pamphleteer, he had an audience for his claims. From there exactly two other

contemporary writers fluff the story up as much as they can. Augustine a generation later takes them seriously; and then a string of church historians follow who turn out to have no idea that there was supposed to have been a pagan revival. When a reactionary writer deliberately set out in 500 to tell a pagan history of Roman times down to his own, he too was unaware that there was ever anything pagan about this insurrection. When the evidence is sifted down, it turns out that the worst Ambrose can accuse Eugenius of is not being himself a pagan, but offering funds to support the traditional cult— banned only a year before his appointment. (Without knowing the circumstances, there could well have been a time and place where this would be a convenient way for a dodgy emperor-wannabe to purchase support for cold cash.) When Arbogast and Eugenius made rude remarks about Ambrose, moreover, their hostility was that of insurgents sneering at a courtier on the side they looked to overthrow. Religion had nothing to do with it.

The most dramatic event of this supposed revival is the final battle on the Frigidus. Statues of Jupiter and Hercules were erected by the insurgents—as would have appeared on battlefields for more than a century, since Diocletian associated those gods with the throne, and as would have been guaranteed to get the goat of the hyperreligious Theodosius. Then a wind miraculously blew up from behind Theodosius's forces and hurled their own weapons back in the faces of the Eugenius/Arbogast party, turning the tide of battle. We are meant to be shocked and credulous. Dead rebels tell no tales.

This is also when the story of the *taurobolium* and other horrific tales of paganism were put abroad by Prudentius, even as the ceremonies were being suppressed. Now and in the century following, stories of Christian martyrs were written in abundance and circulated widely, with as little regard for fact as possible. The audience was invariably Christian, eager to oppose the demonic old world and to justify the suppression they now enacted in the name of truth and love.

The best marketing often consists of abusing your competition. A last example of contemporary Christian polemicists' flair for such billingsgate can be found in a Latin poem attacking a leading citizen. The poem survives in a single manuscript in Paris, compiled in the 530s for a high-ranking Roman dignitary, descendant of some of the leading lights of the 380s, and including works of Prudentius and then this single poem standing alone appended. In other words, everything about the poem keeps it in the circle of elite Christian Latin literature produced and consumed in the city of Rome. The manuscript itself flattered the Christian self-esteem of its owner.

When the poem's 122 verses attacking a consul and prefect who died a slow and painful death were forced to fit the life story of the rebel Flavianus (whom we saw die of battlefield suicide), it supported stories of pagan revivalism. No one now believes there was such a thing. So what is it?

It's a fine poem, first of all, if perhaps a little over the top, taunting the followers of the old gods on the death of their elegant friend. "Oh, ye pagans, do you really believe that shameful story about Jupiter and Leda?" Then the poet interrogates the dead man: "So why do you go to the temple of Serapis by night? What has tricky Mercury promised you? What's the use of worshiping the *lares* and two-faced Juno? What pleases you about Terra, the beautiful earth mother of the gods, or barking Anubis or wretched Ceres and her mother Proserpina below, or crippled Vulcan hobbling on one foot? Didn't everybody make fun of your bald head when you went to the altar of the Egyptian gods? . . . Now you lie there in your pathetic tomb."[3] The deceased had even undergone the *taurobolium*.

To understand the contemporary jealousy that underlies this piece of defamation, we need to look back to the year 384, when the distinguished prefect Praetextatus was at the height of his power. Though we've tended to focus on his religious interests, we know much more about him. He was a senior aristocrat and serious official.

His work in office had been, unlike that of his protégé Symmachus, successful and effective. His adroit handling of an urban riot—provoked by the election of a new bishop of Rome, Damasus—preceded his election to praetorian prefect and Ammianus describes his service thus: "He discharged the office of urban prefect in a lofty way, with many acts of uprightness and integrity. From earliest youth, he earned the unusual distinction of keeping the affection of the citizens while giving them cause to fear him. The unrest among the Christians he put to rest by his authority and his respect for the truth."[4] Everything we know suggests that he was a gracious and upright man, easily admired by many. He was praetorian prefect in 384, as we have seen, when he died, at an advanced age. It would be no surprise if he had a great funeral attended with real respect and mourning by people of every kind.

He had, yes, been a frank and continuing performer of the old rites, restoring a temple on the slope of the Capitoline Hill overlooking the forum, while serving as, among other things, priest of Vesta and a member of the still-functioning *quindecemviri sacris faciundis*. (But we have no reason to believe that his Christian enemies had actually seen him participate in all the rituals the poem lists.) He did as his fathers had done. Nothing suggests he was in any way inappropriate in his fulfillment of these offices, and he was clearly missed by many when he died.

Many were jealous of his success, in particular, Pope Damasus, who was eighty years old at the time of the prefect's death. Though Praetextatus had supported him in office, they were old rivals. Damasus had a young cleric named Jerome on his staff, who had a long future of his own in front of him as translator of the Bible, and who in the late 390s would recall with his special nastiness an anecdote from the days of the Damasus riots. The city prefect, he said, looked at the contest for power (and wealth) that had grown up around the office that would become known as the papacy and

quipped, "Make me bishop of Rome, and I'll turn Christian right away."[5] Pope Damasus has now been revealed as the author of the vindictive poem as well, though he may have had help from his bitter young secretary.[6]

This stinging poem evaporates then as rebuke of rebellious pagans and reveals itself to be a piece of personally motivated invective by one angry old man against a lately deceased rival. The whole story becomes uglier and much less interesting.

The age in which this poem was written already presents to us many individuals who embody not the stern opposition between paganism and Christianity but a more amphibious world. Take Furius Dionysius Filocalus, a famous artist, who prepared a calendar book for the year 354 CE and dedicated it to a wealthy friend, Valentinus. Though the book is now lost, careful medieval copies allow us to reconstruct its contents and artistic program with great success.[7] It was something like what moderns might call an almanac. Here is a rough list of what it contained.

- A dedication page by the artist addressed to his distinguished patron.
- Pictures of the patron goddesses of good fortune (*Tyche*) of four great cities of the Roman world: Rome, Alexandria, Constantinople, and Trier. (Trier's rank depended entirely on being in the mid-fourth century a regular imperial residence.)
- Dedication to the emperors with a list of the birthdays of the Caesars, from Augustus forward, arranged by months and days of the year, selectively omitting unsuccessful or unpopular emperors.
- The planets and their legends, followed by . . .
- . . . the pattern of the zodiac. Here we might think of the zealot Firmicus Maternus, whom we have met, author of two

surviving books, one a treatise on astrology, the other a violent rant against "profane religions"—in other words, traditional practices. Modern readers have generally assumed that Firmicus converted to Christianity after writing the first of those books, but that's not necessarily the case. Astrology was widely respected and studied, if not always by the most austere bishops. And not every pro-Christian ranter was himself the most consistently devout and orthodox of Christians in an age when it could be very lucrative to be on the right side.

- A calendar proper with illustrations of the months, all very traditional, with a list of public events by their annual dates, including the most traditional religious festivals.
- Portraits of the two consuls of 354, the emperor Constantius and his junior colleague, the Caesar Gallus.
- A formal list of the consuls of Rome, from the earliest in 509 BCE forward, punctuated by occasional brief historical notes of important events, a few of them Christian.

Then, with nothing to indicate a change in purpose, direction, authorship, or sensibility:

- The Easter Cycle—a list of the dates of Easter from 312 (because of Constantine's "conversion" attributed to that year?) forward for a century to 411.
- A list of the prefects of the city of Rome from 254 to 354 CE.
- A list of the "depositions" (that is, deaths and burials) of bishops of Rome from 255 to 352 CE.
- Then the depositions of the martyrs of Rome. The two lists (of bishops and martyrs) are kept separate and each is arranged by month of the year. The year for the martyrs in particular begins with December 25, marked as the nativity

of Jesus—and therefore this is a very early indication of celebration of that particular date. These two lists are very like the other festival lists already included in the calendar.

- A list of bishops of Rome, from Peter to the present, arranged chronologically. These last two sections (martyrs and bishops of Rome) are the earliest such documents surviving from the Roman church.

- A list of prominent buildings, followed by:

- An outline history of the world translated from Greek. *These* two sections may well not have been part of the original calendar book, but inserted after.

- A "chronicle of Rome"—outlining the history of the city and its successes from Romulus and Remus to the present, which undoubtedly was part of the original book.

What should we make of the tastes of the author and his intended readers? The central fact is a devotion to the city of Rome; the second fact is a desire to situate the Rome of the day in the history and geography of the traditional ancient world; the third fact is that consuls, bishops, and martyrs are all adduced as figures of power in that landscape.

Did the maker of this book and his wealthy customer just not know that pagans and Christians were supposed to be at one another's throats? Unlikely. It's fairer to say that it represents a long period of rapprochement, when many could appreciate old and new, people whose religious *practices* lie beyond our grasp. No one can know where Filocalus and Valentinus went or what they did to make their peace with divine power. They made their choices in a world in which traditional and novel forms of religion lived side by side, attracted adherents, and were far from persuading many people that exclusive choices had to be made. People trying to make that case had a long way to go yet.

If Filocalus and Valentinus were typical Romans of the mid-fourth century, their ilk continued to emerge in the decades to come. The poet Claudian, for example, was Greek and Egyptian by origins, but mastered Latin and appeared at Rome in the early 390s, putting himself at the service of Christian regimes of the time, praising child princes and heroic generals in equally elaborate, elegant, and traditional verse. A slightly naughty marriage song for a Christian emperor was all part of the job, and three fine mythological books on the rape of Proserpina were equally welcome to his audiences. He could also spin off this equally deft and elegant piece "On the Savior":[8]

> Christ, powerful over all,
> founder of the golden age that will return,[9]
> voice and mind of the highest god,
> whom the father poured out from his lofty thoughts,
> and made to be co-ruler in his kingdom:
> you have subdued the wicked sins of our lives.
> You have allowed godliness to be clothed in human shape,
> and human beings to address you openly
> and acknowledge you are a man.

He goes on to describe the annunciation, the virgin birth, the crucifixion, and the ascension into heaven. Then he ends with a different kind of piety:

> Cherish our Augustus, that on all the sacred days
> He may celebrate the annual feast days of the holy calendar.

As recently as forty years ago, the best book ever written on Claudian had to spend pages on the vexed question of whether Claudian was a pagan or a Christian or whether this poem is authentic.[10] A simpler threefold truth is now unavoidable: we can't know his

beliefs; we know that if he were at court as successful poet in the 390s and afterward he surely made his peace with the outward forms of Christian worship; and the traditionalism, elegance, and polymorphousness of his poetry were to be expected given his circumstances.

There were other poets equally dexterous and amphibious, without any sense of controversy. Nonnus of Panopolis, also an Egyptian, lived around the same time. His two extensive surviving works are an epic about the god Dionysus and a verse rendition of the Gospel of John. The notion that he too must have converted midstream has been very tenacious, but now seems unlikely.[11] The fifth century is the last century in the Latin west to see many elegant throwbacks, but Byzantine Greek culture would still see many assiduous students and imitators of ancient traditions.[12]

Certainly Christianity triumphed in a way. The Christianity-professing population of the empire had ballooned and emperors made sure that they mostly agreed with one another, in public at least, and that they organized their affairs consistently from place to place. We hear mainly from the leaders and enthusiasts on the Christian side, so it is worth pausing to remember that not everyone who showed up in a Christian church on Sunday felt the need to differentiate himself strongly from his neighbors who didn't.

One of the wisest of modern readers of this period calls this time after the official establishment of Christianity and the official discorporation of paganism "the end of ancient Christianity," for certainly things would never be the same again. Christianity as we know it was being invented in plain sight.[13] It was acquiring its large buildings, elaborate services, elegant vestments, well-fed clergy, and enormous wealth.

Outside those buildings and away from those services, slaves and servants and tenants and dependents shifted religious allegiance sporadically and variously, often enough worshiping as they were told by their lords and masters. If the old shrines on a

zealous Christian's great estate were torn down and Christian chapels erected, most of what worship there was would be Christian, whatever anyone in those chapels believed or thought. If it took a generation or so before lingering old habits died mostly out, nobody much cared. Pockets of tenacity needed not be troubled over.

Clerical and official Christianity had its formalities of doctrine rigidly insisted upon—and just as rigidly attacked from within. The creation of an intellectual church in the east in the second and third centuries was now followed by the even more remarkable creation of another church in the much less promising lands of the Latin west. The western church, of course, built a stock of rich cultural capital on which Europe's Christians would draw gratefully until our own times. The intellectual church created styles of spiritual experience, moreover, as calm, persuasive, and beautiful as any that human beings have known. Monks, first in the Greek east in the fourth century, then in the fifth and sixth centuries in Gaul, then Italy, then Ireland, then across the western and eastern worlds for hundreds of years more, wrote about and practiced a mode of life that cannot be denied its power and charm. The generosity of the rich to the poor was a fresh aspect of institutionalized altruism; prescribed humility provided a new dimension to religion as well.

True, Christianity had won these benefits by open alliance with the violence and threats of violence of emperors and soldiers, and true again, small choices made in those days offered large disastrous futures then unimagined. Wrestling with the nature of the relationship God had intended between Christians and Jews led some—not all—to tyrannies that were local at first, like the forced baptism of Jews,[14] but baleful for the future on a much wider scale and to a higher degree. Similarly, the doctrine of original sin burgeoned from a logical necessity arising out of a spontaneous liturgical practice. Parents who feared perdition for their children, who often died very young, began to have them baptized, just to be safe; Augustine's

influential teaching arose from his attempt to put logic around a practice he initially mistrusted but could not stop, without imagining the theological battles that would be fought over his teaching centuries later.[15] Doctrines about the human body and its fleshly appetites were worked out in a world where self-denial for the privileged had its own logic. But these would later make it difficult for some branches of Christianity to be credible witnesses in the very different cultures of gender and sexuality to follow.[16]

The hegemony of doctrine and practice would turn out to be a challenge—and a scandal—when the Jesuits imposed their religion upon China or the Franciscans imposed theirs upon the pueblos of northern New Mexico. The fundamentally countercultural spirit of the Gospels struggles incessantly in all forms of Christianity with routinization and legalism. Where it prevails (surprisingly often), it gives token of a kind of experience that finally eludes the historian.

What had changed and what did triumph was what may be the most successful and widely held doctrine of Christianity: that Christianity is fundamentally different from all other religions, that its rival paganism exists and is a meaningful category for a taxonomy of human experience. Once you accept that idea, you have allowed Christianity to define, defend, and declare *itself* in unique ways. Jewish exceptionalism had never dared claim as much. Christianity's claim to unique truth was plausible because only Christians made that claim.

Chapter 18

CICERO REBORN

THEODOSIUS DIED IN 395, SHORTLY AFTER THE BATTLE OF THE Frigidus. No one has ever claimed there was a serious threat to the stability of Roman order based on allegiance to the traditional gods at or after that date. Allegations of some pagan insurgency, quickly and brusquely squashed if it ever happened, are made by Christians at two later isolated dates in the fifth century, while there are a few other small spasms of Christian outrage at discovering that various old rites and practices have survived. The fifth century can show isolated intellectuals expressing dissent or nostalgia, but no sign they took their own resistance seriously. The silence is deafening. We can give equal credit for this silence to the effectiveness of Christian measures of suppression and to the power of ordinary indifference.

We can also see plenty of evidence of the survival of belief, practice, and allegiance in the realm of the ordinary. Most people didn't care. The town of Harran on the Persian frontier, for example, was widely reputed to have held on to its ancient practices until the time of the Arab conquest—as why not? Old rites of the Lupercalia and

the festivities surrounding the opening of the new year in January crop up at isolated points in the fifth century.[1] The silence, I say, is deafening by comparison to what we might expect if the self-serving Christian narrative about die-hard resistance were true. The survival of traditional practices never amounted to an expression of a pagan movement. Outside Christian imaginations, there was no such thing as paganism, only people doing what they were in the habit of doing.

The questions that the history of paganism raise at the end of antiquity are actually questions about Christianity. One might reasonably ask what Christianity really was. And the answer is that Christianity was many things still in the process of evolving, collapsing, and reinventing themselves. Association with empire gave Christian leaders the opportunity to compel creation of a more coherent, hierarchical religious movement than had ever been associated with the names of Jesus or Christ before. We have mostly forgotten to be surprised that a street preacher's followers discovered, several hundred years after his death, how to be a regimented multinational corporate enterprise.

Let us consider one example of how this played out in practice. Let's go to Calama (mod. Guelma, Algeria), a modest Roman city in North Africa, one hundred fifty miles west of Carthage, in a valley about forty miles inland. One day in 408 CE in that very ordinary sort of place, people came out in numbers to celebrate an old local festival. Legally forbidden practices would not have been tolerated—certainly no blood sacrifice, for example—but traditional images and songs and costumes? Not unlikely at all. There were many places like this where people made necessary adjustments and continued to do things they had always done.

On this particular day, local Christian clergy objected to something going on in the festival, and the crowd reacted badly. What followed fell somewhere between a brawl and a riot. Rocks were thrown. The clergy remonstrated with the local authorities afterward

and got blowback for their pains. As the days passed, a second, then a third hubbub broke out. On the third occasion, people tried to set fire to the church, one lower-ranking cleric was killed, and the bishop concealed himself in a secret place in the church to escape the angry mob. The bishop's followers thought the hailstorm that day had been a divine warning to their enemies.[2]

On that telling, which comes from a Christian source, is that an outbreak of paganism? Or is it not what happens when enthusiasts pick a fight and get more than they bargained for? The people who tried to set fire to the church may well have been in the church on another day themselves as worshippers, passively and cheerfully enough. When the authority figures in the church interfered, perhaps tactlessly, with local prerogatives, we cannot be surprised if there was some vehement, violent reaction. None of this behavior reflects well on the parties involved, but only one side of the squabble fought with any ideological commitment.

We know of this event because the bishop of a larger neighboring city fell into correspondence with a local dignitary at Calama named Nectarius. Nectarius was a citizen of good standing, a churchgoing, Christian man, not the sort of person out in the street throwing rocks at a church. He began the correspondence with an appeal to the senior churchman to intervene and make the local clergy—whose bishop had been trained in the bigger city—calm down, respect local traditions, and not make trouble where trouble need not be. Nectarius hoped for, perhaps expected, understanding and a sympathetic response, but the bishop responded in the vigorous negative, and his friend was disappointed.

Affairs in Calama quieted, so it was some months later when Nectarius wrote back reflectively and respectfully. He compared his churchman friend to Cicero himself. "So when you made a powerful case for worshiping and following the god who is over all, I listened with pleasure. When you persuaded us to gaze upon the heavenly

homeland, I was delighted to hear it. For you were not speaking of a city that has a circle of walls around it, nor even a city that the books of the philosophers argue we all belong to in this world, but rather a city occupied as their own by a great god and the souls that have deserved well of him, the kind that all the laws are seeking to establish by their different paths and ways, which we cannot express in words but perhaps can imagine in thought."[3]

Handsomely said, I think we would agree. Nectarius goes on: "This city is to be sought and loved above all, but I still do not think we should abandon the one in which we were begotten and born: the city that first bestowed the gift of light upon us, that nurtured us, that educated us." He closes by asking his friend to imagine the tears Nectarius is shedding for the city he loves and to respect the patriotism of this world along with the patriotism of the next.

Nectarius is so reasonable and gentlemanly that he was for a long time thought to be a pagan himself. The evidence is clear, though, that he was a churchgoing baptized Christian. At the same time, he clearly distances himself from his zealous bishop and neighbors by his willingness to see the good in continuity of tradition. He does *not* explicitly defend anything pagan—that is, cult paid to the old gods—in what had been going on; his only point is to resist people who make trouble for an established, peaceful, law-abiding community.

Nectarius is known—and interesting—to us because the bishop with whom he corresponded, the one who reminds him of Cicero, was again the famous Augustine of Hippo. Three or four years after this encounter, Augustine began writing one of his two great books, his *City of God,* that picked up the very ideas that Nectarius was so charmed by and used them to paint a great canvas of human history. Cicero was much on Augustine's mind when he wrote that book, as model and as rival. I've written the story of Augustine's life elsewhere, but let me show him in a light relevant to our purposes here.

Augustine makes sure to tell us, in his *Confessions* and other works,

that his life fell into two neat halves, Before and After—the old man and the new, in Pauline terms, the un-Christian and the Christian. We can and should remember to see the way in which the Christian Augustine had been there all along, in his mother's faith, in his own attempts even from early childhood to draw closer to the church, up to the long journey through Manicheism—a form of Christianity—and the ditherings of Milan that led him to seek baptism.[4] There was never anything remotely "pagan" about Augustine's religious affiliations.[5] He was there just as Ambrose was quarreling with Valentinian II and the boy emperor's mother over points of doctrine, with riots in the streets, and as Magnus Maximus, having overthrown Gratian, was threatening further advances.

That is one side of the story of Augustine's conversion: that he never needed converting because he was Christian already, in the eyes of many.

Even there, the very notion of "Christianity" was unstable and in play. When the Manichees prayed, they turned by day toward the sun, by night toward the moon, and offered their prayers that way. Though even hostile readers would admit sometimes that this was a symbolic deference to the way those astral powers showed their own homage to the divine, when it was polemically convenient to do so, that practice could be termed *pagan*.[6] Such an accusation is as well grounded as any—and as irrelevant as most. The function of it is not to state a fact about the opposition but to claim a mantle of purity and postpagan integrity for the attacker. From within Manicheism, as from within the form of Christianity that Augustine eventually chose, the fundamentally "modern" rhetorical gesture was to spotlight the newfound problem of ancient religion in all its pluralities and to propose an alternative path of singularity, purity, and global authority. That ambition was common. Which of the ambitious parties would prevail? How was this question being worked out in churches, communities, and the imperial court?

There is another way of looking at this story: to conclude that Augustine never converted at all. Every powerful personality finds himself the object of multiple stories and we do not know someone until we know the range of stories that are told. This one gets told infrequently at best, so I will take a little time with it.

Augustine began life in the rigid and predictable confines of the lower upper class of the Roman Empire, in a family proud enough of its Romanness to use men's names borrowed from public life. *Augustinus* would ring as heavily as Washingtonian might in the name of an American, while his father was *Patricius,* a title of rank in the empire and which might have the same ring as the surname Noble. Augustine was brought up to the old ways of class and culture and given the best entirely traditional education that borrowed money could buy. He excelled at it and became himself a professor who purveyed the means of demonstrating full membership in the elite classes of a traditional society. Until he was in his thirties, he pursued a highly visible career pointed straight at the top of Roman society. At least a provincial governorship is what he was aiming for when Symmachus sent him along to Milan and the imperial court in the summer of 384 with a recommendation for the senior professorship there. Within a few months, he was delivering high ceremonial oratory in honor and in the presence of the emperor. That it was a child emperor probably only made the drama more pompous and the effort of glorification more strenuous.

Then he broke off. The *Confessions* tell us, more or less, why and how he decided to abandon that career in the late summer of 386, rising his thirty-second birthday. What he did then was entirely of a piece with his class and culture. He borrowed a country villa, rounded up friends and students, and went there to read, talk, and write. What he wrote that winter at a place called Cassiciacum—the first works that survive from his pen in an oeuvre that amounts to five million words in all—were dialogues exactly modeled on those Cicero had written in the last years of his life at Tusculum, his villa not far from Rome.

In those books, learned amateurs indulge the pleasures of country house life, including philosophical dialogue not *too* technical to follow, not *too* demanding even for participants who were not as well educated as the host. The philosophical dialogues took place in the afternoons at Cassiciacum; the mornings were spent reading Vergil's *Aeneid* with students. The works that Augustine then circulated to a few friends had splendidly jejune titles: *The Happy Life, The Academic Philosophers, Order in the Universe,* and (here a new word he coined with a long future in front of it) *Soliloquies,* in which "Reason" and "Augustine" enjoyed a dialogue without mentioning the pleasures of the country house. Just as Cicero constructed his Tusculan dialogues to evoke Platonic models, so Augustine set out, at the onset of his now more professedly Christian life, to make himself a new Cicero. He did a fine job of it.

In *The Academic Philosophers* he made an interesting peace with the radical skepticism emerging from one strand of the Platonic tradition. The work has usually been titled *Against the Academics,* but it is not really a critique or refutation of the school whose views we encountered in Cicero's *The Nature of the Gods.* Rather, in agreement with Cicero, Augustine underscored the argument that there was no philosophical way to prove the truth of fundamental propositions. Augustine's addition to Cicero is his assertion that faith in Christ provides an alternate path to truth, the only one that works for humankind. For Augustine at this moment, Christianity is deeply embedded in the classical philosophical tradition and speaks to its issues decisively.

Should a fastidious Christian criticize him for doing that? In one sense, of course not. Jesus had suggested that putting new wine in old wineskins would burst them disastrously, but writers had been doing that for centuries in Augustine's time and have done so for many centuries since. Augustine differs from Nectarius in his judgments of what can be safely retained and what must be discarded, but both agree that much can and should be retained.

How did a future Christian bishop come to display such cultural savoir faire? Our earliest glimpses of Christians from an outside perspective show us small, isolated social groups rather than churches or cults. In the early second century, the younger Pliny, serving as governor in Bithynia in northwestern Asia Minor, wrote to the emperor Trajan for guidance in dealing with them: "They claimed that all they did was meet regularly on a certain day of the week before dawn to sing a hymn to Christ as to a god, then to make an oath together, not to commit any crime but to refrain from fraud, theft, and adultery and to keep their commitments to one another. When they had done this, they went away to gather again later for a meal of the most ordinary and innocent kind."[7] In the second and third centuries, for many people, a Christian group meant a social club often centered on tending the graves of ancestors and relatives.[8] Such behavior did not differentiate them sharply from that of many other religious groups. For followers of Jesus who heeded the messages embedded in the Gospels, at least, this was not surprising. Jesus never prescribed elaborate ritual, large buildings, or close connection with civic and imperial power.[9]

Many communities of early Christians were neither the poor and the downtrodden nor the social elites with traditional educations and an admiration for the life of the mind. In some places, especially Alexandria, Christianity could be found among intellectual classes, and those people shaped much that would come after, both in Christian doctrine and in style of life. But it did still take until the fourth century for any appreciable group of intellectually ambitious and articulate leaders to emerge in the Latin church. One reason we pay so much attention to Augustine, Ambrose, and Jerome is that they had no real predecessors in three hundred fifty years of Christianity in the Latin realms.[10] If we think now of Roman Christianity as a movement and an organization with theologically articulate leaders, we must reckon with that three-hundred-fifty-year gap (as long

a time as separates us from Milton and Cromwell) and reflect on the kinds of lives Christians lived in the meantime.

In Constantine's wake, social and cultural opportunities arose for Christianity that would have been unimaginable before. The informal meals of early Christianity had turned into a Eucharistic ritual with the air and atmosphere of a recognizably traditional religious rite, complete with the exclusion of noninitiates from the central part of the ritual. That exclusion went against at least one Gospel parable—that of the wedding feast and the host who went out to round up guests from the highways and byways. In this respect it had become more traditional. And it is this version of Christianity that concerns "Augustine After," the Augustine of his conversion, after he'd written in the style of Cicero.

After taking baptism in the spring of 387 at the hand of Ambrose in Milan,[11] Augustine and his family, no longer expecting the plum jobs of empire, made their way back to his native Africa and to the family estate at a place called Tagaste. It was another Calama or Sufes, with a few more Christians perhaps. Its Christians had fallen afoul of imperial law a few years before Augustine's birth, and so its clergy had been replaced with imperially approved priests imposed from outside. This purge went on in a variety of ways and places from the fourth century onward, standardizing, stabilizing, and official-izing churches.

There back in Tagaste, Augustine followed his father's model, taking up the duties and social roles of a Roman landowner. He had entered an early, imprudent marriage with a woman beneath his mother's ambitions, so Monnica broke it up when she thought she could make him a better match. With Monnica dead and his desire for marriage abandoned, Augustine was left with a son and heir named Adeodatus ("Gift of God") to look after, not least by preserving the family wealth. Rich and idle, Augustine wrote a few books and letters to share among like-minded intellectually able friends. He was

not well connected with wider literary or social circles and there is no evidence that what he did or said in these years mattered to anybody beyond his tiny circle of friends and readers. At age thirty-seven, he was a typical Roman failure. He'd had his chance for advancement and distinction, left it behind, and gone home to go to seed.

Then his son died in his teens, making Augustine's financial legacy moot, and his mind turned to finding a different, still more obscure way of life, in a "monastery." These communities were still rare in the Latin world, and Augustine had probably never seen one, but he knew it was a place of seclusion, where he could concentrate on prayer and study. What he found instead was a second chance at fame and glory.

He took it. Visiting the coastal city of Hippo (modern Annaba, Algeria), mingling with the local Christians, he fell in with, as Ambrose had, enthusiastic Christians who pressed him to accept ordination as a priest. He wept at the idea when he thought of what he was giving up, underwent ordination, then fled home to Tagaste, not sure what he would do. He could have made good an escape, but he went back to Hippo and took up responsibilities he would very much rather have avoided. Perhaps he remembered Ambrose's own career and decided to attempt something like it.

What emerged was the Augustine of history. As priest for five years, then as bishop for thirty-five, he made this ordinary provincial city, known only as a port for shipping grain from Africa to Rome, into the base for his expanding fame. His preaching built his local reputation while his writing extended his reach into the rest of the Latin world.

This was the great age of the bishop as preacher. Leaders of Christian communities had always preached, but perhaps because few to none were brilliant scholars, pulpit performers had not been on high display. It was in the late fourth century that oratorical stars such as Augustine and Ambrose and John Chrysostom

("Goldmouth"—from the magic of his oratory) emerged in Constantinople.[12] Churches were thronged with the best people—men and women carefully separated—hanging on every word.[13] That was how Augustine had come under Ambrose's spell—he said he just went to church to hear the famous speaker.

In the society of the intimate assembly—the Senate house and Forum, in particular—oratory had been the making of leaders in the Roman Republic. With the concentration of power in the hands of emperors, however, speakers had been kept on a tight leash. Demonstrated oratorical skill still qualified men for public life, and the very best could wield some cultural influence, but this influence was divorced from political power.[14] Roman education for centuries had idealized the orator—what old Cato called "the good man skilled at speaking"—as the paragon of civility. Under the emperors he could be a paragon of celebrity.

Augustine as bishop was back in the element he had been trained for. His city of Hippo was marginal to the movement of wealth and power in his world, so for many of the years of his bishopric, he left home after the great festival of Easter to travel to Carthage a hundred fifty miles away along the coast. There he spent the summer and early fall months preaching in the churches and working with his senior colleague, Bishop Aurelius of Carthage. They were allied in a struggle to establish their church organization as the dominant one in Africa, but they began from behind.

The African church had divided into two factions in the time of persecution almost a century earlier, "Donatist" and "Caecilianist" we may call them after early leaders on each side.[15] The Donatist church had inherited the traditions and practices of pre-Constantinian Christianity in Africa and embraced the greater number of congregants in the larger and wealthier churches of the province for many years. A burst of imperial suppression in 347 had temporarily given the Caecilianist party an advantage, but Julian

had, among his other cheerful mischief-making, undone that imperial preference. By the time Augustine came to the church at Hippo, the community he joined embraced the minority group, the Caecilianists. His church defined itself by allegiance to the kind of Christianity sponsored by the emperor and obedient to imperial dictates. The Donatists attacked both emperors and Caecilianists as persecutors of the true church, arguing that nothing had truly changed with Constantine if emperors were still sending soldiers to harass and suppress the true followers of Christ.

The upshot of the controversy marked the high point of Augustine's public influence and position. In 411, he managed to arrange for an imperial commissioner to be sent to Carthage to review the dispute between Donatists and Caecilianists. A formal public debate between the two parties was held, with hundreds of bishops present for each side, in June 411, in the grand city baths of Carthage. We have the stenographic transcript of most of the proceedings. The fix was firmly in and the imperial commissioner found for the Caecilianists, ordering the Donatists to submit to Caecilianist leadership and discipline, even to the point of giving up their church property to the other side. The threat and, when needed, fact of imperial force was effective and the Donatist church went largely away or at least into abeyance, whatever resentments and resistance lurked beneath the surface. The Caecilianists called themselves Catholic in the new fashion the better to show their alignment with the emperors and the imperial church. Modern historians have let them use it, granting them a tacit marker of their success in defining western Christianity. Whatever it meant now to be the de facto leader of all Christians in Africa, that was the position Augustine had achieved at age fifty-seven.

Chapter 19

A ROMAN RELIGION

I N HIS HOUR OF TRIUMPH, AUGUSTINE BEGAN TO WRITE HIS MOST extensive and thoughtful study of what it meant for Christianity to have emerged in the Roman world. To see Augustine as Cicero reborn, his *City of God*—examining themes dear to Nectarius—is the best place to look. Augustine had already written some of his major works and was well advanced on others, but most of what he had written had been directed to purely Christian audiences— exhorting his followers and attacking his enemies.

The refugee crisis that the emperor Valens bungled, precipitating his demise, in 378, had become a continuing challenge for Roman rulers. Much of the group that had crossed the Danube remained together, armed, moving through the Balkans and into Italy seeking a place to settle. (Eventually they would reach Spain, settle, and become the backbone of late Roman civilization there.) These people are conventionally called Visigoths, though the name is misleading. It was applied to them after they entered the empire, and though some of the migrating people were of Gothic ancestry, by no means did all fit any single ethnic description. They came, moreover, from

the formerly Roman province of Dacia (modern Romania), and they were far from un-Romanized before they entered Roman territory. They found fellowship among the remains of Arianism in Roman Christianity just as Catholic orthodoxy was prevailing.[1] As is true for most refugees and migrants, their presence on Roman soil was a sign of their admiration of Rome, its wealth, and the life it could offer them.

Emperors and generals had trouble seeing them as future Romans and chose to treat them as hostile invaders, to be fought or bribed, as whim and circumstances dictated. Bribery meant money and land, in the hope of getting them to settle in one place. Through the 380s, 390s, and 400s, a series of Roman generals and emperors dealt with the newcomers without lasting success. Opposition alternated with alliance—so, for example, at the battle of the Frigidus in 394, the Visigoths under Alaric fought for Theodosius against Eugenius and Arbogast and Flavianus, with suspicions afterward that they, as outsiders, had been pushed forward to take the brunt of battle. No satisfactory place for settlement was found. By the years 408–410, they had grown weary of seeking homes in the relatively unpromising lands of Greece and the Balkans and set their sights on Italy. There might well have been a solution involving settlement in Italy without significant disruption, but Rome resisted.

When in 408, moreover, the de facto Roman ruler in the west, the general Stilicho, was killed in a palace coup, the new regime took a harder line. Stilicho was the power behind the throne for the callow young emperor Honorius, who had removed his capital from Milan to the marsh-girt port city of Ravenna on the Adriatic, in case he needed to flee by ship—and Ravenna remained the imperial capital in Italy for centuries. Stilicho himself was a "barbarian" in origins and his crafty policy of containment, conciliation, and temporizing was interpreted by hardliners as softheartedness at best and connivance and treason at worst. His successors, from the bluster and bungle

school of Roman military tradition, lost control of the situation and found themselves with even more barbarians in Italy and no idea what to do next. Roman military force of any substance was mainly kept on the frontiers in these days, so there proved little that the Roman military could do to protect citizens from groups like the Visigoths once they had penetrated to heartland territories like Italy, Gaul, Spain, and Africa.

This shabby story came to a crisis when, in August of 410, the Visigoths reached the city of Rome and undertook a three-day exercise in plunder and punishment. The greatest impact of their attack was psychological, for the city of Rome had considered itself immune from attack. No foreign invader had breached the city walls since the Gauls in 390 BCE, exactly eight hundred years earlier. The Visigoths themselves moved on quickly afterwards, first down the peninsula with half an idea to find settlement there or take ship for Sicily or Africa, then reversed course. Avoiding Rome, they made their way first to Gaul and then eventually to Spain, where they began seriously settling within a decade.

The psychological blast waves radiated out: shock, anger, exaggeration, unmediated reaction, sentimentalism. In some of Augustine's letters we hear of aristocratic refugees turning up in Africa in the early fall of 410, fleeing Rome for their estates in Africa. They would bring with them their lifestyles, their attitudes, their deep but narrow Roman culture, and their overheated interpretation of recent events.

From Augustine and his friend the imperial commissioner Marcellinus we hear that speculation began to run among the refugees that there was perhaps a world-historical explanation for this unprecedented disaster. After all, the gods had protected Rome for many centuries; unseated, their worship curtailed, could the gods be offended and holding themselves aloof?

You didn't have to be a pagan to ask this question. Nobody

seemed inclined to change their ways if the answer was yes. Some asked primarily to unsettle a fierce bishop. In particular, a very well-connected man named Rufius Antonius Agrypnius Volusianus seemed keen on exasperating Bishop Augustine. Volusianus's father, of the impossibly distinguished Ceionii family, had been prefect of the city twenty years earlier and was remembered later as one of the most learned men of his age. Volusianus's mother was a Christian, and his niece was the most famous (and wealthy) Christian woman of the age, the ascetic Melanie the younger. At her instigation, Volusianus would finally accept baptism on his deathbed in 436. He knew everyone, served years later as both city prefect and praetorian prefect, was praised by high-minded traditionalists, and did the emperor's bidding to suppress Pelagianism. As Henry Higgins would say, just an ordinary man, of a certain elite class. To categorize him as either pagan or Christian is to play into the game of opposition that the Christians of the period were creating. We have no way of reading his heart.

Augustine welcomed the news that impudent questions were in the air and saw an opportunity.[2] First in an exchange of letters with Marcellinus and then with Volusianus, he sketched a reaction. In what eventually became twenty-two books of *City of God* he gave that sketch substantial form. The grand thrust of the work was to invoke a biblical history of the world explaining how Christianity emerged to great success so late and how Roman grandeur had been earned not by the gift of the old gods but by the support of the new. The god of Israel and of the Christians wanted there to be a world empire in place at the birth of Christ to make it easier for the new message to be spread abroad.

Stretched out over a thousand pages that took fifteen years to write, the argument is ample, learned, powerful, and persuasive. For the first ten of twenty-two books, Augustine does not depend heavily on scriptural argument, ostensibly to make the way easy for

those who were yet unpersuaded of his main thesis. In those books, he attacks the idea that the old gods could bring happiness in this world or the next. Then in the last twelve books, he uses scripture to frame an outline of sacred history from creation to everlasting life, with a long detour through the fallen world of humankind and its history.

The grafting of sacred and secular stories together into a fundamental pattern of history for the whole known world had been working in Christian minds for a long time, both at the level of interpretative narrative and at the level of pure chronology. When he began writing *City of God*, Augustine seems to have wanted to avoid writing the historical narrative itself and so asked a flamboyant younger colleague, Paulus Orosius from Spain, to compose it. The resulting *Seven Books of History Against the Pagans* was so triumphalist and outspoken that Augustine was embarrassed and had to write his own more restrained history for the later books of *City of God*.

He had a tough task. Orosius's view had been that the Christian god had lain back in the weeds, allowing human history to unfold, shaping it rough-hewn to his own ends. According to his account, God brought forth Christ in a dramatic moment of revelation, from which point divine intervention became increasingly overt, until the triumph of Christianity in the fourth century created the ideal synergy of empire and church, all getting better and better and bolder and bolder all the time. The Christian empire Orosius imagined was a new and improved Roman Empire, rather than a replacement brought about by divine intervention and overthrow. (The author of the book of Revelations might have been surprised to hear this.)

Augustine, to his great credit, saw that this narrative was fundamentally flawed. He emphasized not only that his god shaped history toward these moments, but that he consciously left the world in a state of ambiguity. A Christian empire is a great and good thing, but not a thing designed to last forever. (Augustine felt that an outright return

to imperial hostility and persecution was a live possibility.) The world Augustine thought he lived in was one that mixed the future citizens of God's city and the future slaves of Satan, still intermingled and interacting, none ever knowing until the end of life and final judgment whether as individuals they had attained salvation. This vote in favor of a religion of individuals rather than of communities, where seemingly faithful Christians side by side might, unknowingly, be pointing in different eternal directions, would have lasting impact on the shape of spirituality in the Latin west.

Augustine began writing sometime after the flurry of concerns raised by the events in Rome in 410, producing the first three books sometime in late 412 or 413. Two more books appeared two years later, then five more two years after that. By 417, ten books had been published. An early reader was very impressed:

> I read your books. . . . They grabbed me, snatched me away from my other business and shackled me to them—for god was kind to me. I didn't know what to admire in them first: the priest, the philosopher, the historian, or the orator.[3]

The first books of *City of God,* in which Augustine sets out to defend the church and its god against the pagans, were written to show off his mastery of the old style. You could almost think Cicero had written them. Seeking to prove that the old gods did not bring greatness and empire and that the new god did not imperil it, Augustine floods his pages with quotations from the classic writers, finding support from internal critics of empire like Sallust, but also in Vergil himself, the classic of classics. Brandishing these quotations from authors Cicero knew, and some he predated, Augustine weaves together a work unique among all his hundred and more titles, fully in the tradition of ancient moral debate and rhetorical presentation. In its form and argument it imitates and then dissents from Cicero's own

dialogue *On the Republic,* which in turn echoed and reprised Plato's more famous work on the same subject. One passage late in Augustine's book makes that choice of lineage clear.[4] Plato's and Cicero's books end with visions of the afterlife in fictional dreams of historical figures—Er and Scipio, respectively; Augustine's work ends in books 19–22 with a cold prose exposition of Christian doctrine of the afterlife.[5]

A debate with Cicero's view of Rome links the early books of *City of God* (traditional in form, polemical in content) and the later ones (more theological and historical in form and content). Augustine took up early a definition from Cicero of what it means to be a "people" (*populus*), criticized it, then put it aside for later consideration. He came back to that exact passage and theme in book 19, written ten years after the original passage, to attack Rome on Cicero's own terms. For Augustine, using Cicero against Rome, the fundamental question is one of justice. "Thus, where there is no true justice there can be no human gathering brought together by a common sense of right and wrong, and therefore there can be no *people*, as defined by Scipio or Cicero; and if there is no people, then there is no common business of a people but only of some promiscuous multitude unworthy of the name of people. Consequently, if the republic is the people's common business . . . then most certainly it follows that there is no republic where there is no justice."[6]

Therefore, Rome was never really a city at all, much less a great one. The chutzpah of this sentiment is all the more remarkable for its traditional dress. The point hits home, because the noun *populus* produced the adjective *publicus*—hence the Roman "republic" (*res publica*) was the embodiment of the *populus* that Augustine was claiming never really existed. (A kingdom without justice, he memorably observed, was nothing but a very large band of pirates.[7])

So his book is not about a republic but a city, defined in so ideal a way that even Rome did not live up to the name. The word for "city"

in the title is not the classical *urbs,* but *civitas*— "body of citizens"— and therefore points not to walls and buildings but to people and community. In debating with Cicero across the centuries, Augustine acknowledges a fundamental point of continuity between old and new. The Christian new did not and could not break completely with any past. It rewrote that past to make it suitable for its purposes, and at the same time rewrote itself to be a worthy heir *and* rival to the past it was claiming.

Could the argument have gone otherwise? We should enter the infinite world of counterfactual history to find suggestions of what might have been only to better see what was. Christians, heirs of the ancient Jewish tradition and beneficiaries of Greek philosophy and culture, still found it sufficient to be Roman-but-different. They did not choose Jewish or Greek pasts as models and ancestors, nor did they select the fresh-faced barbarians outside the boundaries as opponents of Rome. Augustine's Catholicism is very much a Roman's Catholicism.

Christianity famously accepted the city of Rome itself. The legend of Peter's and Paul's martyrdom at Rome wove the strands of Christian tradition into the fabric of the city. Saint Peter's basilica, the site of Peter's death outside the old city walls, was already becoming a place for pilgrims in the fourth century, while the basilica of Saint John Lateran within the walls, Constantine's first church, was the headquarters of the church in the city. The calendar of 354 shows us distinguished Romans taking the bishops of Rome very seriously, for they were by now men of wealth and standing. The subsequent emergence of the papacy and Rome's primary association with Western Christianity from that day to this is too familiar for us to notice how astonishing it is.

So Christianity became Roman. Augustine became, in his mature years, the dignified Roman orator and statesman he had set out to become, full of praise for wise and benevolent Christian emperors.[8]

He anticipated the generations of cultivated gentlemen at court, especially in Constantinople, who would master the old traditions and texts, subserve sometimes brutal imperial will, and make as much peace as needed with the church. Much was changed. Much remained the same.

Despite the power and prestige of Christianity over many centuries and the span of many modern nations, clerics rarely ruled and rulers were rarely clerics. Even when a cleric became king, as happened when Jan Kazimierz, Jesuit priest and cardinal, became king of Poland and grand duke of Lithuania in 1648, he carefully resigned his church office first. The prestige and autonomy of emperors persisted until World War I, when four successors of Constantine sent their nations to war.[9] When at the height of its power the papacy found itself ruling its own states, the connection was incidental and limited to a relatively small region. Augustine's *City of God* assumes and predicts what we have come to call "separation of church and state." He could have argued otherwise.

One more line of continuity is important to observe. Augustine began *City of God* a century after Constantine formed his vision. Much had changed, and Augustine's world was Christian in a way Constantine would have had trouble imagining. Constantine in his vision and Augustine in his great book agreed on one great thing, however: that the affairs of this world were in the hand of the Christian god who really did show favor to those who stood well with him. For all that Augustine backs away from triumphalism, he still cannot resist believing that a world marked by tragedy, brutality, and death—to say nothing of the premature deaths of innocents—can be read as showing forth the benevolent hand of a deity looking after his followers. The subtlety and sophistication of the argument cannot mask how traditional—dare one say classical?—it is.

If we look a few years past Augustine, another African wrote a book that offers a quiet conclusion to our reflections. Ambrosius

Theodosius Macrobius carried the names of the bishop and the emperor who collaborated on the final imperial solidification of Christianity. But fifty years after Augustine's *City of God* he wrote a book that has often been taken as a gesture of dissent. Macrobius's *Saturnalia* brings together a touching and sentimental portrait of Roman aristocrats at elegant play. Even to a modern reader unsympathetic with many of their concerns, the charm and polish of the portrait are clear and enticing; to others closer to the author's point of view, it might have been magical.

Saturnalia is set as a narrative dialogue among leading worthies of the city of Rome in the year 384. Macrobius writes so feelingly and persuasively of these men and their concerns that the work was long taken to be nearly contemporaneous with the dialogue itself, thus written in the 390s, amid the other excitements we have dealt with above. For a writer at *that* moment to bring forward the venerable Praetextatus, poignantly and unknowingly a matter of a few weeks from death, and others from the families of the Flaviani, the Symmachi, the Albini, and to depict them serenely exploring the riches of ancient tradition, seemed to be a closet commentary on the events of the great last struggle between pagans and Christians. Macrobius seemed a closet pagan, holding out against the onrushing darkness. We now know that the book was written in the 430s, not the 390s, in Africa, not Italy.[10] In form, it is another replica of Cicero's *Republic*. Was it therefore also a response that *City of God* evoked from one of its readers?[11] Both Macrobius and Augustine found high cultural value in imitating a single work of literature at that point almost 450 years old.

The aristocrats Macrobius depicted cared primarily about themselves. They were the very few vastly wealthy, vastly self-assured citizens sitting at the top of the pyramid of Roman society. If they were not really the few heirs of ancient lineage, they were the heirs of Constantine's new class, the heirs of the arrivistes of a century before,

people who had seen and seized the opportunity to make themselves grandees of Rome when that still mattered to emperors.

Macrobius's nostalgia is for the reinvention of Rome that the fourth-century newcomers enjoyed. They were the people who created "classical Latin literature" for us, by their tastes and their willing preoccupation with the old. Greek was now Greek to them, so to speak, and Cicero their best philosopher. His philosophical writings had very little success or imitation between his death and the fourth century, but he came into his own as a philosopher—not just an orator—when the elites could no longer read Greek, and the philosophical treasures of the Greeks were opaque to them. Arnobius, Lactantius, Ambrose, Augustine—these writers of the fourth century are the most sophisticated, interested, and interesting disciples of Cicero from all antiquity. By the time they read him, Cicero was as far from them as Montaigne is from us.

One old light of traditional religion flickered then but remains lit to this day. The title *pontifex maximus* was old and now questioned. Emperors had learned to do without it. We have seen hints that in the time of Praetextatus, people were thinking about how else one might manage to keep the title alive. But though Christians had no qualms about calling their leaders "pontiffs" (*pontifices*), it took centuries before the bishops of Rome began to use it, as they do today.[12] Shall we call that a survival of paganism?

EPILOGUE

STORIES END, LIFE GOES ON. I CLOSE MY NARRATIVE OF THE GODS with Augustine and Macrobius and their continuing loyalties to the past even in the hour of Christian victory. The history of paganism was just beginning. Once you had been taught what a pagan was, you started seeing them everywhere. Christian conquerors and missionaries would find paganism wherever they went for the next thousand years and more. They would read the religious practices of newfound peoples as extensions of the familiar story of credulous primitives and Christian exceptionalism. Examples among such missionaries of respect, curiosity, and a willingness to learn are few on the ground. The Jesuits in China are the most notable exception.

No question, Christianity welcomed and took advantage of its new privileged position in the Roman world with energy and imagination that are scarcely believable in retrospect. A Christian of the year 300 CE would be astonished if he could see what his community would become in a single century. By the 530s, Justinian's vast Hagia Sophia church in Constantinople (he boasted of having outdone Solomon and his temple) manifested the drama of Christianity's self-proclamations and the power of its leaders. We lack, still, the transformative book that needs to be written about the history

of Christianity, one that can step back from the familiar claims and counterclaims of believers, other-believers, and unbelievers and tell the story in a way that does it real justice.

Note first the smallness, modesty, and persistence of the communities that invoked the name of Christ for the first three centuries, demonstrating their differences of belief and practice in a hundred ways. The explosive growth of those communities when once they were given imperial patronage cannot be overstated. The idea of orthodoxy and the coherence of a community that now spread across the empire and beyond its borders had the power to set Christianity free of emperors, armies, and boundaries. New forms of religious expression blossomed with that success.

By comparison with that effervescence of faith and practice, the undramatic persistence within Christianity of traditional ways of thinking and acting has understandably been of lesser interest, but needs to be understood. Christianity seized its time and made its message compelling, even for many of those who had joined because of another kind of compulsion. In many respects Christianity was as much a creation of the fourth and fifth centuries as the idea of paganism had been.

In one way Christianity's triumph really is universal. If the non-Christian philosophers of late antiquity had succeeded in making people think of a divine world larger and simpler and stranger and more overpowering than anything their old gods could show them, the Christians succeeded in introducing the movement of time into the cosmic landscape. Nineteenth-century thinkers called this the introduction of the idea of progress, an enthusiasm much in the air a century and more ago.[1] Even as we become skeptical about progress with a capital P, we have settled for understanding *progression*. Time's arrow really does fly in one direction and some change is irreversible. Few moderns may think of the linear development of human history in the same terms the old Christians used, but the modern world of

ideas is unimaginable without the irreversible linearity of connection and direction they provided. Everyone on the planet recognizes the Christian scheme of marking and pointing time's arrow, even when we noncommittally mark our dates BCE/CE.

And of course much of what was old and familiar survived and lived, overtly and covertly, consciously and unconsciously, in the new world of Christian emperors and powerful bishops. We've seen examples of this and cited more of the evidence, but the historical record necessarily understates such persistence. What continued in family and household and city practice would naturally escape attention and leave scant record. Sure, blood sacrifice had very nearly vanished by the fourth century, but it had been on the way out for a long time. By comparison, antiquity's new age cult of astrology has turned out to be unkillable.

Then there are a few notorious anecdotes that should be read cautiously, telling a familiar story of doughty pagan resistance. One story goes that a band of philosophers from Athens, evicted when the emperor Justinian closed their school in 529, sought refuge for their pagan ways in the Persian empire. Closer examination reveals a very local claim about Christians undermining an institution they mistrusted and a Christian source telling us the story. Whatever went on there was less dramatic than telling has made it.[2] The better the story, the less likely that it is true (as often).

And so time passed. Looking back fifteen hundred or two thousand years can be a pleasant pastime, watching costume dramas unfold in our imaginations with just enough of the exotic about them to hold our attention. What we should remind ourselves at the beginning and end of such stories is how easily we assume that the people in them are really just like us. The stories I have told of sites and shrines, slaughter and superstition, should certainly remind the reader how far away most people today stand from the most civilized and reasonable ancients. The Christians in these stories are no less distant

from us, even those of us who claim to be orthodox believers. The material, social, intellectual, and spiritual conditions of their world differed dramatically from our own. A Christian of the sixth century has some things in common with a modern Christian that a Roman of the first century did not, but at least as much separates him from us as connects him. Perhaps the lasting lesson of this book is that the creation of "Christianity" as an idea in the course of our story is the truly interesting and important historical development we have seen: the idea of a single community of thought and action, consistent and unchanging in important ways over time. "Pagans" offered the perfect foil to set off and glamorize that idea.

To recite the creed of Constantinople's council from 381 CE in a church in 2014 is to assert a uniquely stable and unchanging identity over time. Christianity's transformations, however, did not end with that age of innovation; they continue to this very moment. The claim that Christianity then and Christianity now are the same thing is a theological proposition, not a historical one. That so many non-Christians accept it unthinkingly should astonish us. That is another great triumph of Christianity.

Will Christianity's many victories be permanent? It might seem so. Creating paganism in order to have vanquished it let Christianity emerge from antiquity presenting itself as a modern, intellectual, imperial, and highly organized religion with extraordinary resilience. It constituted itself, though, by reading books and reacting to them, and it created its own abundant literature of response to biblical authority. The age of Augustine was a great one for broadening, deepening, and extending the world of readers and writers. Classical Islam was equally fortunate in presenting itself as radically new in the seventh century, while rabbinic Judaism succeeded with very similar tactics in fashioning itself as radically old and traditional. (The Talmud's first versions fall in the age between Augustine and Muhammed.) The making and management of books was fundamen-

tal to all three Abrahamic families. With books, they could offer all that the gods had offered and more besides. If the great age of the written word, however, is ending or morphing into something very different from what we have known and depended on for more than twenty-five hundred years, the future of the children of Abraham may be a clouded one.

And what became of the gods who never existed yet lived so long? In a nutshell, they got small. Novelty intervened to distract people. War and social upheaval shrank their revenues. Then one day an ordinary sort of emperor happened to pick as his patron a god whose followers, all unknowing, were ready to take their deity very large indeed. That deity brought in his train, moreover, a parade of exciting new saints and martyrs who could find places in churches and stories everywhere. He and his team did a remarkably good job of satisfying the religious needs of the culture. Humankind learned new ways, then prided itself on thinking those new ways were newer than they actually were. And in the process forgot some old ones.

The gods were no longer needed.

NOTES

PROLOGUE

1. Statius, *Thebaid* 10.899ff. All translations are my own unless otherwise noted.

2. If we're wrong, the novel *Gods Behaving Badly* (New York, 2007) by Marie Phillips imagines their story: overthrown and disregarded, aging ex-celebrities, they live more or less incognito in London. A promised film will relocate them to New York and cast Sharon Stone as Aphrodite.

3. The latest survey of the whole story, concise and spare, two volumes, 1,000 pages, $250, is outstanding, and it can offer barely a snapshot: M. Salzman, ed., *The Cambridge History of Religions in the Ancient World* (Cambridge, 2013). A fuller scholarly inventory is being built by the *Thesaurus Cultus et Rituum Antiquorum* (Los Angeles, 2004).

4. Just in English: S. Dill, *Roman Society in the Last Century of the Roman Empire* (London, 1899); A. Alföldi, *The Conversion of Constantine and Pagan Rome* (Oxford, 1948) and *A Conflict of Ideas in the Late Roman Empire* (Oxford, 1952); A. Momigliano, ed., *The Conflict Between Paganism and Christianity in the Fourth Century* (Oxford, 1963); J. Geffcken, *The Last Days of Greco-Roman Paganism* (New York, 1978; trans. from German original of 1920); and P. Chuvin, *A Chronicle of the Last Pagans* (Cambridge, Mass., 1990).

5. E.g., Lawrence Wright, *Clean and Decent: The Fascinating History of the Bathroom & the Water Closet, and of Sundry Habits, Fashions & Accessories of the Toilet, Principally in Great Britain, France, & America* (London, 1960).

CHAPTER 2: THE GAMES OF THE CENTURY

1. Ovid, *Fasti* 2.131ff.
2. P. Zanker, *The Power of Images in the Age of Augustus* (Ann Arbor, 1988), reveals Augustus's mind by showing how he consciously used the visual arts to consolidate his power and make his story prevail.
3. Standard study: B. Schnegg-Köhler, *Die augusteischen Säkularspiele* (Munich, 2002).
4. Athletic triumph in Fenway Park in 1918 and 2013 and none between had something of the flavor, as does the singing of the Mallard song once a century at All Souls' College, Oxford.
5. E. Fraenkel, *Horace* (Oxford, 1957), 364–82, for his study of the *carmen saeculare;* see now M. Putnam, *Horace's Carmen Saeculare* (New Haven, 2000).
6. G. S. Aldrete, "Hammers, Axes, Bulls, and Blood: Some Practical Aspects of Roman Animal Sacrifice," *Journal of Roman Studies* 104 (2014), is astute and even entertaining in working through the gorier bits of this procedure.
7. Colleagues who very much prefer to remain anonymous observe that the absence of leavening would produce something perhaps flatter and drier, like a galette in the original sense; one even suggests a comparison to Cheez-Its. Cupcakes would have done the job perfectly.
8. Not only the impertinent will think of *The Dinner Party* of Judy Chicago as a modern equivalent for its forthright celebration of womanhood in ritual.
9. This may be our earliest surviving mention of the seven *hills* of Rome, a more modest and apposite name than the "mountains" or "summits" or "citadels" commonly spoken of before.
10. Zosimus, *New History* 2.1–7.

CHAPTER 3: AN ELOQUENT MAN WHO LOVED HIS COUNTRY

1. Plutarch, *Cicero* 49.
2. Plutarch, *Cicero* 19.
3. Cicero, *Laws* 2.15–21 for these quotations.
4. Ammianus 21.1.14; he's remembering something from Cicero's *The Nature of the Gods* 2.12, where it is the Stoic speaking, not Cicero.
5. Cicero, *Academica posteriora* 1.9.

CHAPTER 4: WHAT IS A GOD?

1. I follow Michael Lipka, *Roman Gods: A Conceptual Approach* (Leiden, 2009); for a measured review by D. Quinn see *Bryn Mawr Classical Review* 2010.5.48. I have adopted and expanded Lipka's taxonomic approach here.

2. Franz Cumont, *Les religions orientales dans le paganisme romain* (Paris, 1906), was the classic statement, by a very great scholar.

3. Rilke, *Duino Elegies* 1.7; Acts 17.23ff. The Christian deity is remarkably without a proper name himself. To many an ancient, a god named God would seem as odd as a dog named Dog.

4. Caesar, *Gallic War* 6.13ff.

5. E. Sanzi, *Iuppiter Optimus Maximus Dolichenus: un "culto orientale" fra tradizione e innovazione: riflessioni storico-religiose* (Rome, 2013).

6. Jane Harrison, *Prolegomena to the Study of Greek Religion* (second edition, Cambridge, 1908), 164.

7. His most influential book may be his *Homo Necans* (Berkeley, Calif., 1983; orig. 1972: a witty title: "man the killer"), but his *Greek Religion* (Cambridge, Mass., 1985) is the standard survey. The passage here comes from his "Sacrifice, Offerings, and Votives," in S. I. Johnston, ed., *Religions of the Ancient World: A Guide* (Cambridge, Mass., 2004), 325. I choose so eminent a scholar and cite so magisterial an article *precisely* to show that this easy slide into error is absolutely central to the way we have all learned to think about these subjects.

8. For Firmicus, G. Stroumsa, *La Fin du Sacrifice* (Paris, 2005), 179; his reviewer, M. Gaulin in *Bryn Mawr Classical Review* (2006.05.09).

9. H. Lloyd-Jones, *The Justice of Zeus* (Berkeley, Calif., 1971), and B. Williams, *Shame and Necessity* (Berkeley, Calif., 1993), explore Greek morality in this sense. Every generalization here is subject to exceptions, and so there were places and times when people wrestled with ideas of divine disciplinarians. Orphic religion, in particular, a breed of classical Greek practice we have learned much more about in recent years and whose tenets are still in hot scholarly debate, did seem to emphasize the underworld as a place of reward. Plato mocked Orphism (*Republic* 2.363c) by observing that their view seemed to assume that a life of eternal drunkenness was the chief blessing awaiting the just.

10. Lucretius, *On the Nature of Things* 1.101; always an outlier and relatively little read in antiquity, Lucretius had a more interesting modern history. See G. Passanante, *The Lucretian Renaissance* (Chicago, 2011).

CHAPTER 5: DIVINE BUTCHERY

1. See, e.g., 1 Corinthians 8.
2. http://www.theguardian.com/world/2009/nov/24/hindu-sacrifice-gadhimai-festival-nepal; consulted January 1, 2014.
3. On sacrifice, see Harrison's *Prolegomena* and Burkert's *Homo Necans*; new and important: F. S. Naiden, *Smoke Signals for the Gods: Ancient Greek Sacrifice from the Archaic Through Roman Periods* (Oxford, 2013); and Aldrete, "Hammers, Axes, Bulls, and Blood," cited above on the *ludi saeculares*.
4. Sallustius, *Concerning the Gods and the Universe* 15–16; trans. A. D. Nock.
5. Isaiah 1.11–14 (King James Version).
6. Burkert, *Homo Necans* 7ff.
7. Lucian, *On Sacrifices* 9.
8. C. Bennett Pascal, "October Horse," *Harvard Studies in Classical Philology* 85 (1981): 262–91.
9. Festus, *On the Meaning of Words* 178.
10. R. Duthoy, *The Taurobolium* (Leiden, 1969).
11. Prudentius, *Peristephanon* ("On the Crowns of Martyrs"), 10.1006–1050.
12. Tertullian, *Apologeticum* 7.
13. Plutarch, *Themistocles* 13.2–3, translated by J. Mikalson in his *Herodotus and Religion in the Persian Wars* (Chapel Hill, N.C., 2003), 78–79.
14. Pliny the Elder, *Natural History* 30.3.12.
15. For the site and its history and rituals, see C. M. C. Green, *Roman Religion and the Cult of Diana at Aricia* (Cambridge, 2007).
16. Servius *Aen.* 6.136, trans. C. M. C. Green.
17. For further history and reflections on this theme, see Stroumsa, *La Fin du Sacrifice*, and S. Bradbury, "Julian's Pagan Revival and the Decline of Blood Sacrifice" *Phoenix* 49 (1995): 31–56.
18. P. Hadot, *Philosophy as a Way of Life: Spiritual Exercises from Socrates to Foucault* (New York, 1995), trans. from French original (Paris, 1981).
19. The best study of the practice documents its powerful survival among followers of Jesus: Ramsay MacMullen, *The Second Church* (Atlanta, 2009).
20. Porphyry, *Life of Plotinus* 10; Porphyry's vegetarianism is outlined in his *On Abstinence from Animal Food*.
21. Quoted from an inscription in Didyma in Bradbury, "Julian's Pagan Revival," 336.
22. R. MacMullen, *Roman Government's Response to Crisis* (New Haven, 1976); D. Potter, *The Roman Empire at Bay: AD 180–395* (London, 2004).

23. See again Potter (preceding note) and T. D. Barnes, *The New Empire of Diocletian and Constantine* (Cambridge, Mass., 1982).

24. A. Frantz, *Late Antiquity, AD 267–700* (Princeton, 1988).

CHAPTER 6: WAYS OF KNOWING

1. Livy 5.52.

2. J. Lightfoot, *The Sibylline Oracles* (Oxford, 2008); D. Potter, *Prophecy and History in the Crisis of the Roman Empire* (Oxford, 1990).

3. I. Hadot, *Arts libéraux et philosophie dans la pensée antique* (Paris, 1984; rev. 2005), meticulously shows how the "liberal arts" in antiquity offered a discipline for would-be philosophers seeking to cleanse their minds of the confusions of the world of matter as preparation for spiritual ascent to union with the divine. "Liberal arts" in modern academic discourse have very little to do with those ancient roots.

4. Josephus, *Against Apion* 1.201–04. The *Against Apion* is Josephus's defense of Judaism against the charges of Greco-Roman traditionalists that it is not a *real* religion. He argues for its greater antiquity and authenticity on quite traditionalist terms.

5. Of many studies, perhaps the best way into the magical thickets of antiquity is C. Faraone and D. Obbink, *Magika Hiera* (New York, 1991), supplemented by the texts translated in G. Luck, *Arcana Mundi* (2nd ed.; Baltimore, 2006). V. Flint, *The Rise of Magic in Early Medieval Europe* (Princeton, 1994), shows how the rise of Christianity not only did not derail but even reinforced these pratices.

6. See J. Gager, ed., *Curse Tablets and Binding Spells from the Ancient World* (New York, 1992).

CHAPTER 7: THE SPECTER OF ATHEISM

1. For the early Christian, to "believe in God" was not a matter of crediting the deity's existence, but of expressing trust, reliance, and confidence in that deity's saving power. C. Mohrmann, "*Credere in Deum*: sur l'interprétation théologique d'un fait du langue," *Mélanges J. de Ghellinck* (Gembloux, 1951), 1.278ff.

2. The French priest Jean Meslier (d. 1724) is widely credited as the first outright proponent of disbelief in any and all gods. See A. C. Kors, *Atheism in France 1650–1729*, volume 1, *The Orthodox Sources of Disbelief* (Princeton, 1990).

3. So the *Martyrdom of Polycarp* 9.2 ("Away with the atheists!") depicts a

common attitude, dated sometime between late-second and mid-third century (for the late dating, see now C. Moss, "On the dating of Polycarp," *Early Christianity* 1 [2010]: 539–74).

4. Celsus as quoted in Origen, *Contra Celsum* 8.2 (translated by Henry Chadwick; Cambridge, 1953); all quotations from Celsus from this edition.

5. Heraclitus, fragment B5 (ed. Diels).

6. Herodotus 2.122.

CHAPTER 8: GODS AT HOME

1. See concisely Burkert, *Greek Religion* 115f; M. Scott, *Delphi: A History of the Center of the Ancient World* (Princeton, 2014).

2. Pausanias 10.7ff.

3. Tacitus, *Histories* 4.81.84; Plutarch, *On Isis and Osiris*; the Christian Clement of Alexandria a few decades later corroborates their story.

4. Fantasies about the library at Alexandria are easier to come by than facts; L. Canfora, *The Vanished Library* (Berkeley, Calif., 1990), has a higher ratio of information to rumor than most other accounts. One common line of fantasy has Christian zealots destroying the library as a by-product of the destruction of the Serapeum. It is more likely that ordinary mischance and neglect had let it fade many years earlier. The death of the philosopher Hypatia in 415 (see M. Dzielska, *Hypatia of Alexandria* [Cambridge, Mass., 1996]) is also instanced as antipagan violence.

5. Maria Grazia Lancellotti, *Dea Caelestis: studi e materiali per la storia di una divinità dell'Africa romana* (Rome, 2010); see also the review at *Bryn Mawr Classical Review* 2011.09.48 by L. Grillo.

6. Augustine, *City of God* 2.4, 2.24.

7. For a concise picture in this spirit, see J. Collins in S. I. Johnston, *Religions of the Ancient World*, 181–89; see also S. Schwartz *Imperialism and Jewish Society 200 BCE to 640 CE* (Princeton, 2001).

8. A non-Jew in the region might have had a very different and less dramatic reading of that revolt and its outcome from the traditional Jewish one: see John Ma's articles, "Relire les institutions des Séleucides de Bikerman," in S. Benoist, ed., *Rome, a City and Its Empire in Perspective* (Leiden, 2012), 59–84, and "Notes on the Restoration of the Temple," in R. Oetjen and F. X. Ryan, eds., *Seleukeia: Studies in Seleucid History, Archaeology, and Numismatics in Honor of Getzel M. Cohen* (Berlin, 2014).

9. That story is seen through the story of the Jewish books and their fate

in Alexandria and beyond: T. Rajak, *Translation and Survival: The Greek Bible of the Ancient Jewish Diaspora* (Oxford, 2009).

10. See again Schwartz, *Imperialism and Jewish Society*.

CHAPTER 9: DIVINE EXALTATION

1. See E. D. Digeser, *A Threat to Public Piety: Christians, Platonists, and the Great Persecution* (Ithaca, 2012), and A. P. Johnson, *Religion and Identity in Porphyry of Tyre* (Cambridge, 2013).

2. The entry in Plotinus's name in the online *Stanford Encyclopedia of Philosophy* (http://plato.stanford.edu/entries/plotinus/) may suffice for most readers curious for an orientation. L. Gerson, ed., *The Cambridge Companion to Plotinus* (Cambridge, 1996), is best then for those looking to go further.

3. J. P. Kenney, *Mystical Monotheism: A Study in Ancient Platonic Theology* (Hanover, N.H., 1991).

4. "[The gods] resided at a great distance from the One, who was their source at many removes" (Johnson, *Religion and Identity* 82).

5. See D. Brakke, *The Gnostics: Myth, Ritual, and Diversity in Early Christianity* (Cambridge, Mass., 2010).

6. R. Lamberton, *Homer the Theologian* (Berkeley, Calif., 1986).

CHAPTER 10: CONSTANTINE IN HIS WORLD

1. "Christ" more than "Jesus": writers of this age refer to "Christ" or the compound "Jesus Christ" very much more often than they speak of "Jesus." The narrative figure of the gospels receded behind the theological figure of interpretation. "Jesus" preponderates in the gospels, "Christ" takes the lead in Paul, but the trend grew much stronger still for many centuries.

2. Egypt is often exceptional in the Roman world as here: its wealth and the relative standing of its wealthy men remained much as before.

3. R. MacMullen, *Christianizing the Roman Empire* (New Haven, 1984), 50.

4. Herodian 5.6, with some paraphrase.

5. Hence the abundance of Christian stories of martyrdom and the paucity of evidence to suggest that such things happened very often at all. See now C. Moss, *The Myth of Persecution* (New York, 2013).

6. Digeser, *A Threat to Public Piety*, persuasively explores the philosophical backstory to this moment, seeing the influence of Porphyry, whom we have met before and will see again, in demonizing the Christians as part of his competing philosophical project; see also Johnson, *Religion and Identity*.

7. Lactantius, *The Deaths of Persecutors* 33.7–8: "The stench didn't fill just the palace, but pervaded the whole city. And no wonder, since the places where feces and urine came out of him had merged into one opening. He was being devoured by worms and his body was melting into a stinking mass and he suffered unbearable pain. 'He lifted up at once horrid cries to the stars, like the bellowing of a bull fleeing from the sacrifical altar.'" (The concluding quotation is Vergil's rendition, *Aeneid* 2.222–24, of Laocoon's death agonies.)

8. Lactantius, *The Deaths of Persecutors* 34.1–5.

CHAPTER 11: A NEW LEAF

1. Michael Sommer, "'Sick not only in body . . . ': Apollo Grannus and the emperor enchanted," unpublished paper at http://www.academia .edu/288221/Apollo_Grannus (as of 9 June 2014).

2. *Panegyrici Latini* 6.21.3ff. Translation here and below draws on C. E. V. Nixon and B. S. Rodgers, *In Praise of Later Roman Emperors* (Berkeley, Calif., 1994). T. Barnes, *Constantine and Eusebius* (Cambridge, Mass., 1981), 36, insists that "it is not necessary to believe that Constantine ever saw such a vision," missing the point. Constantine clearly had visited the shrine, a very public gesture, and was happy to have it known that the god had favored him and that he himself had been seen to resemble the god.

3. *Panegyrici Latini* 12.25.

4. Nixon-Rodgers, *In Praise of Later Roman Emperors*, 14.

5. Zosimus 29.5—the same historian who had reliable information about the *ludi saeculares* of Augustus's time.

6. "By divine inspiration": *instinctu divinitatis*, the word specific for imperial godliness again.

7. Lactantius, *The Deaths of Persecutors* 44. This symbol is a combination of the chi and rho letters that began the name of Christos in Greek, but as given in Lactantius, the appearance is that of a cross made up of vertical and horizontal crossbars (the X twisted to stand on one end) and the topmost bent around to look like an English P or Greek rho. Later versions will have the chi as an X shape and the rho imposed on it. The combination of letters may have been recognizable from other uses before Constantine, but none is securely identified as Christian (see note in A. Cameron's translation of Eusebius's *Life of Constantine* [Oxford, 1999], 210–12).

8. The senators were likely the *quindecemviri sacris faciundis*, still in business three hundred years after Augustus's *ludi saeculares*.

9. Eusebius, *Life of Constantine* 1.27ff.
10. *The Theodosian Code* (trans C. Pharr, Princeton, 1952), 9.16.3.
11. *The Theodosian Code* 16.10.2.
12. S. Bradbury, "Constantine and the Problem of Anti-Pagan Legislation in the Fourth Century," *Classical Philology* 89 (1994): 120–39, makes a serious argument for accepting the evidence that I reject, following on and modifying the more vigorously credulous case made by T. D. Barnes, *Constantine and Eusebius*, 210. Barnes has renewed his case in his *Constantine: Dynasty, Religion and Power in the Later Roman Empire* (London, 2011), drawing in part on K. W. Wilkinson, "Palladas and the Age of Constantine," *Journal of Roman Studies* 99 (2009): 36–60, who redates to Constantine's time verse complaining of antipagan terrorism. My own view is that the most that can be proven is that Constantine's support for the new god unleashed outbursts of remarkably bad behavior by other followers of that god, but the issue will remain controversial.
13. F. Millar, *The Emperor in the Roman World* (Ithaca, 1977), shows in handsome detail what emperors actually did for a living.
14. Libanius, *Oration* 30.6.
15. Peter Brown, *Through the Eye of a Needle* (Princeton, 2012), describes how a flood of wealth astonished the churches of the fourth and fifth centuries.
16. Those followers of Christ who were distressed by the materiality and anger of the god of the Jews and would either dispense with the writings of the Jews entirely or would make various provisions to choose which teachings they could accept. Acceptance of the Jewish past remained the predominant view, but the story is complex. See Paula Fredriksen, *Augustine and the Jews* (New York, 2008).

CHAPTER 12: THE BIRTH OF PAGANISM

1. There is no entirely satisfactory history of the formation of Christian doctrine and its controversies in this period: the best are still written by scholars with too much invested in the consequences of the debates. The most traditional account in one volume is J. Pelikan, *The Christian Tradition*, volume 1, *The Emergence of the Catholic Tradition (100–600)* (Chicago, 1971).
2. With common acceptance of the Old and New Testament books of what would come to be called the Bible, these debates drew on a wide variety of disparate texts; so e.g., Proverbs 8.22–29 was broadly agreed to be a text about the Christ who would come and thus a focus of debate (did it

imply creation and subordination or eternal coexistence?) and a source of ammunition for debates very nearly equal in force to texts of Gospels or Paul.

3. Pope Benedict XVI sanctioned restoration of "consubstantial" from the long-used Latin *consubstantialis*; the importance assigned to the change is a mark of continuing uneasiness about getting this essential point unambiguously right.

4. For the dynamics of these processes, see R. MacMullen, *Voting about God* (New Haven, 2006).

5. *Life of Constantine* 2.63–72.

6. T. D. Barnes, *Athanasius and Constantius* (Cambridge, Mass., 1993).

7. R. Van Dam, *The Roman Revolution of Constantine* (Cambridge, 2009), 23ff, takes up this episode and documents the history of debate.

8. By the seventh century, the author of the *Paschal Chronicle*, devoutly Christian, thought it flattering to claim that Constantine had transferred to his new capital from the old the *palladium*, the same venerable image we saw Elagabalus trifling with.

CHAPTER 13: THE BAPTISM OF PAGANISM

1. Cicero, *On His House* 74.

2. I outlined the evidence and history in my *"Paganus," Classical Folia* 31 (1977): 163–69, now at http://www.georgetown.edu/faculty/jod/ paganus.html.

3. A handful of inscriptions on stone from earlier in the century show the first reappearances of the word. The first surviving writers are Filastrius of Brescia and Marius Victorinus, both Italian intellectual Christians.

4. Herodotus 2.52 thought *theos* came from the Greek for setting/establishing, and so made the *theoi* the givers of *themis* (law). The idea made perfect sense but, like a great many ideas that make perfect sense, did not happen to be true.

5. English "heathen" gets rewritten in popular imagination in a comically similar way. It comes from the Greek *ethne* through German *Heide*, but is often written of as though it were a "calque" on *paganus* from the highlands of Scotland, where a heath-dweller would be prone to polytheism just as a *pagus*-dweller might have been. It has been common to say that *paganus* had an extra charge of pejorative implication, something like "hick" or "rube," but it's now clear that we needn't and shouldn't draw that conclusion.

6. Self-identifying pagans are a much later development, indeed a modern invention. Michael York, *Pagan Theology* (New York, 2003), is a forthright statement of the claims of that approach. To my eye, modern pagans tend to mix together things nobody would have thought to combine until somebody else slapped the same label on them.

7. Analogous in a different way is the term *jahiliyyah* in Arabic, literally "ignorance," but used specially of the religious condition of pre-Islamic Arabs, associated with idolatry.

8. P. Gay, *The Enlightenment*, volume 1: *The Rise of Modern Paganism* (New York, 1966), tells the story of paganism's rise to prestige; J. Fleming, *The Dark Side of the Enlightenment* (New York, 2013), makes the picture a little less inspirational.

CHAPTER 14: THE FIRST CHRISTIAN EMPEROR

1. Gore Vidal, *Julian* (New York, 1964): Vidal read widely and well in the ancient sources, and the book he wrote reflected the best current scholarship. Its picture of the period is partisan and old-fashioned now, but still well worth reading.

2. J. Bregman, *Synesius of Cyrene, Philosopher-Bishop* (Berkeley, Calif., 1982).

3. Theodoret, *Ecclesiastical History* 3.20

4. Some think him the "Sallustius" who wrote *Concerning the Gods and the Universe*, which I quoted above on the issue of ancient attitudes to sacrifice.

5. Ammianus 22.10.7; "overwhelmed in eternal silence" comes very close to the language of the old Roman custom of *damnatio memoriae*, "condemnation of the memory," when names of disgraced officeholders would be physically obliterated from stone inscriptions and every other record. This is strong stuff. R. Cribiore, *Libanius the Sophist* (Ithaca, 2013), 229–36, observes the reservations traditionalist intellectuals had with the same decree, seeing it as excessive. For contrast, Julian's fellow student from Athens, Basil, in his "Address to Young Men on Greek Literature," demonstrated by precept *and* example how a Christian would read the Greek classics—primly enough, but in a way that would not seem offputting to many Platonists and other philosophical readers untouched by Christianity.

6. Ammianus 23.1.

7. The scholars' Julian wars are lively. For the standard view see G. Bower-

sock, *Julian the Apostate* (Cambridge, Mass., 1978), and P. Athanassiadi, *Julian and Hellenism: An Intellectual Biography* (Oxford, 1982), Freudian and romantic in interpretation respectively; the reformed view depends on J. Bouffartigue, *L'Empereur Julien et la culture de son temps* (Paris, 1992), and R. Smith, *Julian's Gods* (London, 1995). A superb new reading of Julian comes from S. Elm, *Sons of Hellenism, Fathers of the Church* (Berkeley, Calif., 2012), who offers a close comparison of Julian and his fierce Christian rival, acquaintance, and critic Gregory Nazianzen, emphasizing how much the two had in common in their contest to be seen as the legitimate interpreter of the heritage of Greek thought.

CHAPTER 15: THE SERVANT OF CHRISTIANITY

1. Samuel Dill, *Roman Society in the Last Century of the Western Empire* (London, 1906), 166.
2. The collapse occurred over the last generation. See my " 'The Demise of Paganism,' " *Traditio* 35 (1979): 45–88, and "The Career of Virius Nicomachus Flavianus," *Phoenix* 32 (1978): 129–43; for full current treatment, see Alan Cameron, *The Last Pagans of Rome* (New York, 2011).
3. Best now: C. Sogno, *Q. Aurelius Symmachus: A Political Biography* (Ann Arbor, 2006).
4. See J. Matthews, *Western Aristocracies and Imperial Court AD 364–425* (Oxford, 1975); for a long time, moderns took the family of the Anicii as paragons of lineage and dignity; see now A. Cameron, "Anician Myths," *Journal of Roman Studies* 102 (2012): 133–71.
5. Cameron, *Last Pagans*, is more skeptical than even I about some of the elements of the traditional narrative that I retain here.
6. Symmachus's words appear in his *Relatio* 3.10, cf. Augustine, *Soliloquies* 1.13.23, *"sed non ad eam [sapientiam] una via pervenitur"* ("not by a single path does one arrive at wisdom") regretted by him in his old age at *Reconsiderations* 1.4.3; the other echo appears at *True Religion* 28.51. Plato likely to become a Christian: *True Religion* 3.3.
7. N. McLynn, *Ambrose of Milan* (Berkeley, Calif., 1994).
8. Ambrose, *Letter* 17.4.
9. *Letter* 17.16.
10. *Letter* 18.1.
11. R. Krautheimer, *Rome: Profile of a City 312–1308* (Princeton, 1980): Constantine's basilica in honor of Saint Peter stood where the present basilica rises, but was on a much more modest scale.

CHAPTER 16: THE TRIUMPH OF PAGANISM

1. N. Lenski, *The Failure of Empire* (Berkeley, Calif., 2002).
2. O'Donnell, *Ruin of the Roman Empire* (New York, 2008), 87–88.
3. No sharp line separates the period we speak of as Roman from that we call Byzantine, but this effective confinement of the emperor to capital and palace makes 395 one good place to draw the line. Justinian's reign of ruinous grandeur (527–565) is another.
4. Jason BeDuhn, *Augustine's Manichaean Dilemma* (Philadelphia, 2009–, two volumes with a third on the way), has made this point well. The use may have originated in Africa a few years earlier, among the faction that Augustine would come to lead: see my *Augustine: A New Biography* (New York, 2005), 358n.
5. Scholars debate just how much violence there was and how much credit it deserves for turning practice and sentiment permanently away from the old ways; MacMullen's *Christianizing the Roman Empire* made it impossible to think any longer of a mainly benign and voluntary "triumph" of Christianity.
6. J. F. Matthews, *Western Aristocracies* 110–11, 140–44.
7. *Theodosian Code* 16.10.12pr.
8. R. MacMullen, *Christianizing the Roman Empire* 59ff.
9. The best account to date is K. Harl, "Sacrifice and Pagan Belief in Fifth- and Sixth-Century Byzantium," *Past and Present* 128 (August 1990): 7–27.
10. Jerome, *Letter* 107; M. Salzman, *The Making of a Christian Aristocracy* (Cambridge, Mass., 2002).
11. R. von Haehling, *Die Religionszugehörigkeit der hohen Amtsträger des Römischen Reiches seit Constantins I. Alleinherrschaft bis zum Ende der Theodosianischen Dynastie: 324–450 bzw. 455 n. Chr.* (Bonn, 1978).
12. Jörg Rüpke, *Fasti sacerdotum: A Prosopography of Pagan, Jewish, and Christian Religious Officials in the City of Rome, 300 BC to AD 499* (Oxford, 2008), catalogs every known holder of traditional priesthoods over eight centuries to the year 500. After 400, Albinus and Longinianus, attested no later than 406, are the only two listed.
13. See L. J. Thompson, *The Role of the Vestal Virgins in Roman Civic Religion* (Lewiston, N.Y. 2010).

CHAPTER 17: WHAT REMAINED

1. See again my "Demise of Paganism," Cameron, *The Last Pagans*, and D. Boin, "A Hall for Hercules at Ostia and a Farewell to the Late Antique

'Pagan Revival,'" *American Journal of Archaeology* 114 (2010): 253–66. We respond particularly to an influential article built on slight evidence: H. Bloch, "A New Document of the Last Pagan Revival in the West," *Harvard Theological Review* 38 (1945): 199–244.

2. Posthumously condemned for his revolt, Flavianus was rehabilitated almost forty years later at the request of his son, by then well along in his own dignified career, and with the approval of the emperors Valentinian III and Theodosius II: see (with more "paganism" than I would accept) C. W. Hedrick Jr., *History and Silence* (Austin, 2000).

3. *Carmen contra paganos*, ed. T. Mommsen, "Carmen codicis Parisini 8084," *Hermes* (1870): 350–63; the quotation is from lines 91–111 (my translation).

4. Ammianus 27.9.8.

5. Jerome, *Against John* 8.

6. Cameron, *Last Pagans* 273–319.

7. M. Salzman, *On Roman Time: The Codex-Calendar of 354* (Berkeley, Calif., 1990).

8. Claudian, *Carmina minora* 32, "de Salvatore."

9. The "golden age" doesn't quite fit in a Christian version of history but is a traditional, indeed trite, image in classical Latin poetry.

10. A. Cameron, *Claudian* (Oxford, 1970).

11. R. Shorrock, *The Myth of Paganism: Nonnus, Dionysus and the World of Late Antiquity* (London, 2011).

12. There is still a tendency among Byzantinists to seek evidence of underground pagan sentiments across many centuries, but a clearer understanding is slowly emerging: see A. Kaldellis, *Hellenism in Byzantium* (Cambridge, 2008).

13. Robert Markus, *The End of Ancient Christianity* (Cambridge, 1990); see also my *Augustine: A New Biography,* 171ff.

14. S. Bradbury, *Severus of Minorca: Letter on the Conversion of the Jews* (Oxford, 1996).

15. See my *Augustine: A New Biography,* 296–300, on the origins of the doctrine.

16. See P. Brown, *The Body and Society* (New York, 1988).

CHAPTER 18: CICERO REBORN

1. Survival happened (see again Harl, chapter 16, n.9) but survival is not always easy to interpret, as in a letter by a late-fifth-century pope about

the "Lupercalia," on which see N. McLynn, "Crying Wolf: the Pope and the Lupercalia," and N. McLynn and J. North, "Postscript to the Lupercalia," in *Journal of Roman Studies* 98 (2008): 161–81.

2. Augustine, *Letters* 90, 91, 103, 104; see my *Augustine: A New Biography* 184ff. Things got uglier in Sufes, another modest city in north Africa, when local Christians in 399 had torn down a statue of Hercules; in the ensuing riot, sixty people were killed. In his angry *Letter* 50, Augustine says he will restore the statue if the city fathers can restore all those lives. We don't hear anything of the other side in that case, but on Augustine's own evidence have to assign the origin of the violence to Christian action.

3. Augustine, *Letter* 103.

4. See now BeDuhn's *Augustine's Manichean Dilemma*, the best fresh work on Augustine's life and conversion in at least twenty years.

5. Never? A decisive moment in his *Confessions* comes when he seeks divine guidance by opening a manuscript of Paul at random and letting the first passage on which his eyes fell speak to him. In later writings he shows bad conscience about this and deplores Christians adopting a practice familiar from ancient use with classical texts like the *Aeneid*. Compare *Confessions* 8.12.29 with Augustine's *Letter* 55.20.37.

6. Augustine, *Against Faustus* 14.11.

7. Pliny the Younger, *Letter* 10.96.

8. MacMullen, *The Second Church*.

9. E. Rebillard, *Christians and Their Many Identities in Late Antiquity, North Africa 200–450 CE* (Ithaca, 2012), is excellent on the diversity that persisted among Christians and between Christians and their neighbors, friends, and relatives.

10. The well-known Christian Latin writers before the late fourth century are few and relatively isolated: Tertullian, Cyprian, Lactantius, Hilary of Poitiers.

11. That moment now has a sympathetic and vivid portrayal in Garry Wills, *Font of Life: Ambrose and Augustine in Milan* (New York, 2011). The following paragraphs draw on my *Augustine: A New Biography*.

12. P. Brown, *Power and Persuasion in Late Antiquity* (Madison, Wisc., 1992); many sermons survive from the period, east and west. The public speaker in Latin antiquity who left behind the largest number of surviving orations is Augustine; in Greek, John Chrysostom, the fifth-century bishop of Constantinople.

13. R. MacMullen, "The Preacher's Audience," *Journal of Theological Stud-*

ies 40 (1989): 503–11, impertinently and trenchantly asked whether that
audience, given the modest size of church buildings, could contain very
much more *besides* the best people and some of their retainers. It's conse-
quently a very open question just how many Christians actually went to
church regularly.

14. M. Gleason, *Making Men* (Princeton, 1994), deftly reads the history of
these performers as a narrative of Roman masculinity in anxiety and
action.

15. The classic account is W. H. C. Frend, *The Donatist Church* (Oxford,
1951), now magnificently complemented by B. Shaw, *Sacred Violence:
African Christians and Sectarian Hatred in the Age of Augustine* (Cam-
bridge, 2011).

CHAPTER 19: A ROMAN RELIGION

1. For "barbarians," the new arrivals in the Roman empire in this period
were remarkable for having been converted decades earlier to the imperial
religion, at a time when it was more Arian than Nicene; P. Amory, *People
and Identity in Ostrogothic Italy* (Cambridge, 1997), 235–76, shows how
easily they fit in with the still-surviving communities of old-fashioned
Latin Arianism even a century later.

2. G. O'Daly, *Augustine's City of God: A Reader's Guide* (Oxford, 1999),
introduces the work and the scholarship; R. Markus, *Saeculum: His-
tory and Society in the Theology of Saint Augustine* (Cambridge, 1969),
views the issues more broadly. An older and very ambitious survey of the
movement of ancient social thought culminating in Augustine is C. N.
Cochrane, *Christianity and Classical Culture* (Oxford, 1939).

3. Augustine, *Letter* 154.2.

4. O'Daly, *City of God* 22.28: "Cicero touched on this in his books about the
Republic—you'd think he was just trifling rather than saying something
seriously, for he brings back to life a dead man and makes him say things
very similar to Plato's arguments."

5. In a way, O'Daly's *City of God* is also Augustine's *Confessions* writ large.
The earlier book had told the story of an individual's sin, redemption, and
progress toward the afterlife and ended with a vivid anticipation of ever-
lasting praise in heaven; *City of God* tells the same story about human-
kind, not just a single human.

6. O'Daly, *City of God* 19.21, picking up the argument from 2.21–24; see
J. Adams: *The Populus of Augustine and Jerome* (New Haven, 1971).

7. O'Daly, *City of God* 4.4.
8. O'Daly, *City of God* 5.26, a passage some of Augustine's friends have found embarrassing for its fawning enthusiasm.
9. The Czar of Russia, the Kaiser of Germany, and the Kaiser und König of Austria-Hungary all claimed the inherited prestige of the Roman Empire as their own, while the Ottoman sultan ruled the realm based in Constantinople that had emerged from late antiquity, with what we would now call a hostile takeover in 1453.
10. Cameron, *Last Pagans* 231–72.
11. For a sniffier aristocratic response, heavily veiled, see A. Cameron, "Rutilius Namatianus, St. Augustine, and the date of the *De Reditu*," *Journal of Roman Studies* 57 (1967): 31–39.
12. I. Kajanto, "*Pontifex Maximus* as the Title of the Pope," *Acta Fennica* 15 (1981): 37–52. See also Cameron, *Last Pagans* 51–56 and, in response, L. Cracco Ruggini, "'Pontifices': un caso di osmosi linguistica," in P. Brown, R. Lizzi Testa, eds., *Pagans and Christians in the Roman Empire: The Breaking of a Dialogue (ivth–vith Century A.D.)* (Zürich/Münster, 2011), 403–23.

EPILOGUE

1. J. B. Bury, *The Idea of Progress* (London, 1920); R. Nisbet, *The History of the Idea of Progress* (New York, 1986).
2. E. Watts, "Justinian, Malalas, and the End of Athenian Philosophical Teaching in A.D. 529," *Journal of Roman Studies* 94 (2004): 168–82; cf. his *The Final Pagan Generation* (Berkeley, Calif., forthcoming 2015).

FURTHER READING

The scholarly literature on the topics covered here is vast, but the notes sign-post it for both those seeking an introduction and scholars who wish to know the basis for my work. For those who wish to consider these subjects further, I strongly suggest a small program of reading in the primary sources from this period. Read these books in light of what I have said, I suggest, and then make up your own mind about the issues. I do not differentiate "pagans" from "Christians" and I list them alphabetically by author to avoid prescribing any particular reading. Make up, as I say, your own mind.

Apuleius, *The Golden Ass*
Augustine, *Confessions*
Boethius, *Consolation of Philosophy*
Gregory the Great, *Dialogues*
Philostratus, *Life of Apollonius of Tyana*

The philosophically determined reader would benefit from the *Enneads* of Plotinus, not omitting the *Life* that Porphyry prefixed to them when he made the original edition. The canonical Christian gospels and the letters of Saul/Paul always repay thoughtful attention.

INDEX